Besides the Screen

KV-731-545

Printed and bound by CPI Group (UK) Ltd, Croydon, CR0 4YY

Besides the Screen

Moving Images through Distribution, Promotion and Curation

Edited by

Virginia Crisp
Coventry University, UK

Gabriel Menotti Gonring
Federal University of Espírito Santo, Brazil

First published 2015 by
PALGRAVE MACMILLAN

Palgrave Macmillan in the UK is an imprint of Macmillan Publishers Limited,
registered in England, company number 785998, of Houndmills, Basingstoke,
Hampshire RG21 6XS.

Palgrave Macmillan in the US is a division of St Martin's Press LLC,
175 Fifth Avenue, New York, NY 10010.

Palgrave Macmillan is the global academic imprint of the above companies
and has companies and representatives throughout the world.

Palgrave® and Macmillan® are registered trademarks in the United States,
the United Kingdom, Europe and other countries.

ISBN 978–1–137–47101–7

This book is printed on paper suitable for recycling and made from fully
managed and sustained forest sources. Logging, pulping and manufacturing
processes are expected to conform to the environmental regulations of the
country of origin.

A catalogue record for this book is available from the British Library.

A catalog record for this book is available from the Library of Congress.

Contents

v

Part III In the Files and Out There: Curation

Figures and Tables

Figures

Tables

Acknowledgements

First, we would like to thank the Goldsmiths Graduate School, Middlesex University and the London Screen Studies Group, without whose funding and endorsement the 2010 and 2012 Besides the Screen conferences at Goldsmiths College, University of London, would not have been possible. Particular thanks go to Maitrayee Basu, Chris Berry, Lynne Crisp, Charlotte Crofts, Janet Harbord, Stefania Haritou, Adnan Hadzi, Julian Henriques, Lesley Hewings, Agnieszka Jedrzejczyk-Drenda, Janis Jeffries, Julia Knight, Rachel Moore, Kerstin Müller, Gavin Singleton, Yigit Soncul and Damian Sutton.

We are also incredibly grateful to the friends and colleagues who have read drafts and provided encouragement throughout the production of this volume. In this regard we would particularly like to thank Feona Attwood, Billy Clark, Sean Cubitt, Vivienne Francis, James Graham, Eleftheria Lekakis, Ben Little, José Carlos Silvestre, Sylvia Shaw and Alison Winch.

Special thanks go out to all of the contributors to this volume. Without their excellent and engaging research none of this would have ever been possible. We would also like to send further special thanks to the photographer Ignez Capovilla and the theatre manager Talmon Fonseca for their help in producing a cover image that has attempted to illustrate the diversity of content within this edited collection.

We would like to send our warmest thanks to our editor, Chris Penfold, and all of his colleagues at Palgrave Macmillan who have worked diligently and expediently to bring this project together.

Finally, we would like to thank our friends and families who have supported us throughout the production of this edited collection. Virginia would like to send extra-special thanks to her partner, Gavin, who has provided unwavering support and encouragement throughout all of her endeavours (academic and otherwise). Menotti is immensely grateful to Rossana, José Irmo and Marcela for their continuing support both near and far.

Contributors

Jonas Andersson Schwarz is the author of *Online File Sharing: Innovations in Media Consumption* (2013) and co-editor of the *After the Pirate Bay* anthology (with Pelle Snickars, 2010). He currently works as a postdoctoral researcher in collaboration with the Forsman & Bodenfors advertising agency and is affiliated to the Department of Media and Communication Studies at Södertörn University, Stockholm. He has a PhD from Goldsmiths, University of London, and in his research he critically investigates behavioural and structural conditions for online media consumption, usage and sharing – with a particular eye towards the technological conditions at hand.

Ana Carvalho holds a PhD in communication and digital platforms from the Faculdade de Letras, Universidade do Porto. Her research investigates identity (collective and individual), documentation, narrative and memory construction within live audiovisual performance. She is a lecturer at ISMAI (Instituto Universitário da Maia) and coordinator of the Ephemeral Expanded research project. She has been involved in several collaborative projects that combine theory and practice. She is co-editor of the VJ Theory project and co-organizer of abertura events in Lisbon. She has been growing gardens, physical and imaginary, as source of metaphors to feed compositions and performances for live audiovisual performance.

Virginia Crisp is Senior Lecturer in Media and Communications at Coventry University and author of *Film Distribution in the Digital Age: Pirates and Professionals* (forthcoming). She is the principal investigator on the AHRC-funded International Network Grant 'Besides the Screen'. She is the co-organizer of the third Besides the Screen conference to be hosted jointly in São Paulo and Vitória, Brazil in August 2014 (in association with the University of São Paulo and Federal University of Espírito Santo). She received her PhD from Goldsmiths, University of London and has published a range of papers on film distribution, file sharing and piracy.

Stefania Haritou studied philosophy in Thessaloniki, Greece and film studies in London. She is interested in the situated, socio-material

practices of film distribution, exhibition and archiving. In her work she uses the analytical and methodological tools of science and technology studies in the field of film studies. Currently she is conducting research on documentary exhibition in Mexico.

Stephanie Janes is a PhD candidate in media arts at Royal Holloway, University of London. Her thesis focuses on the function of promotional alternate reality games (ARGs) in marketing campaigns for contemporary Hollywood cinema. She has published on ARGs in *Networking Knowledge: Journal of the MeCCSA PGN* and co-authored a forum article in *Participations: Journal of Audience and Reception Studies*. Broader research interests include promotional materials, audience research and media fandoms.

Zlatan Krajina is Senior Lecturer at the University of Zagreb. He is the author of *Negotiating the Mediated City* (2014). His background is in radio and television production (2000–2008), and in media and cultural studies, which he studied, at both master's and doctorate levels, at Goldsmiths, University of London (2006–2011). He teaches graduate courses on media audiences and media cities, and is interested in establishing productive connections across different disciplines for a critical understanding of contemporary urban living.

Gabriel Menotti Gonring is a critic and curator engaged with different forms of cinema. He has previously organized pirate screenings, remix film festivals, videogame championships, porn screenplay workshops, installations with super8 projectors, generative art exhibitions and academic seminars, among other things. He is also a co-founder of the Besides the Screen Research Network and conferences. He holds a PhD in media and communications from Goldsmiths, University of London, and another from PUC-SP. He is the author of *Através da Sala Escura* (2012), a history of movie theatres from the perspective of audiovisual performances, and *Curatorial Approaches to Cinema: Projection Technology and Aesthetics* (forthcoming). Currently, he works as a lecturer at the Federal University of Espírito Santo, Brazil.

Ya-Feng Mon holds a doctorate in media and communications from Goldsmiths, University of London, where she researched the sensory aspects of cinematic communication. Her background in film journalism has allowed her unique insights into the complex terrain of film production and consumption. Her recent research interests lie in

various embodied experiences of technologies. These include, specifically, the way in which the embodied experience of cinema might have merged into the embodied experience of religion, and how the practice of antique trading might corporeally reconfigure cultural identity. 'Tragic but Brave', her critical essay on the works by British documentary filmmaker Kim Longinotto, is published in *The Book on Women-made Moving Images* (ed. Taiwan Women's Film Association, 2006).

Claudy Op den Kamp is a senior researcher in the DIASTOR film digitization and restoration research project at the University of Zurich. She previously worked as an account manager at the Dutch film restoration laboratory Haghefilm Conservation and as a film restoration project leader at the Nederlands Filmmuseum (now EYE Film Institute Netherlands). She is a graduate of the University of Amsterdam (film and television studies) and the University of East Anglia (film archiving). She is currently finishing a PhD dissertation on audiovisual archives, copyright ownership and the film historical narrative at Plymouth University (Transtechnology Research).

Alejandro Pardo is Associate Professor at the Department of Film, TV and Digital Media, School of Communication, University of Navarra (Spain), where he teaches film production and audiovisual project management. He specializes in production for film and TV (UCLA Extension), entertainment and media management (UCLA Anderson School of Management) and audiovisual management (Media Business School, Madrid). He is also a visiting researcher at the UCLA School of Theater, Film and TV, as well as a guest scholar at the DeSantis Business and Economics Center for the Study and Development of the Motion Picture and Entertainment Industry (Florida Atlantic University). Publications include *The Europe–Hollywood Coopetition: Cooperation and Competition in the Global Film Industries* (2007) and *The Audiovisual Management Handbook* (2002) as editor. He has also written a number of contributions to collective books on film and television industries as well as a number of journal articles. He is a member of the European Media Management Association, the Society of Cinema and Media Studies and the European Network for Cinema and Media Studies. He is currently researching on the impact of digitization on the film industry.

Elena Papadaki is an art historian and cultural theorist. Her doctoral research (Goldsmiths, University of London – Centre for Cultural Studies and Department of Arts and Computational Technologies) examined

the curation of screen media in diverse physical environments. Her research interests lie in the intersection of screen-based arts, architecture and audience reception. She is an associate lecturer at the University of Greenwich and a founder of Incandescent Square, a collaborative meeting point for research and design.

Enrica Picarelli completed her PhD in cultural and postcolonial studies of the Anglophone World at 'L'Orientale' University of Naples, where her dissertation addressed the reverberations of the post-9/11 culture of fear in American science fiction. From 2011 to 2013 she was the recipient of the 'Michael Ballhaus' fellowship for postdoctoral research at Leuphana University (Lüneburg), where she investigated the affective economy of media promotion. She is currently a postdoctoral researcher at the Centre for Comparative Studies of the University of Lisbon, where she is working on a publishing project about Afropolitanism and 'black' fashion. She has published articles in various journals and anthologies.

1
Introduction: In the Grooves of the Cinematographic Circuit

Gabriel Menotti Gonring and Virginia Crisp

It has become commonplace to talk about the influence that technological developments have on audiovisual media. At some point in the 20th century, video and broadcast television came to disturb the traditional organization of the cinema, revealing the image as soon as it was captured and bringing it into the audience's home. Currently, computer synthesis and online networks have even stronger effects on the medium as they increase the public's agency in the dynamics of the movie market. Film, as Professor Janet Harbord has so concisely summarized, 'is not what it used to be' (2007, p. 1). A number of technological, industrial and social shifts have affected it in recent years, the most notable being the fact that film is no longer 'filmed' – at least not on celluloid. Inasmuch as this might be the origin of a crisis in medium specificity, it is also what allows film to seamlessly converge with other media, escaping from the bounds of cinematic presentation into potentially limitless sites of exhibition and consumption, from mobile phones to public facades.

It is impossible to count here the myriad ways that film production, distribution, exhibition and consumption have changed over recent years; not least because by the time of publication the 'new' developments will undoubtedly have been superseded by yet more epoch-altering changes. Suffice to say that while the methods of production and consumption of film and other media content undergo an endless cycle of birth, rebirth and death, so too does the scholarship that attempts to grasp the complexities of the mediated world we all inhabit. Film studies and its cognate disciplines have been trying very hard to keep up with these fundamental transformations of their subjects.

1

This volume was inspired by one such attempt: a series of conferences organized in 2010 and 2012 by a group of then-PhD candidates at Goldsmiths, University of London. Named Besides the Screen, these events meant to address seemingly disparate areas of study in audiovisual media, such as archiving, curating, distribution, exhibition, codification, projection, piracy and marketing. In spite of their obvious differences, these practices had been put together for two reasons: first, the fact that they are generally overlooked by the field's scholarship; second, the fact that they are being equally overhauled by digital computation. In paying attention to them, one comes to realize that new media technology impacts cinema well beyond film. It also promotes a reorganization of its logic of circulation, modes of consumption and viewing regimes. In that sense, the scrutiny of these spaces, practices and structures that happen around visual surfaces may give a new depth to film studies.

The chapters presented here, as a sample of the work that has developed out of the Besides the Screen events, have been organized according to three key themes: the distribution, promotion and curation of moving images. This volume's main argument is that we must leave the image aside for a while and examine these largely invisible processes if we are to fully consider how cinematographic experience is mediated by the various sociotechnical changes that occurred in the early decades of the 21st century. In other words, it is only by looking *besides* the screen that one is able to generate a really cohesive picture of the converged media landscape that we have around us.

This is by no means the first endeavour to address such themes and suggest that film studies could profit from sidestepping film. Nevertheless, while a great deal of interesting research about audiovisual practices is being conducted, the results seem to take the form of an archipelago of scholarships: islands of specialized knowledge that very rarely interface with one another. If we mean to honour the intrinsically relational character of cinema, would it not make sense to produce connections between all the academic work already being undertaken? So, bringing economic and materialist concerns together with an interest in the aesthetics and language of audiovisual media, this edited collection aims to fill these gaps within the ever-expanding discipline of film studies. To begin with, the following section will chart some of the more significant strands of scholarship that continually intersect and interact to create a 'film' studies discipline as dynamic as the industries and practices that it tries to understand.

Contexts, paratexts and cultures: From film to off-screen studies

Since the early days of film theory, following a tradition inherited from literary studies, there has been a focus on textual analysis. However, as the discipline developed it became clear that this method, while potentially unearthing illuminating readings of film, did not have the capacity to reveal how moving image works might be experienced and 'read' by audiences during the act of consumption. As Jonathan Gray suggests:

> Just as taking apart a machine would not necessarily explain why a given person chose that machine over another tool or machine, close reading may tell us little about how a viewer *arrived at* a text. Why view *this* program, or *this* film, as opposed to the many thousands of other options.
>
> (2010, p. 24)

During the 1990s–2000s, as if responding to this limitation, film studies experienced what could be hesitantly termed an 'exhibition turn' led by the work of scholars such as Gregory Waller (2002), Douglas Gomery (1992) and Ina Rae Hark (2002). In the spirit of audience studies, these projects revisited the history of exhibition spaces and practices, analysing the constitution of viewing regimes. Such an approach provided ways to understand the contexts in which film was consumed, and how these contexts affected the meaning and value of the cinematographic work.

Nevertheless, the focus on exhibition only enables a limited understanding of the industrial and social processes that take place after film production and yet play a key role in dictating which works reach audiences in the first place. It is film distribution – that oft overlooked grey space between creation and consumption – that will allow for a more complete picture of moving image's conditions of existence. This area has long been a site of theoretical interest: for instance, both *Global Hollywood* (Miller et al. 2001) and *Global Hollywood II* (Miller et al. 2005) contained sections on film distribution, as did Janet Wasko's seminal text *How Hollywood Works* (2003). What these examples demonstrate, though, is how scholarship in distribution was often hidden within larger, more general, studies of the film industry (in particular Hollywood).[1] As acknowledged by theorists such as Sean Cubitt (2004), Dina Iordanova and Stuart Cunningham (2012) and Julia Knight and Peter Thomas (2008), film distribution is still a woefully

under-researched area. It is only recently that the topic has entered the spotlight of both academic and industry concerns because, in many respects, control of this sector of the industry is being wrestled away from the Hollywood majors who have traditionally dominated it.

On the one hand, there are companies like Netflix, Amazon and Hulu, referred to as 'disruptive innovators' by Stuart Cunningham and Jon Silver (2012), who have led the field in providing online video on demand (VOD) and subscription video on demand (SVOD) services. While many of these amenities are only available in certain territories,[2] and so the extent to which they have 'revolutionized' the worldwide consumption of motion pictures should be stated with caution, these companies now hold the key to an important consumption 'window' for film and TV viewing when such release windows were once, at least in the case of the film industry, almost exclusively controlled by the major Hollywood studios.

On the other hand, and at the same time, fundamental changes in film distribution are being caused by developments in the illicit or illegal circulation of content; that is, film piracy. In his book *Shadow Economies of Cinema* Ramon Lobato helpfully makes the distinction between formal and informal film distribution (2012). Such a distinction allows us to consider the multiple ways that films circulate to and amongst audiences without making the almost inevitable distinction between the legality (or otherwise) of such practices. Thus, informal distribution can refer to lending films to friends or film societies at universities, as much as it might also be a term to describe the sale of counterfeit DVDs by street vendors or the 'sharing' of files online through a variety of means.

While Lobato's terminology is undoubtedly helpful, it is important to also remember that informal/formal and illegal/legal forms of distribution are not mutually exclusive and that there are interactions and connections between such practices on a number of levels. Such intersections between formal and informal modes of film distribution are central to the research interests of one of the editors of this book and are examined in her forthcoming monograph *Film Distribution in the Digital Age: Pirates and Professionals* (Crisp, 2015). Here Crisp makes the case that while film texts are disseminated in a variety of professional, social and (il)legal contexts, there is a lack of research that directly examines the nature of the relationship between these differing forms of film distribution. As such, she examines film distribution in both formal and informal contexts, whilst considering how these practices of dissemination might ultimately conflict, interact with or complement one another.

Distribution in this context means far more than the link between content production and exhibition in the industrial chain. The film 'distributor' may have the power to dictate many parts of the process of content production, dissemination, marketing, exhibition, consumption and preservation, depending on a variety of factors. In fact, one might argue that the very term *distribution* is misleading when referring to the media industries because, in this context, such intermediaries are more concerned with the exploitation of intellectual property rights rather than the actual dissemination of products.

This is the point where the sheer dissemination of content gets entangled with the exploitation of its meanings. Film marketing, a process that ordinarily resides within the remit of the film distributor, does more than entice potential audiences to attend cinema screenings and purchase DVDs and movie merchandising. The way a film is advertised, marketed and promoted has the power to shape our textual experience before we ever enter the cinema or settle down on the sofa to watch a DVD.

There has been scholarly work on film marketing for some time. In particular, Justin Wyatt's incredibly influential text *High Concept: Movies and Marketing in Hollywood* (1994) demonstrated how films since the 1970s are typified as 'high concept' by their increased focus on marketing and merchandising. However, as Finola Kerrigan points out, while such examinations of the important function that marketing plays within the film industry are certainly welcome, they often disregard marketing theory and focus on cases of marketing from within film, media and cultural studies. In that sense, Kerrigan's own work *Film Marketing* (2010) provides a much-needed comprehensive overview of what film marketing is and how it functions, by bringing theory and knowledge from marketing into dialogue with studies of marketing within the film industry. In his book, Kerrigan suggests that 'many isolated pockets of film marketing knowledge co-exist within the benefit of cross-reference' (2010, p. 2). This observation again serves to highlight how an interdisciplinary approach to screen studies is both welcome and necessary as the media landscape continues to evolve.

Despite these important interjections, the focus within screen studies has hitherto invariably been on the film 'text' itself rather than its manifold 'paratexts': the materials that circulate around it, such as trailers, TV spots, adverts, merchandising, DVD covers and so on. Such ephemeral media has been, at worst, rejected as 'promotional' (and thus not a 'text' worthy of scholarly discussion) or, at best, simply overlooked or ignored.

Nevertheless, they are crucial to the workings of cinema. According to Gray's book *Show Sold Separately*, paratexts not only

> tell us about the media world around us, prepare us for that world, and guide us between its structures, but they also fill it with meaning, take up much of our viewing and thinking time, and give us the resources with which we both interpret and discuss that world.
>
> (2010, p. 1)

Furthermore, Gray makes a distinction between 'entryway paratext' (e.g. trailers that shape our experience of the film before consumption) and 'in medias res paratexts' (those experienced during or after the film) (2010, p. 22). Such classification into subtypes serves to illustrate that paratexts are multiple and varied, and are serving to extend the experience of the wider 'text' for the audience with every iteration. As their role becomes more prominent and influential, their inclusion within the wider body of film studies becomes imperative.

Intersecting with all of these areas is work on 'film cultures' more generally. In 2002, *The Film Cultures Reader* edited by Graeme Turner brought together chapters on film technologies, industries, meanings and pleasures, identities, and audiences and consumption. In many ways this publication began the work that *Besides the Screen* seeks to continue. It brought together in a single place considerations about many different aspects of cinema and was not constrained by concerns of uncovering the meaning contained within film texts, but rather examining how meaning is created and developed through the industrial and social processes that constitute film production and consumption.

While such an examination of film *cultures* rather than film *texts* might be welcome, there is still a limitation: as modes of delivery (if not also production) for film and TV mingle with one another, speaking specifically of *film* might be perceived as misleading. The continuing media convergence has caused inevitable repercussions for the study of cinema as a distinct medium. As Harbord suggests, 'the effects of such transformations, considered together, produce a disorientation, perhaps a momentary vertigo, for film studies' (2007, p. 2). This sparked renewed interest in the ontology of film itself, along with the realization that 'intellectual traditions and methods of a discipline determined three decades ago have come to acquire an emptiness' (p. 2) as the stalwarts of structuralism and semiotics no longer have a place in this brave, new, converged world.

Considering developments in digital technology, does it still make sense for a discipline of 'film' to exist distinct from cognates such as television studies? As the title of the pre-eminent film studies journal *Screen* highlights, these fields have been bedfellows for quite a while, dedicating similar attention to the flat surfaces in which moving images appear. Here, a structural element such as the 'screen' seems to work as a useful common denominator for new epistemological endeavours, more aware of the interactions between what used to be considered ontologically distinct media. As our interest moves from the film-as-text to the cultures that surround it, it seems relevant to evoke Gray's call for the development of '*off-screen studies*' – which, for him, implies an extension of 'screen studies' that considers the way that paratexts help to shape and develop the meaning of the wider 'text' (2010, p. 4).

While Gray's approach is an interesting point of departure, we would like to suggest it does not go far enough to capture the multiple instances where meaning is made during encounters with media content. After all, by focusing on paratexts the *textual* (albeit the wider textual universe) is still the focus. A thorough study of the phenomena that exist besides screens also needs to acknowledge the material and sociotechnical attributes of cinematographic practices. The articulation of these layers allows for the production of complex links to other media, providing a new understanding of the negotiations and interfaces operating within the process of convergence. In the following sections, we will see how this approach is deployed in the book's chapters.

Part I – Through many channels: Distribution

Computer networks are systems within which the processing of information is deeply intertwined with its transmission. As audiovisual media fully incorporate these technologies, it is not a surprise that their effects will be felt particularly in the domain of moving image circulation. Carried out by digital means, the practices and structures of film distribution not only become more diverse, opening a territory for disputes of both meaning and value, the influence they exert on film aesthetics, economy and means of operation also becomes harder to deny.

Such is the panorama offered in Alejandro Pardo's chapter, 'From the Big Screen to the Small Ones', which opens this first part and the book. The piece is deliberately broad so as to provide a backdrop to many of the developments discussed in the other texts within this volume. Drawing from both scholarly writing and trade papers, Pardo examines how

processes of digitization are transforming the distribution, exhibition and consumption of movies. He brings to the table the perspective of the film industry, concerned with the creation of new business models able to cope with the effects of digital technologies. Such an approach provides a very pragmatic, almost matter-of-factly tone to the survey, which helps undo any suspicion one might have that computer networks would begin a total revolution in film. On the contrary, even though the changes caused by technology are presented as significant, they seem nonetheless manageable. To take care of them involves, first and foremost, responding to a specific kind of audience: the breed of peer-to-peer (p2p) user who engages with media in a more 'active' way.

Those consumers' 'preference for versatility and portability over quality', as Pardo puts it, gives them a leading role in the formation of new distribution models, whether their behaviour creates market niches or because it pushes for the free circulation of audiovisual material. Meanwhile, the disappearance of physical movie copies in the Western world consolidates the online marketplace as an environment of content diversity, competitive pricing and ultra-personalized services. For Pardo, the combination of these factors can be seen as responsible for changing paradigms in moving image distribution. Already in this exploratory phase, led by independent films and companies, the direct access to content seems to be causing a general 'disintermediation trend' characterized by simultaneous release across different platforms and the narrowing of release windows.

This does not mean that intermediaries have been entirely removed from the distribution chain. On the contrary, the emergence of alternative dynamics relies on informal agents that act outside of the already established industry. It is important to assess the redefinition of distributors' strategies in relation to the shifts of power from one group of gatekeepers to another. Traditional exhibition venues, for instance, try and keep their upper hand in the new scenario by fabricating differences. They adopt digital standards, which would otherwise approximate them to the online domestic channels, in order to promote a particular brand of consumer experience. Thus, the theatrical event becomes enhanced with a surplus of technology: IMAX screens, 3D projection and higher-frame-rate movies.

But perhaps the most disconcerting aspect of cinema's reaction to other media is how it actually *incorporates other media*. The real-time streaming of spectacles such as opera, music concerts and sports is becoming an inherent part of some theatres' programmes. Online marketing, in the form of peer recommendations and viral campaigns,

extends the possibilities of cinematographic storytelling across the most diverse situations. In that sense, the search for an adequate business model is increasingly opening cinema to transmedia interactions. The contemporary condition of moving image exhibition seems to be that of multiplicity, in which a number of possible 'small' windows supplement the 'big' theatrical one.

This complex interplay of screens is examined by Stefania Haritou's 'Notes on Film Distribution'. The chapter consists of a detailed report of how the current technologies are being deployed by Curzon Artificial Eye, a traditional London-based exhibition chain. The development is twofold: on the one hand, as a means to update regular theatrical projection; on the other hand, in order to establish an online VOD service. Whereas the current debate about film distribution could find here a schizophrenic situation of 'crisis and disruption', Haritou's account discloses the production of new associations – a continuing process of 'reintermediations'. The case expresses a highly transitional period, in which analogue and digital systems coexist while their roles and modes of operation are being arranged in relation to more practical interests.

Under such rule, the pace of technological progress is far from steady – its route anything but straightforward. One should realize how long it took for digital cinema projectors, a technology inaugurated in the USA more than a decade ago, to start replacing the long-established, mechanically operated 35mm devices. Even now, the conversion is not fully complete. Haritou describes how in Curzon's Renoir theatre, where movies are regularly screened from computers, the storage of data files still relies on physical media. Digital information must be transported to and from the venue in encrypted hard drives, employing methods comparable to those used for film reels. It shows that the configuration of professional practices does not necessarily follow changes in infrastructure. In spite of the stark differences between both systems, there are some protocols that cannot be easily dissipated.

Meanwhile, the Internet allows for the creation of platforms like Curzon on Demand, a website where the company provides high-definition streaming of some of its programmed content to the audience's personal computers, mobile devices and set-top boxes. Movies are made available at the same time as their release in Curzon's theatres, for a price considerably lower than the cinema ticket. This case of seeming self-cannibalization represents a very strategic adjustment to the new geography of the cinematographic circuit. As screens become similarly networked, no single kind takes precedence over the others, causing hierarchies of film exhibition to collapse. Moving images

are thus entangled within many simultaneous flows, both online and offline. Inasmuch as it provides a rationale for the reorganization of distribution, this is a cue for Haritou to call into question the character of film as a network – a multiple and relational object that exists across different media technologies, material practices and situated screens, assuming various forms depending on its circumstances.

Just as it unfolds the material assemblages that constitute cinema, the process of scrutinizing technological infrastructures also brings to light the social interactions that articulate them. In that respect, Jonas Andersson Schwarz's chapter, 'Catering for Whom?', turns our attention to the communities built around cinephile file-sharing websites. We are introduced to a portrait of the aforementioned consumers who, willingly or not, are among the main reasons for the emergence of new dynamics of moving image circulation. Their activity as informal agents of distribution is rather complex, not being restricted to the search for privileged access to particular titles of interest. It might comprise practices as diverse as subtitling movies, amateur music production, blogging and getting involved in activism. And while some engage in p2p distribution and consumption for the sake of ease of use and convenience, others manifest the more ambitious desire to gather a 'universal library' that serves the wider public.

But do they really have such a benevolent wish to serve the public good? On the premise that file-sharing communities are embedded in larger fields such as online networking and film consumption, Schwarz assumes that this philanthropic mission expresses less the consumers' altruistic tendencies than the limitations of our current copyright systems. He goes on to demonstrate that such communities are irregular only from a legal perspective. Taking into account the number of participants one might have, raking in the hundreds of thousands, it would not be too far off to consider cinephilic p2p distribution and consumption as an expected application of the 'decentralized duplication of data files' in which the Internet has always been based. The lack of official sanction does not preclude it from being a highly consistent endeavour, organized by strict internal regulations that overlap with those of film fandom. As such, the practice has profound connections to a wider economy of film circulation, user agency, knowledge and affects.

In conclusion, Schwarz draws from Pierre Bourdieu's theories to interrogate the role that these emerging technologies and material practices might have in the current arrangements of cinema. According to him, film distribution can be seen as a highly mutable, always contested field, co-created by the many different agents that interact with it. Digital

networks enter into this sphere of relations as a newcomer, opening a breach for heterodox behaviours that challenge the status quo and provoke a radical shift in the allocation of capital and access to authority. This process entails continuous struggles that mean to both reconfigure the field analytically and legitimize certain demeanours. Here, the tangible restrictions embedded in the infrastructure appear to exert a hard determinism, leaving most of the dispute to happen on a discursive layer, as a negotiation of the field's norms. While the industry makes efforts to uphold the law, users justify its eventual transgression by appealing to a 'domestic mode of reasoning', objectifying technological changes from the perspective of their own personal experience.

Part II – Under the spotlights: Promotion

The new models of film distribution demand proportionally complex means of publicity. As content becomes more easily and widely accessible filmmakers must dedicate themselves more extensively to generate visibility for their productions. This management of economies of attention is particularly crucial since the possibilities of movie circulation in the network can be directly affected by the consumers. In the face of more convenient options, the industry often needs strategies that earn the hearts and minds of the public for the 'right' channels, whereas independent players could rely on this opportunity as a way to sidestep the established advertising schemes and score a big hit.

The second part of the book concerns these issues, delving into the domain of film and TV marketing as it grows at once more interactive and more intimate. Part II begins with '1-18-08', Stephanie Janes' study of the viral campaign employed for the feature *Cloverfield* (2008). It is a very telling case about the ways in which Hollywood studios can expand the filmic universe across different media, creating an immersive experience that leads the audience to collaborate with its publicity. A rather laconic teaser trailer, which appeared unannounced in the theatres, sent the curious spectators on a quest for further information online. This investigation would develop into an alternate reality game (ARG) that comprised real social media profiles of the main characters, video messages exchanged between them, the websites of fictional companies and even a landline that the public could call. All of these elements were set and updated in real time, telling a story that culminated on the day of the movie's actual première.

Standing as entertainment in their own right, promotional pieces such as these are remarkably different from more prosaic press kits.

They attempt to make the most of the Internet's ever-expanding connectivity, mobilizing it in favour of the cinematographic product rather than away from it. The lesson has been learned since *The Blair Witch Project* (1999), a horror feature whose fictional website was instrumental in positioning it as a piece of found footage, maximizing spontaneous buzz and propelling a huge box office success. What this genre of marketing strives to do is not only to create a stronger online presence for the movie, but also to stage an off-screen world that engages with the audience's expectations beforehand. Their particular aesthetics produce a sense of participation worthy of videogame interactions, in what Janes understands as a means to recreate some of the pleasures of interactive media instead of competing with them. The marketing experience builds towards the theatrical release, creating a complex viewing pattern that will later encourage direct-to-home sales (most likely involving DVDs packed with extra content).

These strategies also represent a radical transformation in the relationship between producer and consumer. Hollywood's previous attempts to integrate filmmaking and promotion, during the 1970s and 1980s, relied on a straightforward communication with the audience. Current viral advertisement, conversely, can be based on withholding clear information and stimulating conjectures. This is a way to earn the interest of influential consumer groups, able to pass the company message along to others. It is an approach suitable to the world of personal blogs, social media and Internet forums, which has made word-of-mouth more important than ever to a film's career. Thus acknowledging viewers' activity, studios rehearse further connections between economics and aesthetics, more appropriate for the participative environment of computer networks.

The industry's intent to get closer to the public can lead as far as building corporeal and affective bonds with it, as Ya-Feng Mon describes in 'Terms of Intimacy'. The chapter examines how the marketing ploys of *Miao Miao* (2008), a Taiwanese coming-of-age queer romance, desegregates filmmakers and audience in a collaborative process of film value production. This strategy was established in the early 2000s with the proliferation of question and answer (Q&A) sessions that were held both before and after a release. The movie director and main staff would tour the country to talk about their work, convening with audience groups even on a daily basis. In doing so they abstained from stardom, a status that often depends on keeping a certain dissociation from the public. Otherwise, making themselves accessible, the crew hoped to breed emotions in potential viewers, thus prompting a consumer attitude.

Based on sheer physical presence, Q&A sessions stand not only as a very budget-efficient means of promotion. The appeal of proximity is particularly adequate to the networked organization of computer media, in which distances have indeed been dissolved. Filmmakers are able to communicate directly with the audience, circumventing professional journalism and other newsagents that traditionally conveyed this contact. Mon notices how they may use this possibility to take further control of the 'intermediary spaces' that negotiate boundaries between cultures of production and those of consumption. Celebrity–audience intimacy, for instance, can now be managed by the means of blog marketing, in the guise of online diaries maintained by the film crew itself. These channels present movie production as it happens, generally employing making-of videos and exclusive interviews in order to transmit an image of expertise and professionalism.

But this objective approach is not the only way to create behind-the-scenes realism. Based on the premises entailed by Taiwanese Q&As, *Miao Miao*'s official blog makes use of an alternative, confessional tone, providing glimpses of the emotions involved in the filmmaking process. The page's comments section becomes a space for spontaneous Internet-mediated intimacy, where readers get the chance to interact with the film director and with one another. When they use this platform to exchange messages about their own investment in the work, as well as about the participation in offline events and screenings, they are contributing with an additional layer to the narrative of the movie's circulation. Such collaboration is much more ambiguous than it might seem at first, though. When the audience responds to posts written by fictional characters as if they were real, it is not simply being misled by the marketing's efforts to conceal itself, as is the case with some pieces of viral advertisement. Rather, Mon remarks, the audience is engaging with an 'affective reality' created through the media – the same reality upon which these promotional strategies draw.

Hence, as the communication practices surrounding screens multiply, the semiotic ecology in which movies are embedded starts to swell. Given the increasing speculation of both the public's attention and affect, how long will it take until the burst of a promotional bubble? Not long at all, as shown in Enrica Picarelli's 'On The Problematic Productivity of Hype'. In this chapter, the subject is the first and only season of *FlashForward* (2009–2010), a science fiction TV series produced by the North-American network ABC. Better yet, it is the marketing campaign that, predating the show, meant to establish the active way in which it would be consumed. Following other titles' experiments with new

formats of distribution and promotion that happened around the same time, the campaign represents a change in the nature of advertisement. Instead of luring the viewers with high narrative quality and originality, ABC expected to do so mostly by the means of an entertaining marketing. The network's purpose was to pre-emptively control the audience's activity, using it to secure stable viewing rates even before the series was released. There was an urge to keep up with the high success of its flagship show *Lost* (2004–2010), which was soon to reach the finale. So, it was not a coincidence that *FlashForward*'s campaign began during the commercial breaks of the special *Lost* 100th episode: the network was presenting it as the heir to the current show, in what Picarelli terms as 'a process of industrial redefinition and intertextual referencing'. On that occasion, five very short, amateur-looking teasers were aired, without fully disclosing their meaning. The main intention was to create an atmosphere that would surprise the viewers and trigger their curiosity. The campaign was based on expanding this aura throughout other media spaces, which included San Diego's Comic-Con and a number of websites and social applications, each with its particular character. ABC even resorted to a partnership with Microsoft in order to reach across multimedia platforms such as mobile phones, game consoles and PCs, creating a marketing circuit that was meant to serve as a vehicle for socialization, stimulating continuous buzz about the new series.

Overall, the results of this multiplexed method were extremely positive. The campaign attained a mass reach, attracting millions of viewers to the series' première. Within a few weeks of its release *FlashForward* had already been negotiated with many other networks worldwide, breaking sales records. Nevertheless, the actual episodes would not live up to hype created by this exciting promotion. Audience rates deteriorated very quickly, and the series was not even renewed for a second season. How to explain this eventual failure? Picarelli leads us to wonder about the disparate goals, temporalities and means of operation that broadcast and promotion fundamentally have. As mingled as their technologies become, perhaps their experiences can never be fully conflated.

Part III – In the files and out there: Curation

Catering for the multiple conditions of the moving image that are allowed by emerging technologies, Part III of *Besides the Screen* goes beyond the ways in which audiovisual works are transported from producers to consumers. Instead, it examines how movies are ultimately

taken care of – either stored in an archive, installed in the public space or decomposed in its material constituents. The idea of *curation* is here employed to address this labour of creating interfaces with the moving image and managing its means of existence, whether in future times, unexpected places or essentially distinct media.

These issues are introduced with Claudy Op den Kamp's 'Audiovisual Archives and the Public Domain', which discusses how even the more seemingly neutral methods of preservation involve many political and aesthetic concerns. The chapter brings together legal and cultural heritage literature in order to explore the dialectical relationship between intellectual property and the changing dynamics of archival practices. Analysing cases such as the Criterion Collection domestic DVD releases, the Internet Archive website and the Dutch national digitization project Images for the Future, Op den Kamp describes how films enter the public domain and are made available in both for-profit and non-profit archives.

Situations of technological transition, when collections must be ported to new formats, entail exceptional challenges. Currently, it is possible to identify a growing *digital skew*: what Op den Kamp calls an 'asymmetry between analogue and digitised collections' caused by copyright gridlock. Legal parameters are not the sole influence in this process, though. Institutional agendas and the ownership of physical sources play as important roles in defining the continuing accessibility of moving images. Contingencies such as these can obstruct the visibility of important works, affecting the way we tell our cultural history. And even though public domain status should facilitate online distribution and foster preservation, paradoxically it may not be the case. Attentive to the ways in which these economic and material boundaries define our capacity to remember, Op den Kamp asks if we should not consider preservation outside the copyright paradigm, in order to account for other, more important, human factors.

The complexity of conserving audiovisual pieces together increases along with their technical ramifications. In 'Live Audiovisual Performance and Documentation', Ana Carvalho demonstrates this point by addressing the efforts to document a range of intermedial moving image practices that are largely informed by technological developments: VJing, live cinema, expanded cinema and visual music. In spite of their differences, these practices share a similar performative dimension that situates them closer to the field of contemporary arts, where the interest in documenting the live event has been going around at least since the avant-gardes from the late 1950s. In this context,

documents can be regarded as the intentional organization of recordings into virtual or physical objects that might fit an archive.

In her chapter Carvalho underscores the contradictions involved in these attempts of fixation, which deny the works' inherent ephemerality. Nonetheless, as they consist of primary evidence of the many intentions behind moving images, documents become crucial for the study, research and construction of audiovisual practices' shared memory. Drawing from Alfred North Whitehead's philosophical constellation, the chapter lays out an alternative perspective about how documentation might operate within a larger understanding of these performances' time frame, traversing three intertwined moments: the creative process, the performance itself and the community gathering around it. Making use of the practices' own tools, the audience alongside the artist could express the many layers of interaction it entails. Whereas a video recording of the work might provide a clear overview of its aesthetics, this complementary approach seems necessary to make visible the connections that bring the piece into being in all its intricacy.

The more we focus on the transformation of film's technical constitution, the further we are took away from the traditions of single-channel works and conventional filmmaking processes, and drawn into situations where moving images could be displayed either as interactive installations or systems of spatial illumination. These dynamics are exemplified in Zlatan Krajina's 'Public Screenings beside Screen', which explores the post-cinematic condition of screens that proliferate outside their habitual spaces and adopt functions other than being a container for audiovisual pieces. Evoking the historical relationship between media technologies and the configuration of the city, the chapter means to overcome reductionist dichotomies and unpack the ways in which public screens contribute to the production of the highly contested urban space. It specifically tells the story of the Croatian Sun Monument, a 22-metre circular screen emplaced along a promenade in the coastal town of Zadar, showing a continuous flow of abstract animation.

Created as part of a refurbishment project, the monument is presented as both a key touristic attraction and a technological heterotopia able to bring local people in contact with the more progressive aspects of Western culture. In Krajina's ethnographic exploration, it is revealed how this token of 'urban hedonism' was appropriated within the Mediterranean custom of the evening stroll, indicating that citizens were able to approach its iconic presence in a critical way and resignify it under particular geographic protocols. In this negotiation between the

form and uses of social space, screens are turned from mere pieces of architecture into places where embodied habits are built. Thus, by the means of audience engagement, moving images and their encompassing structures are shown to operate synergistically, each affecting the meaning, context and organization of the other.

The micropolitics of user interaction takes centre stage in Elena Papadaki's 'Interactive Video Installations in Public Spaces', which follows on the topic of audiovisual formats in the media city. The chapter means to analyse the exhibition practices employed by Rafael Lozano-Hemmer's Under Scan, 'the largest interactive video installation and the longest-running event to be presented in Trafalgar Square', a famous tourist spot in central London. Being on display for nine days in November 2008, the piece functioned as a sort of ephemeral monument. It used a computer-controlled multi-projection system in order to create an immersive environment where the shadows of the passers-by were used to trigger the appearance of assorted video-portraits onto the ground. Provoking the seeming fusion of light projection with the presence of the public, Under Scan establishes a viewing regime marked by fuller sensorial engrossment. In comparison to more traditional moving image spectacles, Papadaki remarks a dislocation of focus from the screen towards the audience activity, without which the work does not exist.

Designated by Lozano-Hemmer as *relational architectures*, pieces such as this are intended to be platforms for social exchange. The artist sees his role as secondary, a mere orchestrator of background processes. What he does is to propose an artificial situation for people to occupy, first by embodying certain scripted behaviours, but ultimately by acting in accordance to their will and adapting the projection to their needs. Thus, through creative participation, the audience undertakes co-authorship of the event. The work comes into being as it gives rise to new associations between different urban agents. In these circumstances, 'new media' is not an end but a method. Being deployed 'for play rather than control', audiovisual technologies become a means to reconnect the city with its inhabitants, open to the unpredictability of a very heterogeneous crowd.

The complex intertwining of cinema and computer networks urges us to leave the safe harbour of spectatorship and plunge deeper into the cinematographic circuit. From the inside of digital archives to the middle of the public space – from the documentation of moving images to the direct engagement with projections – these final chapters indicate how even the more conventional audiovisual technologies are intrinsically connected to other cultural practices. By going besides the rigid

hierarchies established within the field of screen studies, and adopting instead an approach that includes both textual, paratextual and structural dimensions of movies, we strive to bring these relations to the fore.

Notes

1. See also: Janet Wasko (2002), Sean Cubitt (2005) and Phillip Drake (2008).
2. At the time of writing Hulu was only available in North America; Amazon Instant in North America and the UK; and Netflix in North America, South America, the UK and Scandinavia.

Bibliography

Cubitt, S. (2004) *The Cinema Effect*. Cambridge, MA: MIT Press.

Cubitt, S. (2005) Distribution and Media Flows. *Cultural Politics*, 1(2), 193–214.

Cunningham, S. and Silver, J. (2012) On-line Film Distribution: Its History and Global Complexion. In: D. Iordanova and S. D. Cunningham (eds.) *Digital Disruption: Cinema Moves Online*, St Andrews: University of St Andrews Press, pp. 33–66.

Drake, P. (2008) Distribution and Marketing in Contemporary Hollywood. In: Janet Wasko and Paul McDonald (eds.) *The Contemporary Hollywood Film Industry*, Oxford and New York: Blackwell, pp. 63–82.

Gomery, D. (1992) *Shared Pleasures: A History of Movie Presentation in the United States*. Madison, WI: University of Wisconsin Press.

Gray, J. (2010). *Show Sold Separately: Promos, Spoilers, And Other Media Paratexts*. New York: New York University Press.

Harbord, J. (2007) *The Evolution of Film: Rethinking Film Studies*. Cambridge: Polity.

Hark, I. R. (2002) *Exhibition: The Film Reader*. London and New York: Routledge.

Iordanova, D. and Cunningham, S. (2012) *Digital Disruption: Cinema Moves On-Line*. St Andrews: St Andrews Film Studies.

Kerrigan, F. (2010) *Film Marketing*. Amsterdam, Boston and London: Elsevier/Butterworth-Heinemann.

Knight, J. and Thomas, P. (2008) Distribution and the Question of Diversity: A Case Study of Cinenova. *Screen* 43 (9), 354–365.

Lobato, R. (2012) *Shadow Economies of Cinema: Mapping Informal Film Distribution*. London: BFI.

Miller, T., Govil, N., McMurria, J. and Maxwell, R. (2001) *Global Hollywood*. London: BFI.

Miller, T., Govil, N., McMurria, J., Maxwell, R. and Wang, T. (2005) *Global Hollywood 2*. London: BFI.

Turner, G. (2002) (ed.) *The Film Cultures Reader*. London: Routledge.

Waller, G. A. (2002) *Moviegoing in America: A Sourcebook in the History of Film Exhibition*. Oxford and Malden, MA: Blackwell Publishers.

Wasko, J. (2002) The Future of Film Distribution and Exhibition. In: Dan Harris (ed.) *The New Media Book*, London: BFI, pp. 195–208.

Wasko, J. (2003) *How Hollywood Works*. London: Sage.

Wyatt, J. (1994) *High Concept: Movies and Marketing In Hollywood*. Austin, TC: University of Texas Press.

Part I

Through Many Channels: Distribution

Part 1

Through Many Channels:
Distribution

2
From the Big Screen to the Small Ones: How Digitization is Transforming the Distribution, Exhibition and Consumption of Movies

Alejandro Pardo

Introduction

From its very inception, the history of the movie industry has been closely linked to the history of technological development. However, the changes caused by the digital revolution are transforming the film industry at a more fast-paced and more far-reaching scale than anything that came before. Producers, distributors and exhibitors are being forced to respond to the popularity of the Internet and the success of digital platforms. As a consequence the ways of consuming movies are dramatically changing and the film industry is desperately trying to readapt itself to this new scenario.

This chapter is focused on the profound transformations that the film industry is undergoing at every level due to the disruptive power of digitization. In particular, I will address here the main changes affecting distribution, exhibition and consumption of movies. The first section can be considered a framework to contextualize this change of paradigm, from analogue to digital. In here, two key issues are approached, closely linked to each other, in regard to this new matrix: the emergence of

This chapter forms part of two subsidized research projects: New Consumption Habits in Audiovisual Contents: Impact of Digitalization on the European Media Diet, financed by the Spanish Ministry of Education and Culture for the period 2011–2013 (CSO2010-20122); and The Impact of Digitalization on the Spanish Audiovisual Industry (2011–2013), financed by the University of Navarra (PIUNA).

a new type of consumer and the consolidation of online markets. The core of the chapter is devoted to identify and explain the main changes in distributing, exhibiting and consuming movies. In the case of distribution, the disruptive power of digitization is demanding new forms of disintermediation, whereas conventional windows need to be reformulated. In addition, exhibitors need to readapt themselves to the new digital scenario, upgrading cinemas' technological standards and diversifying their business model. Regarding consumption, audience demands a customized way of enjoying entertainment, with freedom of choice, unlimited access and a high grade of flexibility and portability. Finally, I will draw conclusions and remarks, although they will be necessarily open.

For this particular research, I am using as a starting point the contributions of scholars about how the Internet and the digital economy are changing current business models and management strategies within the media industry (McPhillips and Merlo, 2008; Clemons, 2009) and more particularly in the case of the film industry (Iordanova and Cunningham, 2012). Included are references and data from trade papers like *Screen Digest, Screen Daily* and *Variety*. In addition, I would also like to underline that this text comes as a further step from other previous research (Pardo, 2009, 2013).

Consumers and markets in the 'age of ubiquitous entertainment'

In 2008, Michael Gubbins – editor of *Screen Daily* at that time – wrote a very suggestive article about the profound changes the entertainment industry was suffering due to the impact of digitization. In that piece, he identified the emergence of new demands for the consumption of entertainment – 'any time, any place, any where' – typical in the so-called 'ubiquitous leisure society'. He nicknamed these new consumption habits as 'the Martini culture', in reference to the iconic advertisement of the 1970s (Gubbins, 2008). More recently, he has further developed these ideas and renamed these convulsing times as the 'age of ubiquitous entertainment', characterized by the following features:

- A radical change in consumer attitudes, precipitated by the widening of choice to unprecedented amounts of content.
- A continuous stream of technological innovations, built on the back of an exponential rise in digitized content and an ever-improving broadband communications infrastructure.

- Record availability of data and market intelligence about audiences and taste, often freely given in return for access to targeted content. A huge increase in choice and access to not just new film, but also to a far greater range of specialist international film and to an increasingly large digitized back catalogue.
- An emerging audiovisual culture where equipment is cheap and widely available, from mobile phones to video cameras.
- The rise of social networks, allowing the aggregation of communities of interest that transcend national borders and ensuring a constant and largely unmediated commentary. (Gubbins, 2012, p. 67)

What lies beneath these characteristics, according to Gubbins, is that the digital revolution has 'changed the relationship between audiences and content' (2012, p. 67) or, in other words, between consumers and markets. These two concepts represent the main axes which vertebrate the matrix of this new digital scenario: on the one hand, the emergence of a new market for the commercialization of movies (Internet, digital reproduction devices, smart phones, smart TVs) based on the disappearance of the physical copy and the (theoretically) unlimited access to content – framed under 'the long tail market' tag (Anderson, 2004); on the other hand, the emergence of a new type of consumer, known collectively as 'the iPod-' or 'the Net-generation' (Tapscott, 2009). I will further explain both concepts.

Regarding the new consumer profile, marketing experts are convinced that this generation of new technology users has now reached a critical mass in numerical terms, and their consumer behaviour is markedly different to that which went before. Among others, the following features should be remarked: (a) a more participative and active attitude with respect to audiovisual and entertainment content (user-generated content); (b) multi-tasking skills; (c) new forms of socializing through virtual communities; (d) a preference for versatility and portability over quality in consumer use; (e) new consumer behaviour as a catalyst for the creation of new market niches (low demand, personalized and individually tailored consumption); and (f) unconventional understanding of the free circulation of audiovisual material (piracy). In summary, as Gubbins remarks, we are in front of a new kind of 'active audience' (2012, pp. 95–96).

If this is the type of consumer to address, what are the corollary characteristics of the emerging online markets? Chris Anderson, editor of *Wired*, christened this recently discovered 'gold mine' with the name 'the long tail', a term that has since become common currency (2004,

2006). His argument, which soon drew on empirical evidence from an analysis of several companies in the retail sector, runs as follows: commercialization on the Internet is not a marginal market; rather, it is an emerging market whose value is increasing all the time. This argument for Internet commercialization defers to three reasons: (a) the Internet brings together a dispersed and fragmented audience which, as a whole, constitutes a significant market; (b) distribution costs are eliminated and product consumption becomes more personalized and attuned to the demands of these 'digital natives'; and (c) popularity is no longer the key factor in market value; in fact, the Internet is especially apt (and profitable) for the sale of relatively unknown or minority interest products (Anderson, 2004, pp. 174–177). Thus, the emergence of this new virtual market undermines one of the classical laws of consumer goods economics, – 20 per cent of products account for 80 per cent of sales (the Pareto principle). This does not mean that the most successful titles in conventional distribution channels cease to be so in the virtual world; however, less-well-known or minority interest products also become more easily available and are acquired by the fragmented audience(s) of which the virtual market is composed. As a result, a specific catalogue of audiovisual goods may repay on the outlay involved in their production, and marginal profits may rise. Finally, Anderson outlines three rules to govern this new distribution model, entirely focused on the consumer's leading role and singularity: (1) availability of a wide range of titles ('make everything available'); (2) competitive pricing in comparison with other distribution channels ('cut the price in half; now lower it'); and (3) personalized consumption ('help me find...') (2004, pp. 174–177).

The two linked key points set out above – consumer and markets – sum up the challenges facing the film producers, distributors, exhibitors and broadcasters. In the following section, the main changes in the distribution model are explained from a different but complementary perspective.

Changes in distribution

No so long ago, *The Wall Street Journal* echoed a report by a consultancy firm where DVD, games and video rental occupied the sixth place in the top ten dying industries in the USA, along with wired telecommunications carriers, newspaper publishing, record stores and video post-production services (Izzo, 2011). Almost about the same time, *Fortune* published another article comparing the different business performances of offline versus online retailers during the last

decade – Netflix versus Blockbuster, Amazon versus Borders, iTunes versus CDs (Cendrowski, 2011). Whereas traditional retailers have gone into bankruptcy, new entrants have exponentially multiplied their income. Both examples are cited by Dina Iordanova to exemplify the disruptive power of new technologies in the film industry, especially at the distribution and consumption levels. As she states:

Traditional distribution – where studios control box office revenues by releasing films for coordinated showing in a system of theatres and then direct them through an inflexible succession of hierarchical ordered windows of exhibition and formats – is radically undermined by new technologies. Chances are that film distribution as we have known it will soon represent a fraction of the multiple ways in which film can travel around the globe. The result will be a new film circulation environment: a more intricate phenomenon that includes a plethora of circuits and, possibly, revenue streams.

(2012, p. 1)

In other words, what we are witnessing here is not only a change of paradigm in distribution patterns but of management mentality as well, in all the key players of the film value chain: the old assumptions of limits on creation and access, typical of an economy of content scarcity, must open way to the new value drivers of free access, an almost infinite variety of products, customized consumption, content aggregators and search engines, typical of an economy of abundance (Pardo, 2013).

Paradigm shift: From old to new distribution patterns

The distribution side of the film industry is probably one of the most affected by the new rules imposed in this digital turn. Peter Broderick has been one of the experts who offer a comparative analysis between the 'old world' and the 'new world' distribution principles, as they are summarized in the following table (Table 2.1):

Table 2.1 A comparative analysis of 'old world' and 'new world' distribution principles

Guideline Principles	Old World Distribution (Analogic)	New World Distribution (Digital)
Control	Distributor in control	Filmmaker in control
Deal scope	Overall deal	Hybrid approach
Release pattern	Fixed release plans	Flexible release strategies

Table 2.1 (Continued)

Guideline Principles	Old World Distribution (Analogic)	New World Distribution (Digital)
Target	Mass audience	Core and crossover audiences
Distribution costs	Rising costs	Lower costs
Access to viewers	Viewers reached through distributor	Direct access to viewers
Sales pattern	Third party sales	Direct and third party sales
Geographical pattern	Territory by territory distribution	Global distribution
Revenues	Cross-collateralized revenues	Separate revenues stream
Viewers profile	Anonymous consumers	True fans

Source: Adapted from Broderick, 2008.

According to Broderick, in the new distribution model filmmakers (directors and producers) can exercise (1) a *greater control* over the distribution process, 'choosing which rights to give distribution partners and which to retain, and having a final word over the marketing campaign, spending, and the timing of their release' – in contrast with the old model where they usually 'have little or no influence at all on key marketing and distribution decisions'. Regarding the scope of the distribution deal, digital paradigm will facilitate (2) the *hybrid distribution* model, where filmmakers are able to 'split up their rights, working with distributors in certain sectors and keeping the right to make direct sales in others' (selling downloads or streaming directly from their websites) – contrary to the old distribution model, where they sign overall deals, giving away their rights for all media and windows in a number of territories for a long period of time. In addition, the new distribution pattern allows filmmakers to design (3) *customized distribution strategies* tailored to their film's content and target audiences. In this way, they can 'outreach to audiences and potential organizational partners before or during production' as well as 'test their strategies step-by-step, and modify them as needed' – whereas in the old distribution system everything is 'much more formulaic and rigid'. In relation to this last principle, digital distribution facilitates (4) the *access to core audiences* 'directly both online and offline, through websites, mailing lists, organizations, and publications'; and, from these, they try to reach a wider public – as opposed to the old distribution system that, in general, aims to reach

a mass audience. From the economic point of view, (5) *marketing costs are less expensive* in the new distribution model thanks to the Internet (instead of traditional spending in print, television and radio advertising) whereas in the 'old analogic world' marketing expenses have risen dramatically. Internet and social media allow filmmakers to have (6) a *direct access to viewers*, whereas in the traditional system the access to audiences is mediated through distributors. The combination of these three last principles leads us to the next one: the digital distribution offer (7) *higher margins on direct sales* than through retail – saving 'intermediation' or distribution costs. In addition, it provides filmmakers with very valuable consumer data and enables them to make future sales of ancillary products (merchandising) as opposed to the old distribution model where filmmakers rarely have access to consumer data and rarely control merchandising rights. Another significant principle, based on the disappearance of physical borders and physical copies, is the possibility of (8) a real *global distribution*. Effectively, thanks to the digital distribution, 'filmmakers are now making their films available to viewers anywhere in the world ... aggregating audiences across national boundaries', in contrast with the rigid and logistically complex old distribution system. This flexibility allows filmmakers to work on (9) *separate revenue streams*, avoiding cross-collateralization risks and accounting problems. 'By separating the revenues from each distribution partner, filmmakers prevent expenses from one distribution channel being charged against revenues from another. This makes accounting simpler and more transparent' – just the opposite of the traditional distribution systems, based on overall deals. Finally, in regard again to principles four and six, the new distribution model create a close relation between content creators and core audience, who become (10) *true fans* more than just passive or incidental viewers. 'Every filmmaker with a website has the chance to turn visitors into subscribers, subscribers into purchasers, and purchasers into true fans who can contribute to new productions' – nothing of this is possible in the old model (Broderick, 2008).

It is interesting to notice how much these guideline principles pointed out by Broderick are intrinsically connected with the two key axes mentioned in the previous section – new audiences and/or consumers (the 'Net-generation') and new online commercial window (the 'long tail markets').

Reshaping the distributor role: New forms of (dis)intermediation

As a consequence of what has been stated before, the distribution sector – as we know it – is condemned to vanish or be dramatically

transformed. The disappearance of the physical copy together with the demand for immediate and universal access to content is obliging distributors to redefine their role. In other words, the new digital environment claims for a sort of 'disintermediation' (Iordanova, 2012, pp. 3–7) or the dismantlement of the current distribution sector's status quo. As Iordanova explains, traditional distribution channels, where film producers enter in contact with distributors for certain territories, are being undermined because the cycle of film theatrical circulation is frequently limited to the interaction between content owner (in this case, distributors) and the exhibitor. Nevertheless, in the online world (peer-to-peer technologies) content providers can deal directly with individual customers under significant lower distribution costs (2012, p. 4). As Iordanova concludes,

> This results in a diminished role for intermediaries; it creates a situation where distributors see themselves cut off from previously lucrative opportunities and resist the change. In turn, digital businesses that are poised to bracket out intermediaries, content providers and cable operators, are set to profit.
>
> (2012, p. 4)

In this sense, more than 'disintermediation', we should talk about a redefinition or a reinvention of the distributors' strategies, since intermediaries are not removed entirely, but power shifts from one group of gatekeepers to another. Effectively, the immediate effects of this reality, as this same scholar points out, are the rushing of new digital providers such as TiVo, Netflix or Direct TV to reach agreements with rights owners (Hollywood studios and independents) for films and prime-time television; and their effort to consolidate the new digital platforms via direct and exclusive streaming (as Apple is doing with the iPhone or iPad, and Sony with PlayStation). We could add here other examples of this trend, as the transformation of online retailers (Netflix, Amazon, Best Buy or Walmart) into pay TV channels – like Netflix – or movie studios – like Amazon (Cohen, 2010; Wallenstein, 2012). Other new forms of intermediation will be to become effective search engines and/or content aggregators, all of them linked in one way or another to content production and distribution as well as to social networks, like Google TV and Facebook (Goldsmith, 2012a, 2012b).

A final word must be drawn in regard to this redefinition of the distributors' role. Virtual markets will be consolidated by the development of cloud computing ecosystems – as the iCloud launched by Apple

(Morris, 2011). Apart from reducing logistical costs, resolving physical storage limitation and facilitating online traffic, cloud computing systems will demand 'new behaviors and attitudes about ownership, discovery, value of storage, offline media use, joint ownership, commoditization of services, competing with freemium business models, and licensing of content across blossoming new platforms' (Johnson, 2012, p. 2).

Taking into account this changing reality from a different perspective, Ramon Lobato offers a new physiognomy of film distribution, differencing the 'formal' and the 'informal' operating systems. Whereas the first one (the 'formal') matches the current model (distribution companies acting as gatekeepers), the new one (the 'informal') – exponentially propelled by the Internet – relies on 'informal agents' acting outside the already established movie industry – legal or illegal distribution systems, physical or virtual (2012).

Redefinition of the windows sequence

This profound transformation in consuming entertainment – consumers' new habits and disappearance of the physical copy – is definitely changing the current sequence of commercial windows. On the one hand, the time period of exclusivity is narrowing – the blockbuster releases are more and more global in scope (Davis, 2006) – in order to avoid market competition and piracy effects; on the other hand, customized consumption obliges distributors to design simultaneous-release strategies – product availability in several windows at the same time with price discrimination (Ulin, 2009, pp. 33–36). In other words, both effects – simultaneous release across different platforms and narrowing of windows – are caused by 'the disintermediation trend' (Iordanova, 2012, p. 4).

In the 'old distribution world', theatrical distribution maintained the privilege of exclusivity for several months to guarantee the maximization of revenues before the arrival of other commercial windows (pay-per-view [PPV] and video on demand [VOD], DVD/Blu-ray, free TV broadcasting). The 'new online world' demands traditional windows to shrink themselves as much as possible. In this line, several Hollywood studios recently agreed to reduce the theatrical window to just two months before releasing new films on premium VOD (Graser, 2011a). On top of this, some distributors are keen to experiment with simultaneous release across different platforms. Recent examples are *Margin Call*, simultaneously released on theatrical and VOD, and *Abduction*, released at the same time on DVD and on social networks – both

Lionsgate productions (Goldsmith, 2012a). Nevertheless, this strategy is still polemic and will not be generally assumed in the short-term, as the recent argument between Ted Sarandos, Netflix Chief Content Officer (in favour of simultaneous release) and John Fithian, NATO President and CEO of NATO (National Association of Theater Owners) (against) have shown (Fleming, 2013; Johnson, 2013; Stedman, 2013; Wallenstein and Setoodeh, 2013).

In addition, simultaneous-release strategies remain underdeveloped outside the USA, to the frustration of many foreign distributors who trust on digital sales to supersede their shrinking DVD revenues. The consolidated power of European exhibitors remains the main obstacle to contracting the windows and moving towards a day-and-date VOD and theatrical model, as the menace of boycott by some European exhibitors against Disney's decision of shortening the theatrical window for some of its releases proved (Goodridge, 2010; Dawtrey, 2012a, 2012b).

This exploratory phase is being led by independent films and independent companies, although – more sooner than later – big firms and mainstream cinema will follow this new distribution paradigm. In any case, the battle between both paradigms will last for a while. As Iordanova forecasts in a concluding way,

> Even as disintermediation leads to improved exposure for independent content, 'Old World' distributors are struggling to preserve the traditional windows of distribution established by the powerful Hollywood model [...] New pressures originating from the growth of VOD are likely to lead to a further narrowing, or even the closure of distribution windows, with traditional distributors no longer controlling the other platforms onto which a film will be released, nor the timing or the sequence of such a release.
>
> (2012, p. 5)

And she adds:

> To a large extent, the closure of exhibition windows is dictated by the need to counteract the speed at which pirated material can now travel over the Internet; but it is not just that. The disintermination processes reflect activist work towards reinstating various other channels of exhibition that were previously pushed aside. And consequently the concept of 'distribution' gradually dissolves, whilst a new concept – one of film circulation – becomes ever more viable.
>
> (2012, p. 6)

Changes in exhibition

In a subsequent level, theatrical exhibition is also suffering a significant transformation under the impulse of digitization. On the one hand, exhibitors need to improve 'the cinema experience' in order to maintain their status quo as the best and most unique way of watching movies (3D projection, immersive digital sound); on the other hand, they have to redefine their business models to become programmers of any sort of massive spectacles like opera, music concerts and sports.

Digital cinema: Improving the audiovisual experience

As they did in the 1950s to survive to the advent of television and in the 1980s to combat home-video competition, exhibitors have reacted to the threats of the online markets increasing consumers' experience and choice. Nowadays we are witnessing the incorporation of digital production technologies, digital distribution and digital projection systems, together with the latest generation of 3D films (Gubbins, 2012, pp. 77–78).

The explosion of 3D movies on a big scale – especially for live-action movies – started in 2009 thanks to the record-breaking success of *Avatar*, which reached up to US$2.8 billion worldwide, followed by *Alice in Wonderland* (2010) with US$1 billion – apart from many animated films like *Toy Story 3* (2010). Since then, the 3D release has become the standard for any Hollywood – or Hollywood-like – blockbuster. And even more, the positive audience's response has led the studios to rerelease former hits in 3D, as happened with some of Disney's classics like *The Lion King* (2011) and *Beauty and the Beast* (2012), and some big titles such as *Star Wars: The Phantom Menace* (2012) and *Titanic* (2012), with excellent results (cf. boxofficemojo.com).

In a parallel way, theatres have rapidly moved to the digital standard. At the present more than 50 per cent of cinemas in the USA and Europe have migrated from analogue to digital projectors. In five years' time the percentage will be close to 90 per cent, and in the more-mature markets (North America and Western Europe), we will also witness the replacement of the initially installed 2k projectors for the 4k or even 6k (*Screen Digest*, 2011; Brunella and Kanzer, 2011, p. 6). In relation to consumers' response, box office figures reflect that cinemagoers are keen to pay higher ticket prices to enjoy a movie in 3D. In the USA, for instance, around 20 per cent of total box office in 2010 and 2011 corresponded to 3D movies (MPAA, 2011, p. 9). In Europe, this percentage varied across countries: whereas in France and Germany, 3D films took respectively

16 per cent and 17 per cent of total admissions, in the UK this reached 24 per cent and in Russia 20 per cent (Brunella and Kanzer, 2011, p. 42).

A last milestone in the implementation of cinema technology has been the introduction of the high frame rate (HFR), at 48 frames per second, associated with the release of *The Hobbit* and its sequels. This new standard has also obliged exhibitors to upgrade their projectors in order to embrace this new enhancing movie experience (Giardina, 2012a, 2012b).

Towards polarization of movie contents

This new film market physiognomy will also lead to a polarization of entertainment contents: on the one hand, the big-budget Hollywood (or Hollywood-like) blockbusters, with high production values, especially design for a 3D-cinema experience; on the other hand, the small and target-specific niche films, aimed directly at home entertainment (VOD) (Berstein, 2013). This polarization also explains the need to create franchises and brand-entertainment content in order to feed a regular flow of product across different platforms (Ulin, 2009, pp. 18–29). This trend will take some time, since both windows – theatrical and VOD – are not yet prepared. Releasing a film on VOD in the USA may diminish its appeal to foreign distributors, who still regard it as a sign of inferior quality. In addition, there are no reliable figures regarding VOD revenues (Dawtrey, 2012a, 2012b).

Reshaping the role of exhibitors as event and on-demand programmers

As said, cinema owners are obliged to redefine their existing business models – so far exclusively focused on film products – and to explore the possibility of screening any sort of massive spectacles, from music concerts to opera, from sports finals or Olympic Games to big cultural events. As Gubbins remarks,

> The Internet has dramatically increased choice and fragmented the user experience, creating unprecedented means for non-linear consumption, but this has also served to heighten the desire for the unique and authentic. In the sport and music industries, for example, where there has been an exponential increase in both on-line content and dedicated television channels, the growth areas have been in the live fields.
>
> (2012, p. 79)

In 2011, for example, a Royal Opera House production of *Carmen* was broadcasted live by satellite in 3D from London to 1,500 cinemas worldwide and premium ticket prices were charged for the screening. In a similar way, the rock concert film *Iron Maiden: Flight 666* opened in 500 screens across 42 countries, with more than 100,000 viewers watching mostly one-day-only screenings (Gubbins, 2012, p. 78). In addition, a number of leading UK cinema chains screened events from the London Summer Olympic Games in 2012 (Wiseman, 2012). In 2010, Spanish exhibitors screened Real Madrid–Barcelona football matches as well as the Madrid Open tennis final live (*Screen Daily*, 2010). Lastly, also Mexico and Brazil have been exploiting their 3D screens on slow days with non-cinema offerings from the Metropolitan Opera and the Bolshoi Ballet, as well as the FIFA World Cup, among others events (De la Fuente, 2011).

On top of that, some cinema-on-demand formulas are being explored. These initiatives consist of allowing a self-selected audience to guarantee ticket sales for a film previously chosen by them. Some examples would be MovieMobz in Brazil, an on-demand service launched in 2008 based on a pioneering network of digital cinemas (Rain Network), where cinemagoers can choose their content, 'mobilize' it through the online community, and select a cinema for a pre-booked screening (Albrecht, 2008). A similar initiative is Moviepilot, a German movie-recommendation service set up in 2010 which launched a service called Support Your Local Cinema to provide a direct link between selections made through its online service and cinemas (Gubbins, 2012, p. 79). Nevertheless, as Gubbins concludes, 'unless there is a radical restructuring of business, on-demand screenings will struggle to be more than a marginal addition to exhibitor revenues in the mainstream market' (2012, p. 79).

Changes in consumption

From the consumer's point of view, digitization has also brought in-depth changes and transformations. The 'active audience' is not only helping to consolidate personalized consumption habits in entertainment, but also is obliging to develop new forms of transmedia storytelling. In addition, the power of online peer recommendation and the effectiveness of viral marketing campaigns are also signs of this change of paradigm. In summary, 'media convergence has empowered consumers [...] the imperative is to develop consumer-centric strategies and keep innovating' (McPhillips and Merlo, 2008, p. 251).

Customized consumption

As explained at the beginning of this chapter, the new generation of tech savvy consumers (the 'digital natives') demand a personalized way to enjoy online entertainment content which means complete freedom of choice, easy access, flexibility and portability. In other words, customized consumption means offering the 'active audience' the possibility of choosing *what* type of content they want to consume (music, movies, television series, videogames) and, more importantly, *how* they watch it (downloading, streaming and so on), *when* they watch it (no fixed programming nor time constraints) and *where* they watch it (on television, computer, tablet, mobile phone and so on). In other words, we are witnessing the consolidation of the 'on-demand culture' (Tryon, 2013).

This 'Martini culture' meeting the 'long tail' markets requires the right targeting, pricing and technological infrastructure (broadband) strategies. The three main forms of online consumption developed so far are: (a) *Transactional*: consumers can buy a permanent download ('download-to-own', DTO), rent a temporary download or buy temporary access to a stream (VOD rental); (b) *Subscription*: consumers can subscribe to an 'all-you-can-eat' rental service offering temporary downloads or streams in return for a single monthly fee (subscribed VOD); and (c) *Ad-supported*: consumers can download or stream titles for free in return for watching video advertisements within the content (free VOD) (*Screen Digest*, 2007, pp. 270–271; Gubbins, 2012, pp. 81–86).

Many online distribution initiatives have flourished along the last decade. According to a recent survey, over 300 online film distribution sites were born worldwide, although many of them are currently extinct (Cunningham and Silver, 2012; plus appendices). In the case of VOD services, the European Audiovisual Observatory accounted for more than 275 VOD services in Europe in 2011 (EAO, 2012). The emergence and consolidation of online distribution has been led by iTunes, Netflix, Blockbuster+Movielink, Amazon+LoveFilm, Hulu and Google+YouTube. Other services such as MUBI, On-line Film, Reframe, IndieFlix, Babelgum and Jaman have also helped to create a space for independent cinema to reach audiences with streamed content, although the VOD market is still strongly weighted towards established brands like the above-mentioned (Cunningham and Silver, 2012; Gubbins, 2012).

Another recent initiative launched by the Hollywood studios to meet the demands of customized consumption has been UltraViolet, an

online content locker that stores and plays movies and television shows on a variety of devices. This platform is intended to enable consumers to purchase a film from any provider and store it online in order to view it using any device with Internet connection – computers, smart TVs, cable set-top boxes, Blu-ray players, videogame consoles, smart phones and tablets. The most significant change is that this new online device really meets the consumption habits and demands of the 'digital natives'. Every single household can create an account for six family members to access their movies and television shows, and later music, books and other digital content, from retailers, cable operators and streaming services. Up to 12 different devices can be registered – to cover most of the hardware options on the market – allowing up to three streams at a single time. In addition, content can be downloaded and transferred onto physical media, like recordable DVDs, SD cards and flash memory drives. Two years since its launch, UltraViolet is still at the takeoff phase. On the one hand, it is only available in the USA and the UK. On the other hand, its title library is still limited (Graser, 2010, 2011b). Nevertheless we are still far from digital consensus. Apple and Disney are both self-excluded from this venture. Disney has been developing its own online window named Disney Studio All Access. As these two cases illustrate, the dilemma here is whether to join efforts in a single-platform and dilute one's brand power or to hold on to a different platform while trusting in one's own brand market appeal? The crux of the question will be if consumers accept this variety of digital lockers to access the entertainment contents they want.

Transmedia stories

'Digital natives' are not only changing the ways of distributing and consuming movies, but the nature of the storytelling as well. Fiction and entertainment content must be developed since its first stage for a multimedia and interactive consumption. From this perspective, the keys to developing successful content are related to its capability to be an audience-driven narrative and distributed across different platforms – that is, content with interactive options, the capacity to tell an original 'transmedia' (multifolded) story and the potential to create a prestigious franchise (Jenkins, 2006; Bernardo, 2011). In this sense, there is also a great influence of games, which have found a means to create multiplayer, interactive content with global influence. As Gubbins concludes, 'the dynamics of cinema will fundamentally change, with a changed

relationship between filmmaker and audience opening up discussions about the primacy of the text over the reader' (2012, p. 92).

Online marketing: Peer recommendations and viral campaigns

Another consequence of the active nature of the 'Net-generation' is its high participatory attitude as well as their self-conscience of peer group. We are living in an era of personalized services and recommendations. In this sense, social networks (MySpace, Facebook, Twitter) have become the most efficient forums to promote any sort of product or event. As Gubbins explains,

> One of the immediate effects of digital change has been the decentralisation of critical comment and recommendation [...]. Word of mouth, amplified by mobile phones, Twitter and Facebook has become a serious force in deciding the fates of film [...]. Yet there is evidence that younger audiences are less interested in the views of traditional critics. For Hollywood, the opinion of particular professional critics has become all but irrelevant and some films can perform well despite pretty much universal critical loathing. This may be welcome on one level, but the shift of power from critic to audience is a challenge to marketers. The opinions of consumers, amplified by mobile phones and social networks, are difficult to control – so far, trying to build a word-of-mouth campaign is providing more art than science.
>
> (2012, p. 74–75)

One example of this power is the case of Harry Knowles, who has become one of the most renowned film critics in the USA thanks to his website Ain't It Cool News (www.aintitcool.com). Another successful example is the popularity of Rotten Tomatoes (www.rottentomatoes.com), a film website which allows instant, aggregated opinion of users. In addition, services such as the iTunes Genius feature and the Ping service launched by Apple show this trend.

The other side of the coin in this respect is the use of viral marketing to create awareness about a particular movie or television show. Hollywood has been quite sensible, taking advantage of these virtual and social marketing mechanisms, not only for building up franchise power (*Lord of the Rings*, *Harry Potter* or any adaptation of comic superheroes), but also to transform low-budget, independent movies (*The Blair Witch Project*, *Cloverfield* or *Paranormal Activity*) into worldwide blockbusters (Mueller, 2007; Kaplan and Haenlein, 2011; Wessels, 2011).

Conclusions: Towards the digital future

It is time to draw some concluding remarks and share some reflections for further discussions. A first conclusive – and rather obvious – point would be that this paradigm shift from analogue to digital has no way back. The changes are profound although some of them are far from being consolidated. The matrix for this transformation is formed by the cross-point between two related phenomena: on the one side, the emergence of a new type of consumer, the 'Net-generation', who behave as an 'active audience' in their use of new media; on the other side, the consolidation of the online markets, propelled by the disappearance of the physical copy, whose economic principles are explained by the 'long tail' theory. In this way, we are moving from an economy of content scarcity to an economy of content abundance, driven by free access to a vast array of products, customized consumption, search engines and content aggregators. The rules of supply and demand have therefore changed as well. In this new digital scenario, the pivotal force has moved from 'product-centric' to 'consumer-centric'.

These new dynamics are deeply affecting the entertainment industry, 'in the short term by undermining the business model on which the industry has been based and in the long term by changing the relationship between audience and content' (Gubbins, 2012, p. 69). In the case of distribution, the disruptive power of digitization is demanding new forms of (dis)intermediation, marked by the direct relation to individual consumers and the reduction of distribution costs. Moreover, the current model of commercial exploitation is at stake: conventional windows need to be reformulated towards simultaneous release of movies across different platforms. In addition, theatrical exhibition needs to readapt itself to these new digital times. Cinemas are being upgraded with the latest digital image and sound standards to preserve their exclusive status and to keep offering a unique audiovisual experience. This move will probably derive into a polarization of the film product, being theatrical release reserved only for big blockbusters or 'event movies'. Nevertheless, exhibitors will not exclusively programme films, but any sort of massive spectacles such as sports, music concerts, opera and alike. Finally, the changes in audiovisual consumption are at the very core of the whole transformation. The 'active audience' demands a customized way of enjoying entertainment, with complete freedom of choice, easy access, total flexibility and almost unlimited portability. This interactive and participatory attitude is not only affecting the nature of storytelling ('transmedia' stories) but also the marketing rules in the online world.

Despite all of the radical transformations that digitization is bringing, there won't be any revolution or 'industry stampede', as some observers predicted; rather, 'the industry will experience an evolution as the old and new models first learn to coexist, until they ultimately converge' (McPhillips and Merlo, 2008, p. 237). In other words, this paradigm shift will not take place overnight in a traumatic way. The different key players in the entertainment industry have been dealing with this change of model for the last 15 years, in a trial-and-error, trial-and-success dynamic. Incumbent firms have gone from initial reluctance to prudent embrace of new technologies, trying to incorporate new business models without killing the most profitable existing ones. In this sense, Gubbins explains:

> The slow progress is partly because the traditional analogue business has been seen as remarkably resilient, continuing to provide the lion's share of revenues and hence being something to be protected: cinema receipts, if not always attendances, have held steady around much of the world; DVD is certainly in decline, but a combination of lower prices, Blu-ray quality and permanence has ensured that we have not seen the free fall that so many predicted; and the linear formats of television (see below) have been highly resistant to change.
>
> (2012, p. 70)

This affirmation leads to a further conclusion – the most crucial: how to monetize these new forms of audiovisual consumption. After many failures and few successes, the search for the right online business model is still a pending issue. For sure, the future business models will not be different from the existing ones. They will combine direct payment, paid subscription and advertising or sponsorship. Which one would be the most significant in terms of income is still an open question. For some experts, paying for content and services will experience the most significant growth (Clemons, 2009, p. 33). In any case, ad-supported formulas will remain if they can find ways of being unaggressive and naturally embedded in the audiovisual content (McPhillips and Merlo, 2008, pp. 250–251). The successful business model should guarantee two key issues: first, the possibility of customized consumption; second, competitive prices. If some of the latest initiatives launched by Hollywood studios (UltraViolet) really address the first demand, other decisions may be probably wrong. Whereas some experts in online markets defend the predominance of free content and are looking for alternative ways of making money out of Internet exposure

(Anderson, 2009), Hollywood studios are thinking of offering select films to rent for US\$30 around 60 days after their theatrical release (Graser, 2011a).

Finally, I will remark, as Gubbins does, that '[t]he digital revolution is in some ways still in its infancy and this makes predictions of future progress difficult' (2012, p. 96). The winds of change remain uncertain, but equally persisting. Nevertheless,

> The changes can be contradictory and confusing; digital change has fragmented audience demand and yet strengthened certain linear, communal forms of consumption. Multiplex cinemas, peak-time television and live music, for example, have all fared relatively well, despite the recent economic downturn. That is not the paradox it seems; while, as we shall see, the huge increase in choice has tended to dissipate demand and disperse audiences, with consequences at both a business and cultural level, the Internet can also aggregate audiences and social networks can amplify demand.
>
> (Gubbins, 2012, pp. 68–69)

The film industry is struggling to come to terms with this new digital environment, yet its sustainable future will depend on how it gets engaged with the 'active audience' and how it comes up with the right business models. In this sense, I would like to close this conclusive section along as Gubbins puts forward:

> Many of the most exciting ideas that promise to transform the dynamics of cinema may simply prove not to be economically viable, particularly given the strain on public finances, which have been so essential to independent cinema. The effect of digital change on cinema will be reliant, then, on the realpolitik of the industrial and economic environment; and yet the experience of other industries is that there are unstoppable tides in consumer behaviour that will have to be addressed.
>
> (2012, p. 97)

Bibliography

Albrecht, C. (2008) MovieMobz Opens Up Moviegoing.*Gigaom*, 21 September. Available from: http://gigaom.com/2008/09/21/moviemobz-opens-up-movie going/ [Accessed: 20 October 2011].

Anderson, C. (October 2004) The Long Tail. *Wired*, pp. 170–177.

Anderson, C. (2006) *The Long Tail: Why the Future of Business Is Selling Less of More.* New York: Hyperion.

Anderson, C. (2009) *Free: The Future of a Radical Price.* New York: Hyperion.

Bernardo, N. (2011) *The Producers Guide to Transmedia: How to Develop, Fund, Produce and Distribute Compelling Stories Across Multiple Platforms.* Dublin: Beactive Books.

Berstein, P. (2013) Is VOD the Future of Independent Film? Yes – and No. *IndieWire*, 11 November. Available from: http://www.indiewire.com/article/is-vod-the-future-of-independent-film-yes-and-no [Accessed: 1 March 2012].

Broderick, P. (2008) Welcome to the New World of Distribution (Part 1). *IndieWire*, 15 September. Available from: http://www.indiewire.com/article/first_person_peter_broderick_welcome_to_the_new_world_of_distribution_part1 [Accessed: 1 March 2012].

Brunella, E. and Kanzer, M. (2011) *The European Digital Cinema Report: Understanding Digital Cinema Roll-out.* Strasbourg: European Audiovisual Observatory & MEDIA Salles.

Cendrowski, S. (2011) Bytes Beat Bricks. *Fortune*, 23 June. Available from: http://tech.fortune.cnn.com/2011/06/23/bytes-beat-bricks/ [Accessed: 24 April 2012].

Clemons, E. K. (2009) Business Models for Monetizing Internet Applications and Web Sites: Experience, Theory, and Predictions. *Journal of Management Information Systems*, 26 (2), 15–41.

Cohen, D. S. (2010) Amazon.com Gets into Development Business. *Variety*, 16 November. Available from: http://www.variety.com/article/VR1118027595 [Accessed: 30 November 2011].

Cunningham, S. and Silver, J. (2012) On-line Film Distribution: Its History and Global Complexion. In: Iordanova, D. and Cunningham, S. (eds.) *Digital Disruption: Cinema Moves On-line*, St Andrews: St Andrews Film Studies, pp. 33–65.

Davis, R. E. (2006) The Instantaneous Worldwide Release: Coming Soon to Everyone, Everywhere. In: Ezra, E. and Rowden, T. (eds.) *Transnational Cinema: The Film Reader*, London: Routledge, pp. 73–80.

Dawtrey, A. (2012a) As DVD Pie Crumbles, is VOD Sweet? *Variety*, 7 May. Available from: http://variety.com/2012/digital/news/as-dvd-pie-crumbles-is-vod-sweet-1118053065/ [Accessed: 7 May 2012].

Dawtrey, A. (2012b) Europeans Take Small Steps in VOD Market. *Variety*, 7 May. Available from: http://www.variety.com/article/VR1118053066?refcatid=1009 [Accessed: 7 May 2012].

De la Fuente, A. M. (2011) Latin America: Alternative Content Helps Fuel Growth. *Variety*, 6 May. Available from: http://www.variety.com/article/VR1118035986 [Accessed: 20 October 2011].

EAO (2012) *Yearbook 2011 Vol. 2: Television and On-demand Audiovisual Services in Europe.* Available from: http://www.obs.coe.int [Accessed: 7 May 2012].

Fleming, M. (2013) Theater Owners to Netflix: You're the One Trying To Kill Cinema. *Deadline*, 26 October. Available from: http://www.deadline.com/2013/10/theater-owners-to-netflix-youre-the-one-trying-to-kill-cinema/ [Accessed: 1 December 2013].

Giardina, C. (2012a) Peter Jackson's 'The Hobbit' Should Hit Theatres at 48-Per-Second Frame Rate. *The Hollywood Reporter*, 18 April. Available from: http://www.hollywoodreporter.com/news/peter-jackson-hobbit-48-frames-per-second-rate-james- cameron-313867 [Accessed: 15 October 2013].

Giardina, C. (2012b) Warners Taking 'Prudent' Approach to 'The Hobbit's' 48fps Release. *The Hollywood Reporter*, 9 August. Available from: http://www.hollywoodreporter.com/news/siggraph-2012-warners-bros-the-hobbit-48fps-360464 [Accessed: 15 October 2013].

Goldsmith, J. (2012a) 'Abduction' in Day and Date Facebook Release. *Variety*, 17 January. Available from: http://www.variety.com/article/VR1118048738 [Accessed: 30 January 2013].

Goldsmith, J. (2012b) Google, YouTube Reveal Partners, Channels. *Variety*, 2 May. Available from: http://www.variety.com/article/VR1118053423?refcatid=1009 [Accessed: 5 May 2012].

Goodridge, M. (2010) A Window to the Future. *Screen Daily*, 25 February. Available from: http://www.screendaily.com/comment/a-window-to-the-future/5011311.article [Accessed: 3 March 2010].

Graser, M. (2010) DECE Unveils UltraViolet Platform. *Variety*, 19 July. Available from: http://www.variety.com/article/VR1118021929 [Accessed: 19 November 2010].

Graser, M. (2011a) Biz Redefines PVOD Plan. *Variety*, 8 July. Available from: http://www.variety.com/article/VR1118039574?refcatid=13 [Accessed: 20 January 2012].

Graser, M. (2011b) Hollywood Clicks with UltraViolet Digital Locker. *Variety*, 5 January. Available from: http://www.variety.com/article/VR1118029799 [Accessed: 20 January 2011].

Gubbins, M. (2008) Film in an 'Anytime, Any Place Anywhere' Martini Culture. *Screen Daily*, 18 April. Available from: http://www.screendaily.com/ScreenDailyArticle.aspx?intStoryID=38291 [Accessed: 20 April 2008].

Gubbins, M. (2012) Digital Revolution: Active Audiences and Fragmented Consumption. In: Iordanova, D. and Cunningham, S. (eds.) *Digital Disruption: Cinema Moves On-line*, St Andrews: St Andrews Film Studies, pp. 67–100.

Iordanova, D. (2012) Digital Disruption: Technological Innovation and Global Film Circulation. In: Iordanova, D. and Cunningham, S. (eds.) *Digital Disruption: Cinema Moves On-line*, St Andrews: St Andrews Film Studies, pp. 1–32.

Iordanova, D. and Cunningham, S. (eds.) (2012). *Digital Disruption: Cinema Moves On-line*. St Andrews: St Andrews Film Studies.

Izzo, P. (2011) Top 10 Dying Industries. *The Wall Street Journal*, 28 March. Available from: http://blogs.wsj.com/economics/2011/03/28/top-10-dying-industries/ [Accessed: 3 February 2012].

Jenkins, H. (2006). *Convergence Culture: Where Old and New Media Collide*. New York: New York University Press.

Johnson, Gigi. (2012) Opening Pandora's Digital Box: Shifting Metaphors and Media Storage to the Cloud. *Digital Media Transition Series*. Los Angeles, CA: Maremel Institute.

Johnson, T. (2013) Ted Sarandos Backs Away From Day-and-Date Movies with Netflix. *Variety*, 4 November. Available from: http://variety.com/2013/

digital/news/ted-sarandos-backs-away-from-day-and-date-movies-with-netflix-1200794822/ [Accessed: 1 December 2013].

Kaplan, A. M. and Haenlein, M. (2011) Two Hearts in Three-quarter Time: How to Waltz the Social Media/Viral Marketing Dance. *Business Horizons*, 54 (3), 253–263.

Lobato, R. (2012) *Shadows Economies of Cinema: Mapping Informal Film Distribution*. London: BFI-Palgrave Macmillan.

McPhillips, S. and Merlo, O. (2008) Media Convergence and the Evolving Media Business Model: An Overview of Strategics Opportunities. *The Marketing Review*, 8 (3), 237–253.

Morris, C. (2011) Apple Confirms iCloud. *Variety*, 31 May. Available from: http://www.variety.com/article/VR1118037790?refcatid=1009 [Accessed: 31 May 2011].

MPAA. (2011) *Theatrical Market Statistics*: Motion Picture Association of America.

Mueller, M. (2007) Marketing – The Social Revolution. *Screen Daily*, 14 December. Available from: http://www.screendaily.com/ScreenDailyArticle.aspx?intStoryID=36313 [Accessed: 20 January 2008].

Pardo, A. (2009) Hollywood at the Digital Crossroad: New Challenges, New Opportunities. In: Albarran, A., Faustino, P. and Santos, R. (eds.) *The Media as a Driver of the Information Society: Economics, Management, Policies and Technologies*, Lisbon: MediaXXI-Formalpress and Universidade Católica Editora, pp. 67–97.

Pardo, A. (2013) Digital Hollywood: How Internet and Social Media are Changing the Movie Business. In: Friedrichsen, M. and Mühl-Benninghaus, W. (eds.) *Media Management and Social Media Business: Value Chain and Business Models in Changing Media Markets*, Berlin: Springer-Verlag, pp. 329–348.

Screen Daily (2010) Taking the Initiative, 22 June. Available from: http://www.screendaily.com/reports/features/taking-the-initiative/5015285.article [Accessed: 21 October 2010].

Screen Digest (2007) Internet Selling of Online Movies, September, pp. 269–276.

Screen Digest (2011) Digital Cinema over the Tipping Point, June, pp. 109–112.

Stedman, A. (2013) Theater Owners 'Might Kill Movies', Warns Netflix's Sarandos. *Variety*, 26 October. Available from: http://variety.com/2013/digital/news/theater-owners-might-kill-movies-warns-netflixs-sarandos-1200765818/ [Accessed: 1 December 2013].

Tapscott, D. (2009) *Grown up Digital: How the Net Generation is Changing Your World*. New York: McGraw-Hill Professional.

Tryon, C. (2013) *On-Demand Culture: Digital Delivery and the Future of Movies*. New Brunswick, NJ: Rutgers University Press.

Ulin, J. (2009) *The Business of Media Distribution: Monetizing Film, TV, and Video Content* (2nd ed.). Burlington: Focal Press.

Wallenstein, A. (2012) Amazon Studios Opens Door to TV. *Variety*, 2 May. Available from: http://www.variety.com/article/VR1118053413?refcatid=1009 [Accessed: 5 May 2012].

Wallenstein, A. and Setoodeh, R. (2013) The Movie Deal Netflix Wants to Make – And It's Not Day-and-Date. *Variety*, 5 November. Available from: http://variety.com/2013/biz/news/netflix-to-preem-movies-the-same-day-they-bow-in-theaters-1200796130/ [Accessed: 1 December 2013].

Wessels, E. (2011) 'Where Were you When the Monster Hit?' Media Convergence, Branded Security Citizenship, and the Trans-media Phenomenon of Cloverfield. *Convergence: The International Journal of Research into New Media Technologies*, 17 (1), 69–83.

Wiseman, A. (2012) UK Cinemas to Screen Olympics. *Screen Daily*, 20 April. Available from: http://www.screendaily.com/home/exhibition/uk-cinemas-to-screen-olympics/5040649.article [Accessed: 30 April 2012].

3
Notes on Film Distribution: Networks, Screens and Practices

Stefania Haritou

Introduction

The chapter begins with the premise that the shift from analogue to digital technologies in the practices of film distribution and exhibition has introduced new ways of organizing, crafting and handling the materials involved in these practices. While under this light, the fields of media and cultural studies have recently drawn theoretical attention to the alternative, or informal, forms of film delivery (Cubitt, 2005; Lobato, 2012) or the transnational channels of legal and illegal film distribution (Wang, 2003), my intention is to shed light on the contemporary, local and situated working practices of a particular institution, the Curzon Artificial Eye (CAE) distribution and exhibition company in London, UK. In particular, this ethnographic study examines the work and technologies-in-use in two sets of practices: the analogue and digital theatrical projection as it is operated at the Renoir Cinema (a member of the Curzon Cinemas chain) and the video-on-demand (VOD) service 'Curzon on Demand', a streaming platform of non-theatrical film distribution and exhibition. Drawing on the methodological and analytical tools of the material semiotic version of science and technology studies (STS) and their call to attend to practices as constitutive of objects, this investigation aims to inquire on the materials, technologies and networks that shape and get shaped by the practices of film projection and exhibition. Relationally it intends to illustrate the generative role of these practices in the interdependent relation between the object of film and the object of the screen and as such to shed light on the continuously transformative socio-material networks that have been integral parts of cinema history.

All there is, are practices

The transition from analogue to digital technologies and the provision of digital content has fundamentally shifted the standards, practices, networks and the socio-material actors involved in film's delivery. For instance, in the current debate on film distribution, the 'formal' circulation of film is marked by notions of crisis and disruption (Cunningham and Iordanova, 2012; Lobato, 2012). In this discussion, the distributed film is caught up in separate transactions between formal economic systems shaped by the link between distribution companies and theatre chains, in which CAE is situated, and informal circulatory systems such as BitTorrent traffic, uploading and viewing on video-hosting sites or pirate disc sales. Thus, besides the paradigmatic shift that digital technologies signal to the industry's economics, power and capital, contemporary film distribution appears to be constituted in diverse sociomaterial settings and distinct processes of organization and circulation of heterogeneous materials and services. While digital technologies are embedded in these practices, the latter are neither homogeneous nor unified. They generate differences and potential tensions between different practitioners, locations, methods, lines and flows that give film its mobility to be distributed and exhibited. This chapter argues that in this moment of transition and change in the tools, materials and organizational practices of distribution and exhibition, it is easiest to learn about the making of the object of film, because in these moments we can easier access and observe the multifarious work of distribution.

Thus this chapter is interested in making ontological claims about the object of film, in this moment of technological transition that underpins all the links in film's chain: production, distribution and exhibition, yet by focusing on the technological and material practices of film distribution. Many argue (Usai, 2001; Rodowick, 2007) that with the transition to digital technologies a different kind of transformation takes place, one that has ontological implications for the object of the film. For instance, David Rodowick argues that while the photographic image's power of analogy in terms of duration has been transformed into discrete units that can be recombined and changed, 'the electronic screen expresses another ontology, which I have characterized as an increased attention to the present and to the control of information' (2007, p. 166). This study intends to present a different take. The transition from analogue to digital technologies does not ascribe to the object of film an essential or foundational difference. Yet, the differences that exist are effects of practices rather than

causes. Against a deterministic or social constructivist approach to technology this study adopts the methodological and analytical tools of STS material semiotics and focuses on the various and heterogeneous socio-technical networks of distribution and exhibition, yet not in the abstract, but within a particular site, the CAE company. Examining the everyday, working activities, material assemblages of film projection and distribution, it intends to show the intersection and interaction of different networks that are formulated within the company's distribution practices.

To study practices, as Law suggests is 'to undertake the analytical and empirical task of exploring possible patterns of relations, and how it is that these get assembled in particular locations' (2009, p. 1). As such, this ethnographic study focuses on the everyday, mundane working practices of CAE. The company is a London-based group formed in 2006 and composed of Artificial Eye (founded in 1976), the UK's longest running distribution company of foreign language and art house films for cinema and home entertainment (as a retail DVD distributor), and Curzon Cinemas, London's independent exhibition company. CAE forms the first group in the UK working both as a distributor and exhibitor bridging the gap between often contrasting commercial interests and logics that define these sections of the film industry. CAE is composed of six movie theatres in London, and among them is the Renoir movie theatre – in which I was an employee for two years, from 2008 to 2010. Since 2010, the company has introduced the 'Curzon on Demand' service, which is the UK's first high definition (HD) online home cinema. As the Curzon on Demand service forms a new outlet for the company's film distribution and exhibition, the Renoir and all of the Curzon's theatrical venues and projection rooms have adopted digital projection. Two sets of practices are the focus of this chapter's analytical interest: the technological and material operations of the dual distribution system, as analogue and digital projection co-exist, in the projection booth of the Renoir Cinema and the networks and technological arrangements of the service Curzon on Demand, a host site of movies on demand that enables their streaming in HD via cable or satellite in small-sized (domestic and mobile) screens.

In these practices, film as a distributed object gets *enacted* differently. Let us put some emphasis on the word that I am using: enactment. In STS' vocabulary to enact means to trace the web of heterogeneous materials and practices that produce an object, a reality, a phenomenon. As Law explains enactment shifts our attention from the concept

construction, which ascribes agency to a 'stable prime-mover, social or individual' (2007, p. 13) and calls us to trace all the heterogeneous elements that are assembled relationally in practices. Exploring how objects are enacted in practices invites us to step aside from general and essential claims about the technological shift from analogue to digital materials. Enactment attends to certain practical activities that might be precarious, short-lived or an effect of certain social, material, technological circumstances.

Thus, to present this line of thought, the study found inspiration in STS' material semiotic tools. STS has been developed upon empirical investigations of how science and technology are performed. Through ethnographic case studies, the field has inquired into the situatedness and accomplishment of knowledge, realities and objects as continuously enacted or performed. In STS materiality is usually understood as a relational effect. Thus it cannot be examined apart from the enactment of relations and the practices that enact these relations. More precisely within STS' version of material semiotics, realities and phenomena (but also knowledge) are not fixed but they are part of the relationships and practices in which they are situated. The semiotic turn in STS addresses a movement away from knowledge dominated by theory to production of knowledge in day-to-day scientific activity to which theory only becomes one aspect. Thus the material semiotic approach invites us to investigate 'the enactment of materially and discursively heterogeneous relations that produce and reshuffle all kinds of actors including objects, subjects, human beings, machines, animals, "nature", ideas, organizations, inequalities, scale and sizes, and geographical arrangements' (Law, 2007, p. 2).

Writing within the material semiotic tradition and its aftermath, Mol's (2002) ethnographic work, in her book *The Body Multiple: Ontology in Medical Practice*, on the medical object of the disease of atherosclerosis articulates the shift from an epistemological to a 'praxiographic' enquiry into objects and realities. In Mol's account the ontology of an object is not pre-given, fixed and stabilized, able to be seen, known and understood by various different perspectives. In Mol's philosophical mode, knowledge is understood as a matter of manipulation rather than reference. Thus knowledge about an object becomes part of the practices in which the object is located and performed. Crucially in her argument, since practices are heterogeneous and precarious, the disease is enacted every time differently, as 'no object, no body, no disease is singular. If it is not removed from the practices that sustain it, reality is multiple' (2002, p. 6). According to Mol's praxiography, the cases made about an

object are situated in specific sites. And within different sites, practices need to be *foregrounded* rather than *bracketed*. Objects, sites and realities step aside from inherent, essentialist qualities.

Thus, according to Mol:

> Ontology is not given in the order of things, but that, instead, ontologies are brought into being, sustained, or allowed to wither away in common, day-to-day, sociomaterial practices [...]. Ontologies are [...] highly topical matters.
>
> (2002, p. 7)

In Mol's philosophy the new 'is' is one that is situated. It does not tell what an object is by nature, everywhere, 'for nothing ever "is" alone. To be is to be related' (2002, p. 54). Objects are not concrete and stable entities, existing in and of themselves; they exist in multiple situated practices.

Based on STS' material semiotics and Mol's philosophical account on multiplicity, my intention is to examine film as an object manipulated in practices and to investigate how practices constitute both the theatrical and non-theatrical distribution and exhibition of film within the working operations of Curzon Cinemas. The focus on the actual, working practices of film distribution and exhibition, guides me to investigate the object of film not as an isolated object, but rather as part of processes that need to be coordinated in the practices in which they are located. Assuming that realities, objects and knowledges exist only in the practices that materialize them, this has an important consequence. Realities, knowledges and objects are not universal, that is to say, they do not take a universal form or shape. Instead they come into being in specific practices and specific locations. As such, a close inspection of the practices as they are operated by the CAE company, can give a different account of the shifts and transactions in which the object of film, either analogue or digital, is enacted in transient material and technological arrangements. Treating film as an upshot of practices, as a practical achievement, permits us to examine what is relevant and at stake with these practices. What follows is not merely a description of practices: it conveys a lot about socio-material relations, networks and infrastructure. It also relates to academic literature, aiming to shed light on other relevant studies that focus on practices and import them into this study not in order to reach 'better' conclusions but to highlight the complex history and present-day of the object of film, which differs between sites, circumstances and temporal configurations.

Analogue and digital practices of film projection

The Renoir movie theatre first opened in the Brunswick Centre, in Bloomsbury, central London, in January 1972. After a period of closure it reopened in 1986 under the management of Artificial Eye, showing first runs of Artificial Eye films. As a first-run art house theatre, the Renoir primarily exhibited Artificial Eye releases, which prioritize French works and independent European productions. In 2006 the theatre united with Curzon Cinemas, which expanded its repertoire with more releases, besides Artificial Eye-distributed films. The Renoir carries the tradition of an art house cinema, hosting films from established directors and new talents from world cinema, but also organizing directors' retrospectives, screenings of avant-garde films, short films and animation.

While digital projection was inaugurated as a technology with George Lucas' film *Star Wars: The Phantom Menace* in June 1999, more than a decade ago, the Renoir Cinema only came to adopt the technology in 2006. Charlotte Crofts (2011) explains that whereas the distribution and circulation of films rapidly emerge on the web, the adoption of distribution practices in theatrical screens, through digital means, has a slower pace. According to her, the reasons are to be found in the relationship between key elements that deal mainly with different market interests and in the need for a change of the current and long-lasting business model. This change is largely connected with the means and materials of film production, which are mainly directed by aesthetic and economic drivers and challenges (2011, p. 1).[1] Yet despite the apparently rapid adoption of digital distribution in other trajectories and practices of film distribution (DVD stores, film-hosting sites online, pirate distribution) the adoption of digital projection by theatrical owners has experienced a slower uptake.

Moving our focus onto the projection room at the Renoir movie theatre, certain socio-material specificities frame its analogue and digital projection practices. As an exhibitor of art house films, director's retrospectives and special screenings of old releases, the Renoir depends on analogue film stock. As such, at the present moment, 10–20 per cent of the films projected at the movie theatre are analogue prints. In its projection booth, there are two 35mm-analogue projectors and a digital projector, occupying the same space as the analogue ones, which operates HD video projection, DVD, mini DV, Betacam and Digibeta projection. The work undertaken by the projectionist within the booth is practical and materially heterogeneous. Technically speaking, digital projection does not radically change the projection as operated by

analogue equipment. Certainly, the analogue film platter is replaced by a digital server, the head of the mechanical projector is replaced by a digital head and the film spool by a hard disk drive. But the way that the film images are illuminated in the theatrical screen is done in the same way as with celluloid. That is to say, both analogue and digital projection transform digital data or the images on the photosensitive carrier into the light that appears on the screen. What changes are the technical operations required by the projectionist to operate the film in order to encounter the screen. These are based on the technological distinction between the photosensitive image carrier of the analogue print and the digital as quantified in binary mode in files in their performance in analogue and digital projectors.

The nature of the technology and machinery of analogue projection is underpinned by mechanical, optical and electronic principles. Moreover, the enacted practice includes the projectionist's mechanical knowledge, technical skills, expertise and working experience. This is how the process of analogue projection is being done: the analogue 35-mm release print is transported in a can and gets delivered to the projectionist by a courier. Placed in the projection booth, the projectionist first needs to check the reels of the film. If there is more than one case of reels – this happens often – they might need to be checked to see if they are set forwards or backwards and then spliced together into one large reel, which is the platter. The projectionist also needs to test the weight of the roll of film on the teeth of the projector; if it is too heavy, it needs to be broken down into smaller amounts of reel, while the flatbed indicates how long it is. The reels will then be assembled with the trailers and the advertisements and they will sit in a horizontal rotating table, the platter. This means that the projectionist does not have to change the reels during the projection's performance. At the same time, while the film is playing, another, the take-up platter, receives the film and winds it into a ready state for the next film screening. The projectionist has to check the light bulb, with respect to the images' luminance. A change in the light bulb's power level could cause flickering on the screen. The film is looped, passed through the projector's sprockets, whereby the strip travels through the gate and the sound drum. After checking the light, the sound and the screen ratio, the projectionist presses the start button: the film is on. The shutter, which by opening and closing controls the time of the standardized speed (24 times per second) of photographic exposure, allows light to come through the lens in order to expose the photographic frames. The shutter guarantees that one frame at a time will be projected, for 1/24

of a second, allowing the moving image to be seen, as opposed to just images sliding by one after the other. The light illuminates each frame that passes in front of it in a three-step act: the frame passed, the frame passing and the frame that will pass. This is the manifestation of the countable movement of the strip. The projectionist needs to hear the sound of the machine in case there is a fault, in which case the noise of the projector will change, thus manifesting the problem. For instance, when the light bulb burns out, the projector creates a clicking sound to indicate that the bulb needs to be replaced.

Although, since the rise of multiplexes, analogue projection has become an automated process, it still demands the implementation and congruence of various skills but also senses by the projectionist. As described above, it is based on a manual process, which also requires touching, watching and hearing the passing of the polyester strip onto the projector's loop. The material object of the film print enters into immediate contact with the projectionist and the projection machine: the occurrence of technical problems is tactile and materially manifested through the interaction of the photosensitive carrier with the machine. The mechanical parts in which the analogue print interacts with the projector machine are visible and detectable, a fact that enables an experienced and skilled projectionist to locate and fix problems or errors in the projection process.

With digital projection, the principle acts of projection, such as the operation of the shutter, the zoom and the focus, are included in a control panel. In the Renoir's digital-projection equipment, in order to enter into the settings of these functions, software is integrated into the projector and can be displayed on the computer's screen. The digital projection process is based primarily on the conversion of analogue prints into electronic form, which are digitized and encrypted, or the projection of digital-born materials. In the Renoir the distribution of the digital, commercial film is made in the same way as the analogue film: the electronic copy of the film's content in the form of a hard drive – a data-packet – is delivered physically by a courier and not via satellite or cable; the reason being the fear of piracy.[2]

The data-packet is a DCI hard drive, which has a storage capacity of 400 GB; this being even better than HD. The information is encrypted and also compressed, a method that enables the reduction of the data transfer rate to a size that can be encoded and projected in real time. Each hard drive stores one film. At the same time, the data-packet carries information about how the different files of the film are linked to each other, which sections of the film are contained and the order in which

they need to be screened. Along with the hard drive, a security key code is sent which enables access to the film and its projection for a specific temporal period. The security key is typically sent via email to the exhibitor by a unique Key Delivery Message (KDM), which is encrypted. One key will work for only one film and one server. If the key is delivered for the wrong server or location it will not function, thereby in theory reducing delivery errors that could compromise the security and thus accessibility to the movie. If a key expires then the exhibitor will need a new one; otherwise the film cannot be played. Moreover, the key needs to be compatible with the projector's certificates. The creation of the KDMs is based on a collection of digital certificates composed of the theatre's equipment and the manufacturers' authorization of the creation of the KDMs. Within this context, the exhibition systems need to remain compatible and, moreover, the distribution needs to be piracy proof, in order to prevent piracy/leakage of the film's content between screens.

In the digital projection, we have optics and bulb (light) and, in general, the projectionist is looking for the same things as with analogue projection: whether the auditorium's lights are down, whether there are images on the screen and whether the sound is working. But in digital projection we do not have light projected through film; instead technologies like Digital Light Processing (DLP) and Liquid Crystal on Silicon (LCOS) are performing the task where, again, a light switch that enables light to be modulated digitally through a million microscopic mirrors is arranged in a rectangular mode. These are the same technologies at work in computers, television screens and mobile phones. They are technologies that do rely on scanning and transmission, in which light passes through the liquid crystals on the way to the lens and is modulated by these crystals as it passes. The light does not derive from the computer console, in which the film's hard drive is embedded, but from the projector's lens in which the film, via software, is to be screened. The information data that needs to be checked is listed on the menu of the computer's screen. The ratio, scope and sound are predetermined by the electronic hard drive, through which the projectionist is able to open ideograms, files and functions. The manual role of the projectionist is transformed into the role of a computer user.

If there are faults on the subtitles or faults on the copy, the projectionist needs to check the images screened on the theatrical screen. There are a number of faults that can be discerned when screening a digital film: strophic failure, problems with the image resolution, image freezing (on

the screen) or loss of subtitles. Since each part of the digital film copy comes in a different file, if there is a fault in one of the files, although the projectionist could check them and test the patches added onto them, they need to be rebooted. With digital projection there is less communication between the projectionist and the server. When a film is projected digitally, anything that does not start as it should might create problems, whereas in the projection of 35mm the things that could go wrong are all there on the material film and evident in its interaction with the projector. Overall, the projectionist is not dealing with fewer problems but different kinds of problems, those which, instead of demanding knowledge of mechanics, require knowledge of the operation of electronics. While, in the case of 35-mm film print, more faults and mistakes can be fixed by the projectionist within the projection room, with digital most of the problems require electronic assistance.

Therefore, crucial to enacting analogue projection are the skills and expertise of the projectionist in managing and manipulating the materials and technologies at stake. Even after the introduction of automated projection devices, the experience, the knowledge of mechanics and the expertise of the projectionist have been definite elements in the practice of projection. Digital projection can be actualized in a less-skilled or laborious and rigorous process. For instance, in the Renoir, the movie theatre's manager has been trained how to project a digital film, as computer literacy rather than mechanical skills is the main prerequisite of the work. Whereas in analogue projection we have a division of activities that are primarily assembled together through the labour and skills of the projectionist, in digital projection, these activities are centralized in the digital projector's control panel. Thus, in digital projection, the control of the process of projection does not lie on the intersection of the film strip with the projector but rather on the screen.

Curzon on Demand

If we move our attention to another practice within CAE's working framework, we can detect a different kind of film distribution and exhibition. In December 2010, Curzon's VOD service opened with the premiere of the film *In Our Name* (2010) directed by Brian Welsh, which was presented simultaneously in CAE's movie theatres and on television sets and personal computers. Curzon Cinemas advertise their VOD service as 'a curated online cinema experience – a twenty four hour service, available, wherever you are'. The advertisement promoting the

service shows three screens, a television, computer and smart-phone screen, graphically designed, with the following promotional straplines: 'redefining cinema' and 'films on the go in all devices'. The service operates as another Curzon Cinema, that is to say films are programmed specifically for this site, in line with the releases that the theatrical venues exhibit. Being within the geographical span – or boundaries – of Ireland and the UK, the service gives the opportunity for its subscribers or pay-per-view viewers to watch the latest cinema releases – films that are currently on theatrical release – on different media-screen platforms but also a curated selection of classic and contemporary film releases from Curzon's 'film library', which is streamed in HD, offering, as the Curzon VOD video ad promotes 'an excellent viewing experience'. The company aims to counter illegal online downloads and intends to use digital technology to bring their independent film distribution to a wider audience, situated at a distance from their theatrical venues in London. At a cost of £6 – cheaper than the current price of a theatrical ticket – for a new release and £2 for a film from the Curzon's library, a film is available to be watched for seven days after its purchase. While previously theatre owners were provided with a limit of three to six months to exclusively show a film in their venues without having to compete with other formats and versions of the film, for instance on DVD rental, or in a shorter period on other VOD hosting sites and services, Curzon on Demand annihilates the temporal distinction of a film viewing by offering simultaneous delivery on both theatrical and small screens. In this way the service accelerates film's delivery, by sequencing new screens and reworking distance and time constraints.

The Curzon on Demand service is fast growing and expanding. Since April 2012, the company has extended its VOD service by allowing its subscribers to watch film content on iPhones and iPads, subject to the user's connectivity, and also on Samsung's Smart televisions – which is the integration of Internet-delivered content with connected televisions – thus enabling consumers to stream movies on their main television set. The service runs through an application developed by the company Capablue's Plus, a recently launched connected solution. As a product developer, Capablue's Connected Plus is a cloud-based platform that enables the monetization of content, in any format, for any media and from any system. The platform transforms the data into apps and portals for any device. In this way Curzon on Demand is available as an application on Samsung Smart televisions, and facilitated by the Internet. Depending on the design and service of these applications, the service

has opened up the possibilities and trajectories of film distribution in various locations and situations, static or mobile.

Based on the delivery method of streaming by cable or satellite, Curzon on Demand viewers access the film content directly and live from the provider. In contrast to broadcasting in which content flows from a central unit to a number of anonymous viewers who receive the same material at the same time, streaming is a non-linear service, as the viewers purchasing a film from the Curzon VOD service can 'pull' content from a network at any time and in a non-linear-viewing context, independent of the linear method and structure of broadcasting, which 'pushes' content to viewers (Gripsrud, 2010, p. 10). The service depends on the customer's bandwidth, that is, the speed of the Internet connection during the time that the viewers pull the content from the Curzon on Demand website or the applications. This service stands at a distance from the processes of film's delivery through physical means (delivery of the film canisters or the data packet and operations by the projectionist) that operate at the Renoir's analogue and digital projection practices and projection room, and is based on transportation via the Internet.

The dislocation of film from the theatrical screen to the multiple non-theatrical screens inscribes to the object of film mobilization, which enables it to move across different geographical points – within the context of the UK – in order to appeal to a wider audience. Films can move between places, as films can be watched on mobile screens. But films also move between times. In contrast to the theatrical screening where the narrative and durational linearity of film stays intact, through Curzon on Demand, a film can be accessed in irregular time, in changing temporal moments, as access to films can be immediate, continuous and repeatable within a week's time. Screens become a constitutive element of the Curzon Cinemas' practices of distribution and presentation. Next to the professionalized practice of film projection, as described in the Renoir's projection booth, the Curzon on Demand viewers are using applications, pushing buttons, purchasing a film online and adding to a shopping basket in the same manner as other purchased commodities. The Internet's potential for instantaneous reach and immediacy can overcome the time and space constraints that define film's theatrical exhibition. Thus the materials and networks of the Curzon on Demand service, in the shape and scale that they take, can be seen as inseparable from the infrastructure, technical solutions, business links and commercial strategies that enact them.

Besides other platforms for the distribution of film which are also operated by CAE, such as VHS and DVD, and which depend

on television screens for exhibition, Curzon on Demand bears the specificity of its distribution networks and technological shape and use of the screens on which it appears. In particular, the Curzon on Demand service is marketed as a discrete entity to be consumed: a specialized channel devoted to current film releases but also for the programming of classic films. Curzon Cinemas' activities, stepping aside from the idea of a singular technological apparatus, the theatrical screen and a specific location, the movie theatre, enact screen practices that become nodes that link audiovisual-branded conglomerates, such as Samsung, Apple and Capablue. The screen deploys exactly this interconnectivity, not only between film materials but also between different technological media and different industrial components. For instance, with a window within a window on a computer's interface, the screen incorporates the pause, fast-forward buttons and the length of the film's duration. Moreover, the Curzon on Demand service commercializes the screen, whether that is a Samsung smart TV or an iPad, the screen bears the marks of the Capablue's design of application or the Curzon website's browser interface.

In the practices of theatrical projection and non-theatrical distribution described above, the object of film is turned into a component of different networks of elements that are arrayed together, a role that can permit to be distributed and redistributed. These descriptions do not have to do solely with the object of the film but with the links that are created with the distribution and exhibition patterns of Curzon Cinemas. As such, film can be seen as a set of characteristics that have to do with the size of the screens, the scale of Curzon networks, number of subscribers to Curzon on Demand service, and the places in which film is brought and enacted. Although the practices of distribution and exhibition at the Renoir Cinema and the Curzon on Demand service, handle, distribute and shape film differently, they are materially brought into being and sustained in particular locations through screens. For instance, on one hand, the screen becomes a window in the theatrical projection practices of the mechanical or electronic operation of the projection machine. It is within the singular, theatrical screen that the faults, errors or technical problems will be materialized and visualized. On the other hand, the screen becomes a node of a multifarious network of actors and technologies in the Curzon on Demand service. Thus the screen becomes a central component in the continuous networks through which film is distributed and exhibited.

The enactment of film in screen practices

As we have seen, there are many variables in the relations and links that are enacted in CAE's distribution and exhibition practices. Relationally there are many processes upon which they depend: delivery and projection in the case of theatrical distribution and an information and communication infrastructure in the case of Curzon on Demand. Based on the description of the CAE's practices it is difficult to singularize the variables, elements or processes that enact film distribution. And yet in these configurations and reconfigurations in distribution practices, the object of the screen takes a prominent role. Drawing on CAE's practices, the relation between the object of the film with the object of the screen is not hidden in the order of things, but it is enacted in complex practices. Thus, in this section I am not attempting to make a shift of attention from the object of the film to the object of the screen, but rather to examine their mutual inclusion, in the present practices of Curzon Cinemas but also in academic literature.

Primarily, literature has enacted the screen as an object with history. For instance, in Charles Musser's account, cinema has emerged out of screen practices that date back to the 17th century (1990). In Musser's study on pre-cinema and early cinema, the history of screens is staged beyond cinema's narrative text, as the screen becomes the common spatial pattern merging the various technological entertainment devices that were popular before, and ran parallel with, the advent of the cinematograph. Musser maps the evolution of different kinds of screens, practices and presentation of images, which are based on the changes and advancements of technologies in relation to cultural, social and economic contexts.

Similarly, Erkki Huhtamo ascribes to the screen a complex genealogy. Thus in spite of their ubiquity, screens have a history which 'should comprise not only the evolution of different kinds of screens and the interconnections between them, but also account for their uses as part of different media apparata and within changing cultural, social and economic settings' (2001, p. 1). Thus, while the theatrical screen, as Anne Friedberg (2006) has noted in her book the *Virtual Window*, has continuously undergone transformations: from the Cinerama to drive-ins and multi-screen installation works, in Huhtamo's account lies a caution, screens from different times and places do not have an immutable essence, if they do have one, it is to be found 'only in the sum total of all the historical manifestations of different screen practices, not beyond them like some Platonic idea' (2001, p. 1).

While both Musser and Huhtamo examine the screen and its related practices by drawing attention to larger elements such as economic forces or cultural assumptions, Haidee Wasson refers to the screen as a technological and material entity, attached, shaped and configured within multiple networks. In her account, 'screens are not autonomous forces but intimate consorts of specific material and technological networks. Their shape, size, control buttons and positioning reflects the logics of the systems and structures that produce and sustain them' (2007, p. 73). Wasson underlines the centrality of the object of the screen in a continuously changing audiovisual culture. As she explains, 'however conceived – as institution, experience, or aesthetic – the past and the present of moving images are unthinkable without screens. Large or small, comprised of cloth or liquid crystals, screens provide a primary interface between the forms that constitute visual culture and its inhabitants' (2007, p. 69). In her argument screens have always been nodes in complex networks. Thus, in her argument the screen is a networked entity. It is not autonomous force but active agent within the systems and structures that sustain it. In her study, drawing on the examples of QuickTime and the IMAX, the small and the spectacular screen, Wasson's uses the concept 'networked screen' to favour the material and technological networks that have always defined cinema, but moreover are re-enforced in the contemporary moment of digitization.

The concept 'networked screen' suggests the screen's 'formative role in transforming celluloid, electronic and digital images into differentiated social and material sites of cultural engagement' (Wasson, 2007, p. 72). Thus Wasson does not specify the networked screen within the contemporary moment of digitization. On the contrary, her study situates the screen as being always part of complex material and technological networks that change the shape of film as an object to be circulated and also the routes it can travel, and the spaces in which it can be seen. As she states:

> Such changes in technology demonstrate that moving images have long been part of abstract systems of transport (airwaves, magnetic tape, digital discs) which have always supported the various contractions, expansions, and modifications of images themselves. Whether carried by celluloid and semi-trucks, by video discs or fibre optic cables, the packaging (or compression), the distribution, and the exhibition of moving images is intimately tied to the material specificities of the networks through which they travel, their

particular technological form, and the specific screens on which they appear.

(2007, pp. 78–79)

The screen becomes a formative component in cinema's networks of exhibition and distribution, in the configurations of heterogeneous material elements that form these networks of elements, processes, activities and working arrangements. Seeing the screen as part of these networks gives it the possibility and flexibility to change based on the configuration of multiple, circulating actors and networks.

In the conceptualization of the network as metaphor and also as transformative within different contexts, media theorist Joost Van Loon[3] states that

in contrast to a (spider's) web which is often concentric and has an identifiable centre, networks have multiple central nodes, whose centrality is not necessarily defined by its location (for example, the centre), but by the relative concentration of links. The more links make up a node, the more central the node.

(2006, p. 308)

In his tracing of the conceptualization of the term in social sciences, in the context of globalization and the Internet, Van Loon also draws on Actor-Network Theory (ANT) and explains that the concept network 'is the consequence of a (temporary) stabilization of a particular set of forces' (2006, pp. 309–310).

In ANT's vocabulary the network has been conceptualized as a device to think about objects topologically. Topology, Law explains, 'concerns itself with spatiality, and in particular with the attributes of the spatial which secure continuity for objects as they are displaced through a space' (2003, p. 4). In this sense the network is an alternative topological system, in which 'elements retain their spatial integrity by virtue of their position in a set of links or relations' (p. 4). Within ANT space is not considered to exist by itself, as part of the order of things, but rather as relational effect. In our case study, space and also distance are made, for instance by trade links, electronic connections and communication and these elements organize the space of distribution. As we have seen in the studies of practices of Curzon Cinemas, the formal theatrical presentation is dislocated from the centre of the company's distribution practices and relocated in the means of film distribution in digital,

television and computer screens. The Curzon on Demand service formulates and shapes a new kind of distributive architecture, a network for disseminating films in new spatial contexts and material platforms, which give accessibility to content outside theatrical circulation. In this case, the scale of film distribution depends on the links and connections upon which the service is been made.

The temporal specificity of the theatrical release existing in theatrical settings is annihilated by the simultaneous release on Curzon subscribers and pay-per-view viewers' different size and shape screens. The distribution of film through the Curzon on Demand service follows an itinerary along which the film might move from one site to another and from one situation to another, for instance from the static to the mobile screen. The spatial network of screens constructs a new topology, a new locale for new enactments of film. As such, the localities over which film is distributed may be geographical points within the UK but also screens in various shapes. While film appears dislocated in different technological screens and across different spaces, these are situated within new technological and spatial networks.

The inquiry about where the practices of materializing exhibition and distribution are located, how they link or differentiate from each other and how they circulate, aims to present a distinctive insight into the character of film's materiality and situatedeness. By following Mol's proposition that the new 'is' is situated, this chapter suggests that multiplicity and difference are not ascribed to film solely in this moment of transition from analogue to digital technologies. The multiple practices in which film is situated and the multiple networks through which it is related with the object of the screen, present an object that gets continuously enacted within diverse material, technological, but also financial and social assemblages of relations.

Notes

1. In particular, according to Crofts, some of the main causes that delay the take-up of digital distribution can be summarized by the analogue film's reliability as a medium, being both interoperable and universal, and the need for international standardization of exhibition specifications is still lacking in digital projection, including the conflict between distributors and exhibitors about who will meet the cost of the transition, the digital shortfall, especially in small venues such as art house cinemas, and issues related to film preservation and archiving.
2. For further discussion on the relationship between film distribution and piracy, see: Kirovski *et al.* (2003), Wang (2003), Klinger (2010), Lobato (2012).

3. Van Loon (2006) explains that a network consists of three elements, the nodes, the links and the mesh. The nodes are the points at which links are being concentrated. The links identify what is, and what is not, bound to the network. Lastly, the mesh is the overall structure of the network and gives shape and dimension to the network.

Bibliography

Crofts, C. (2011) Cinema Distribution in the Age of Digital Projection. *Post Script: Essays in Film and the Humanities*, 30 (2), 82–98.

Cubitt, S. (2005) Distribution and Media Flows. *Cultural Politics*, 1 (2), 193–214.

Cunningham, S. and Iordanova, D. (2012) *Digital Disruption: Cinema Moves Online*. St Andrews: St Andrews Film Studies.

Friedberg, A. (2006) *The Virtual Window: From Alberti to Microsoft*. Cambridge, MA: MIT Press.

Gripsrud, J. (2010) Television in the Digital Public Sphere. In: Gripsrud, J. (ed.) *Relocating Television: Television in the Digital Context*. London: Routledge, pp. 3–26.

Huhtamo, E. (2001) Elements of Screenology. *WRO Center for Media Art: WRO 01*. Available from: http://wro01.wrocenter.pl/erkki/html/erkki_en.html [Accessed: 20 May 2014].

Klinger, B. (2010) Contraband Cinema: Piracy, Titanic, and Central Asia. *Cinema Journal*, 49 (2), 106–124.

Kirovski, D., Peinado, M. and Petitcolas, F. A. P. (2003) Digital Rights Management for Digital Cinema. *Multimedia Systems*, 9 (3), 228–238.

Law, J. (2002) *Aircraft Stories: Decentring the Object in Technoscience*. Durham, NC: Duke University Press.

Law, J. (2007) Actor Network Theory and Material Semiotics (Version of 25 April 2007). *Heterogeneities.net. STS Papers*. Available from: http://www.heterogeneities.net/publications/Law2007ANTandMaterialSemiotics.pdf [Accessed: 18 May 2014].

Law, J. (2003) Topology and the Naming of Complexity. Published by the Center for Science Studies, Lancaster University. Available from: http://www.lancaster.ac.uk/fass/sociology/research/publications/papers/law-topology-and-complexity.pdf Previously published at http://www.comp.lancs.ac.uk/sociology/stslaw3.html in 1997 [Accessed: 15 December 2010].

Law, J. (2009) Collateral Realities (Version of 29 December 2009). *Heterogeneities.net. STS Papers*. Available from: http://www.heterogeneities.net/publications/Law2009CollateralRealities.pdf [Accessed: 23 January 2014].

Lobato, R. (2012) *Shadow Economies of Cinema: Mapping Informal Film Distribution*. London: British Film Institute.

Loon, V. J. (2006) Network. *Theory, Culture and Society*, 23 (2–3), 307–314.

Mol, A. (2002) The Body Multiple: Ontology in Medical Practice. Durham, NC: Duke University Press.

Musser, C. (1990) *The Emergence of Cinema: The American Screen to 1907*. Berkeley, CA: University of California Press.

Rodowick, D. N. (2007) *The Virtual Life of Film*. Cambridge, MA: Harvard University Press.

Usai, P. C. (2001) *The Death of Cinema: History, Cultural Memory and the Digital Dark Age*. London: British Film Institute.

Wang, S. (2003) *Globalization and Film Distribution in Greater China*. Oxford: Rowman & Littlefield Publishers, Inc.

Wasson, H. (2007) The Networked Screen: Moving Images, Materiality and the Aesthetics of Size. In: Marchessault, J. and Lord, S. (eds.) *Fluid Screens, Expanded Cinema*. Toronto: University of Toronto Press, pp. 74–95.

4
Catering for Whom? The Problematic Ethos of Audiovisual Distribution Online

Jonas Andersson Schwarz

Introduction

The purpose of this chapter is to make some general conclusions from recently conducted fieldwork on one of the world's most comprehensive, but also selective, communities for film swapping; I have chosen to omit the name of this community out of concern for its members. Specialist torrent sites like these are unregulated in that they are not sanctioned by the copyright industry – yet, internally, they remain highly regulated. The chapter will provide an overview and a discussion of these sites, and the way these are integrated in a wider economy of film circulation, user agency, knowledge and affects. In theorizing my findings, I will mainly draw on theories of culture and sociality outlined by Pierre Bourdieu.

First, I will describe the phenomenon of private torrent trackers. Secondly, I will discuss some of the signifying discourses that users of one such forum presented in the fieldwork. Mainly, I will criticize the ideal of a 'universal library' that many of these users invoked, by contrasting this with the heritage of self-reliance that characterizes peer-to-peer-based file-sharing. Third, the chapter will provide a theoretical discussion of how Bourdieu can be related to the field of film consumption, premised by the re-distributive and productive aspects lent to it by file-sharing networks.

Bourdieu's project aimed at getting beyond the structure/agency dichotomy. The chapter shows that different social structures exist that subjects always act in relation to. The secretive online communities around private torrent trackers can be seen as a very tangible kind of structure, which is, in turn, embedded within larger structures or *fields*

of, for example, online networking and film consumption. It is vital to emphasize that structures are constantly co-created by individuals who socially interact within them; according to Bourdieu, structures are never static, but highly mutable.

This fieldwork was partially made possible thanks to Swedish research foundation Riksbankens Jubileumsfond.

Trackers and indexes

A BitTorrent tracker is a server dedicated to coordinating communication between peers in order for them to share the decentralized, fragmented data in a torrent swarm. A tracker is normally complemented by a Web-based index, containing the small files with the .torrent suffix which act as pointers to the tracker server.[1] This index can be hosted on entirely separate servers, but many BitTorrent websites act as both tracker and index.

Trackers can be either *public* or *private*. The addresses to public trackers can be added to any .torrent file, allowing the tracker to be accessed by anyone who wishes to participate in collective file-sharing. Before it was disabled, the Pirate Bay tracker was arguably the world's most famous and extensively used public tracker; the Pirate Bay website now only operates as a torrent index.

A private tracker, conversely, is a BitTorrent tracker with restricted access, in that users are required to be registered with a website or community in order to use it. Most often, registration works by a user-invite process; users have to be invited by other users in order to access the site and share digital files via the tracker. One reason for this secrecy is to minimize the risk that anti-piracy groups would infiltrate communities and instigate legal crackdowns, but another reason is that many communities want to maintain certain standards concerning spamming and misconduct. Private trackers tend to implement rather strict rules, in order to maintain stability and reliability, and are often specialized in terms of genre and types of content.

No copyrighted materials are ever physically hosted on the trackers or in the indexes; however, BitTorrent indexes and trackers provide means to receive and send copyrighted data between users. Legally, if the servers are deemed to have this coordination as their main purpose, while having few or any other purposes, the server owners can be judged as directly aiding and abetting copyright infringement on a large scale.

Despite being accessible by means of invite-only, and remaining very elusive in terms of public presence on the World Wide Web, many of

the file-sharing communities mentioned in this article comprise thousands of users – the one which I am personally focusing on has around 30,000 users, around half of whom visit monthly; a third visit weekly; and around 4,000 visit daily. The index involves around 100,000 torrents; 75 per cent of which are movie titles, the rest are music (17 per cent) and literature (6 per cent). Around 60 per cent of these torrents are available; seeded by at least one user. However, almost all of the remaining 40 per cent of titles are inactive (that is, having no active uploaders or downloaders).[2]

Historical context

I will not go into extensive detail on the corpus of literature on fandom, subculture and youth culture here. Much has been written on this subject. Bolin (2000) and Dinsmore-Tuli (2000) have, for example, written about video film swappers; there is a whole body of work on reciprocal gift cultures; and Gray et al. have written extensively about fan cultures and their highly textual modes of exchange (2007).

Bolin (1998) researched Swedish video-collector communities in the 1990s, focusing – amongst other dimensions – on *taste* as a distinctive practice, especially since the film-swapping communities he researched were based on otherwise neglected genres such as horror, splatter and blaxploitation. His work signifies a maturation of the field of youth culture studies, as youth agency is here no longer depicted in an overly pejorative way or in an overly celebratory way. The film swappers were managing their own distribution networks, as the films they were interested in were not distributed via the regular distribution networks in Sweden, and had to be imported privately from abroad. Further distribution was achieved by copying and swapping the films, largely via postal distribution. This is reminiscent of the function that the communities listed in this chapter perform – however, these new forums perform these functions in ways that are, in technical terms, entirely new.

One of the conceptual novelties addressed by Bolin at the time was the increasing emphasis on *productive agency* among media consumers; something that was exemplified not only in the fan-built distribution networks, but also in their discursive production (fanzines, indexes and so on) which complemented the distribution networks. Since the late 1990s, a veritable explosion has taken place, regarding the capacities for citizens to take part in collective re-distribution, fan fiction and metadata compilation of this kind: the advent of file-sharing networks on the Internet.

The BitTorrent ecosystem relies on a number of *indexes* and *trackers* – overall figures are extremely opaque, but sites like Torrent-invites.com and BTRACS list a few hundred active sites[3] – some of which are *closed* (or *semi-closed*) while some are *open trackers*,[4] and *open, Web-based indexes*[5] searchable via Google. There are also specialized search engines that list torrents without being affiliated to any trackers.[6] The secrecy can be rigorous for the closed trackers, involving interview processes either via Web-based forms that users have to fill out, or via chat forums (IRC channels). Sometimes one site requires membership in other sites in order to join.

The particular tracker/index addressed in this chapter was founded in early 2005, which largely coincides with the rise of BitTorrent as a newer, largely more efficient phase of peer-to-peer (p2p)-based file-sharing, suitable for larger files such as entire movies; see Andersson (2012) for a historical overview. The convenience of being able to have Web-based, exclusive community pages adjoining the pure sharing functionality is very apparent on this particular site; the community features a range of auxiliary functions that enable users to find out more about content which they would not perhaps already be acquainted with, supplementing the plain search function with a browsing experience. Not only are there extensive discussion threads connected to each film, the site administrators also run an RSS feed in order to feature new material, as well as a curated section that has been running on a somewhat regular, monthly basis where particular themes are selected, such as 'Iranian cinema' and so on.

Methodology

In 2006, I conducted a study of file-sharers affiliated to the Swedish *Piratbyrån* forum, where I interviewed a number of users – who remained anonymous to me – via email exchange, with the purpose of letting them answer open questions at considerable length. In 2012, I conducted a similar study, this time pertaining to users of other file-sharing communities. The one in question for this chapter is a private, invite-only BitTorrent community, with its server located in Amsterdam.[7] In file-sharing circles this community is somewhat legendary, having been described (in other file-sharing forums on the Internet) as: 'the cinephile equivalent to the freemasons'; 'as far as an archive of rare films you can't do better unless you work at Cinémathèque Française'; 'it has amazing old, cult and classic movie content, and an extensive database. Apart from movies, it also has music and literature, and again, it doesn't

house ANY popular stuff that you may get on ANY general trackers'. As a means to preserve research ethics, both user pseudonyms and the actual name of this forum remain anonymous. The respondents were found by approaching several users in the online forum affiliated to the tracker and index site. Before this, the site administrators were asked for permission, as it would have been both unethical and overly risky to conduct covert research.

In my previous research on the topic of p2p-based file-sharing (Andersson Schwarz, 2013), I have looked at the way file-sharers justify their behaviour; the modes of reasoning involved, and how the arguments are structured. Here, the work of Boltanski and Thévenot (2006) was very useful, as these authors present a conceptual scheme of several interrelating modes of justification; registers that are invoked (not dissimilar to Bourdieu's concept of *fields*, see below) which are sometimes incommensurable, sometimes partially overlapping. Boltanski and Thévenot emphasize how reflexivity is always inherent to processes of justification; 'persons must be capable of distancing themselves from their own particularities in order to reach agreement about external goods that are enumerated and defined in general terms' (2006, p. 27). By treating the various modes of generalization that respondents adhered to, 'it became clear that the constraints attached to the various modes of generalization applied not only to the actors' practices of justification but also to the various analytical frameworks for understanding the social world' (2006, p. 9). For example, *statistical evidence* only lent itself to 'a form of industrial generality', whereas knowledge based on *examples* was instead valued by 'the testimony of trustworthy informants and thus relies on a form of domestic generality' (2006, p. 9). Boltanski and Thévenot observe six such 'orders' or 'economies of worth' (systematic and coherent principles of evaluation) – *civic, market, inspired, fame, industrial* and *domestic* – that all coexist and overlap, with their own criteria for assessment. The situational character of justification must be stressed; individuals 'shift from one mode of adjustment to another, from one measure of worth to another' (2006, p. 16) in a flexible way. Also, the non-essentialist nature of these registers must be underscored. Like with Bourdieu's notion of fields, each register involves its own argumentative logic – rules – but can include a heterogeneous mix of referents.

Something that I also noted in my previous research was how p2p-based file-sharing tends to involve certain barriers of entry: material ones (you have to have access to a certain material setup), knowledge-based (you have to know about networks and applications that access

them) and – as in the case of this particular community – also in terms of social reciprocity (you have to become invited, and also act in particular ways in order to maintain your ratio; see below). On early file-sharing networks and protocols (for example, Soulseek, Direct Connect, eDonkey, FastTrack, FTP) it was notable that several of the users interviewed held that they made judgements in terms of status and positioning, perhaps not overtly but at least tacitly – for example regarding the common behaviours of 'seeding' (uploading, contributing with content) and 'leeching' (downloading, making use of uploaded content). However, the BitTorrent protocol renders these practices less obvious, as it makes users simultaneously upload while they are downloading, by default. Conversely, communities like the one described here often feature internal visibility, as a listing is presented of all the torrents that your avatar has downloaded.

A similar distinction that some of the previous interviewees had made was to consider certain uses to be of a 'data-hoarding' kind (relating to simply increasing your *upload/download ratio*, or building an impressive database, somewhat regardless of what the data actually represents) or of a more 'culture-oriented' kind (making valuations based on notions of quality rather than quantity). Regarding this particular tracker in question, I came across a thread from 2007 in a Swedish online discussion forum, where one user wondered if it really was the 'right' kind of people who sought invites to it; people who were just in it 'for the buzz of exclusivity' were occupying space for 'real cinephiles' who would – implicitly – be more deserving. It should be noted that open trackers do not involve ratio systems and should be expected to lessen the need for such distinctions, but both Direct Connect, FTP servers and closed trackers still rely more heavily on ratios and invites for example.

Regarding the users of this particular site, I thus had several hypotheses about them – not least since I had personal experience, ranging back to 2006, from this tracker, knowing about the highly selective nature of content and strict rules to its setup. All usage on it is built around the common practice of an upload/download ratio – with the added qualitative requirement that far from any content will be allowed. Further, any form of disruptive behaviour results in a warning, after which the user will be banned for any offence. In order to maintain its high-quality, cinephile profile, the site incorporates a content policy that is (in)famous in the file-sharing world, outlining detailed rules for what content is allowed with rather extensive requirements in terms of filenames and other metadata. As the site is an attempt to collectively build one of the world's most comprehensive libraries of cult,

classic, documentary, experimental, non-Anglo-Saxon, art-house and rare movies, and encourage custom creation and translation of subtitles for such movies, my expectation was that the users of such a site would be particularly motivated in this area.

Hence, I expected these users to be culturally knowledgeable, highly discerning and to each have quite extensive amounts of content in collection. Further, I expected they would be skilled in terms of finding content, and consider it to be easily found; that they would be more meticulous in regard to content than most other media consumers, and occasionally express pejorative attitudes towards non-members. I expected them to appreciate the various auxiliary functions of this website. Additionally, I had the presupposition that they would be rather driven, pragmatic individuals, 'getting hold of what they want when they can get it', so to speak.

Findings

Most of my presuppositions turned out to correspond with the users I interviewed. However, I could sense a contradiction in that much of the discourse invoked a rather highfalutin ideal of a 'universal library', which clashes with the requirement that access on sites like this is, after all, only granted to knowledgeable, skilled individuals. Further, this was seen in the approach to the auxiliary functions of the tracker; some interviewees did appreciate such functions, but appeared to be so self-directed and self-reliant that they personally saw some of these functions as rather superfluous.

Eight conclusive interviews were conducted, each such interview involving seven to eight questionnaires. The respondents all turned out to be male, and all appeared to have a rather specialized approach to both media consumption and technology. Tellingly, several of them rejected the notion of having 'specialized knowledge' in terms of file-sharing, Internet or computers in general, and preferred to see themselves as 'technologically literate' or 'average'. Judging from their answers, a relatively high familiarity with technology and the ecology of online file-sharing was manifest; however, their technical skill and knowledge did not appear to be as extreme as that of hackers or software programmers.

Their level of reflexivity seemed rather high. First of all, the response rate was much higher in this forum than in forums related to other, more open trackers/indexes.[8] The respondents were sometimes keen to write very long answers: one of them was a media student and referred

to concepts such as 'outlaw heterotopias'; another one was also a student and referred to Baudrillard in one answer, libertarianism in another one, and later blogged about aspects of our interview. One respondent was an occasional activist, keen to question established notions of culture and property. Another respondent wrote a page length of text on independent movie distribution in Zagreb, Croatia, where he resided. Most of the respondents were able to scrutinize critically their own behaviour and opinions. A shared justificatory trope was the emphasis on *unstoppability*, and – in the case of this forum, even stronger than in previous accounts – an emphasis on *improvement in access* and hence *emancipation*, especially for people in poor countries or rural areas.

> If you live out in the middle of nowhere but can communicate with other people who love Jess Franco films or obscure b&w movies from the 1930s, it feels great.
>
> (DT, 54yrs, UK)

Some key differences were found between the users of this tracker and other users interviewed: not surprisingly, the users of the cinephile tracker were more likely to actually buy and collect films, whereas other file-sharers previously interviewed were less likely to pay for films, television, music and/or games. These file-sharers also tended to invoke things like *ease of use* and *convenience* more, whereas the cinephile users tended to invoke the *library* metaphor.

I will now turn more specifically to this trope, as this was one of the more telling particularities found. In general, all of the cinephile respondents held that their viewing habits and taste had become broader, more experimental since they had begun file-sharing. One respondent (CI, 30yrs, Germany) meant that this breadth had at the same time made his devotion more shallow, while another one (EC, 23yrs, India) held that his entire view of the world had deepened. The following is indicative of how habits and taste seems to become more self-directed:

> It was easy at first, became difficult as my tastes started expanding. It was necessary to start going private once I became interested in more niche cinema. Once I realized truly organized and sustainable communities existed to keep extensive libraries, it quickly became a lot easier. I'm uncompromising with regards to my cultural tastes, and finding everything I am interested in would be financially impossible. I buy something if I can't find it on any tracker.
>
> (YG, 20yrs, USA)

While the last sentence could be questioned, two themes that were central to many of the respondent accounts are hinted at: the emphasis on a *library function* and a heritage of *self-reliance*. Interestingly, both of these concepts can be found in the Open Source community and its 'hacker ethic' (Himanen, 2001; Levy, 2001; Wark, 2004). The hacker ethic is characterized by an ideal of systemic openness and universal libraries, paralleled by a meritocratic impulse; an awe of highly functional systems, serving the interest of large, even global communities. One could make the argument that such meritocracy (found both among hackers and in academia) fosters a 'brokered' form of collectivism, societal awareness and ultimately a sense of duty, mainly by channelling subjective opportunism to more utilitarian ends. Yet, in the particular setting of illegal, semi-hidden file sharing, this emancipation is nevertheless compromised – as the functioning of the system does rather little to ameliorate the fact that you have to rely on yourself, and that the world remains a 'dog-eat-dog' place, where adaptable individuals are rewarded.

Of course, the cinephile forum members would subscribe to an ideal where these conditions should be ameliorated, but, tellingly, such functionality – an editorial function that serves to advertise the existence of cultural content, enthuses audiences, and serves to educate those who desire to learn more – is, in the world of torrent trackers, rather secondary to the function of mere distribution. Such auxiliary functions are found on this particular site, but the users interviewed displayed a rather lukewarm opinion of these, as they personally seemed to get by rather well without those particular functions. Nevertheless, of course they relied on auxiliary metadata and advice from other users, but this was attributed to the world outside; the mass media in general and the Web in particular. It is important to note how this extraneous knowledge is in fact attributable to a wider sphere, or field, than the site itself.

A structure within a structure

Sites like the one under study could be seen as manifestations within the broader fabric of file-sharing as a mode of distribution of digitized information. Here, it is noteworthy to see two layers of information exchange, which current copyright legislation helps to separate:

A. One layer of legally allowed information-about-artworks; *metadata* which is found in Web-based indexes such as Wikipedia, IMDB, Discogs and so on, alongside snippets, trailers and excerpts that

are not seen as encroaching on the copyrighted artefacts, such as Youtube, iTunes and Amazon clips.

B. Parallel to this layer is the *actual distribution* of the copyrighted artworks, which either has to be sanctioned by payment of some kind or otherwise illegally managed.

As Star and Bowker (2002) have pointed out, infrastructure is *embedded*, *transparent* and *becomes taken for granted* in the sense that it is starts out as a practice which is extraordinary at first, becomes learned by continuous use and successively made mundane. Further, Star and Bowker argue, that it links with conventions of practice and becomes an embodiment of standards. Following this reasoning, layer A is common – to the point of invisibility – to most Internet users, whereas the currently illegal dimensions of layer B are familiar to a select few – those who are familiar with file-sharing – whereas it remains exotic to other groups of users, due to its surreptitious nature. Elsewhere (Andersson, 2012) I have argued that the group who would find file-sharing natural is, however, considerably large – especially among knowledgeable Internet users. In looking at the private trackers listed above, the total amount of users still range in the hundreds of thousands. Thus, private torrent trackers of this kind are only interventions when seen through the prism of legal stipulations. In a technical sense, they can in fact be entirely expected, since the Internet has been based on decentralized duplication of data files from the outset.

Hence, what was seen in the respondent answers was that there exists a constant diffusion between the allegedly 'closed' private tracker (and its adjoining Web community) and the surrounding Internet and, in turn, the wider world. However, when attributing the site to an ideal of a 'public library', one could ask whether it is problematic that this archive is – manifestly – not for everyone. It seems like copyright is not the only reason for secrecy; integrity of content is another one.

> Speaking about the 'inequality', I think it is a good idea that [the tracker in question] is not open to the public, since it is just not possible that every person will appreciate this library and will not try to deface/harm the contents or existing members of this library.
>
> (OA, 22yrs, India)

If copyright were abolished and [the tracker in question] were suddenly to become open, the quality of uploads would probably decline

and you may have less reliable seeders (and user dependability for reseeds is the functional crux of the site).

(YG, 20yrs, USA)

For its users, the world is permeable; they shift through registers of knowledge management and draw on layer A in order to access layer B. For the non-users, the site is closed, open to members only – layer B is literally fenced off.

Following the logic of Bourdieu, a social field is to be considered an objective structure, that subjects relate to by way of incorporated structures – those of the *habitus* (1998, p. vii). We should not equate the site in itself with a field; rather, the site forms part of individual users' habitus, enabling them access to the wider field of film fandom. Access is granted by way of incorporating a habitus that involves certain degrees of cultural capital (knowing about the site, knowing the codes), technical capital (having the right gear and technical ability) and social capital (knowing the right people).

Fields, according to Bourdieu, are relationally defined. The field is constituted by struggles between interested agents over the distribution of capital; capital that, correspondingly, finds its value only in relation to the particular field in question. The struggles always relate to who should have access to the specific authority that is distinctive to each field – and the monopoly of (symbolic) violence that this entails. This structure – the state of affairs – is always contested, in flux. The field is (re)constituted every time a newcomer tries to enter the field of relations, or challenge the status quo, as *heterodox* behaviours act to expose that which is *orthodox*. However, in order to challenge the existing doxic beliefs within the field, any newcomer is forced to take the field seriously, as well as learning its rules (Bourdieu, 1991, pp. 127–128).

The field is thus defined by detailing what conflicts there are, and what specific interests exist. It is not exhaustively defined solely by the infrastructures of access (such as the building that a library is hosted within, or the actual bookshelves) but such infrastructures and material practices are central constituents to the way the field is constituted. Nevertheless, Bourdieu shares the constructivist assumption (found in, for example, Saussure) that the object is created by the point of view; the delimitation of the field is thus an analytical one (Vandenberghe, 1999, p. 44). The invisible system of relations does not exist in itself; it only manifests itself empirically in the real world thanks to the intervention of the habitus, which 'realizes' the theoretical system of constructed relations (p. 42). Despite largely avoiding the question of ontology,

Bourdieu in fact shares an epistemological tradition with actor-network theory in that his theory strives to 'untangle' those relational configurations that saturate everyday life. While 'everyday essentialism' naturally reifies what are really relations into substances, 'the rationalist (or realist) construction of the theoretical objects as "bundles" of relations is inherently linked to a relational mode of intellectual production' (Vandenberghe, 1999, p. 43).[9]

Reflexive objectivation

Bourdieu advocated a wary approach to actors' subjective accounts (Swartz, 1998, pp. 56–58). Like so, Boltanski and Thévenot (2006) become useful when criticizing consumers' arguments rather than simply acclaiming them. Discourses act to legitimize certain behaviours, often against better evidence. Take, for example, the common assumptions that serve either side of a convenient dichotomy: either it is stipulated that file-sharing would simply replace sales – or it is said that unauthorized sampling actually feeds legal purchases. While the former assumption can be ruled out by invoking Lessig's simple observation that there are at least four scenarios to everyday downloads of file-shared content, only one of which being clearly harmful to producers (2004, pp. 68, 296–297), the interviews indicate that it is not as simple as the latter assumption would have it either:

> Let's be honest, if you're uploading the latest DVD it impacts on the number of sales it will get. That's not to say everyone who downloads would have bought it. And some people might buy anyway if they like it. But it makes it more difficult for small production companies. That's why I like the rule at [10] where you can't upload a DVD or movie until 12 months after release. It gives the guys a bit of breathing space. Though to be honest, you'd probably get it from somewhere else.
>
> (DT, 54yrs, UK)
>
> I certainly never buy what I have on my harddrive. Especially when you can download full DVD images.
>
> (YG, 20yrs, USA)

When deliberately provoking one of the respondents, by asking whether there is a risk that movies and TV shows acquired through file-sharing would not be watched or purchased once they are commercially released

(as the fans would already have got them on their hard drives) he responded:

> I would think so, but statistics don't seem to indicate that. But I would not go to the cinema to watch a movie that I have already downloaded.
>
> (CI, 30yrs, Germany)

This makes for a telling illustration of Bourdieu's point, regarding the objectivity of constructed statistical reality 'out there', and the lived, subjective experience that respondents simultaneously make reference to, almost as if using personal experience to make up for the 'hard facts'. CI seems to admit that the facts would speak for themselves, but at the same time be rather incongruous with everyday experience. One could call it a *domestic* mode of reasoning taking precedence over an *industrial* one. This is clearly problematic. As C. Wright Mills once remarked, a person's account of what motivates him should never be taken at face value:

> When an agent vocalizes or imputes motives, he is not trying to *describe* his experienced social action. He is not merely stating 'reasons.' He is influencing others – and himself. Often he is finding new 'reasons' which will mediate action. Thus, we need not treat an action as discrepant from 'its' verbalization, for in many cases, the verbalization is a new act.
>
> (1940, p. 907)

Bourdieu provides a way out of this by invoking 'participant *objectivation*' (emphasis added) as this involves critical reflection and empirical inquiry on the social and epistemological conditions that make possible a sociological view of the social world (Bourdieu and Wacquant, 1992, p. 68, in Swartz, 1998, p. 58). Pondering on the probable consequences of one's actions is always done by an individual tethered to his/her bodily disposition and incorporation into the fields of which he/she is part (habitus). The questioning of norms is not done by an agent who is merely performing a rational calculation of mind; bodily dispositions, habits and subconscious affects make part of this reasoning too.

The self as glorious exception

The respondents generally appeared to be rather active, productive consumers. One of them had experience of subtitling movies, others had

participated in activism, amateur music production and blogging. When I asked about the reasons (besides the obvious, functional ones) for keeping the community so closed, one respondent answered:

> It enhances a sense of community, of togetherness. Also helps to build a sense of snobbishness. Our taste is better than other people's. I kind of mean it in a positive way.
>
> (DT, 54yrs, UK)

When prompted with the notion of 'extreme behaviour' they however distanced themselves from this, locating this with other users rather than with themselves. Some respondents pointed out that 'serious users', individuals who hoard data, in fact serve to benefit the community. One user once again invoked the library metaphor, in order to criticize my reference to 'extreme users':

> Not sure what you mean with extraordinary, extreme users. I'm glad that some people are dedicated hoarders (ok, call them collectors) and keep huge amounts of content and share it with me and you. Again, would you say that a public library with many many book[s] is an extraordinary, extremist institution?
>
> (UE, 40yrs, Netherlands)

> Again, I don't have a problem with elitism as a concept. The entire idea of a private tracker is elitist, but within it, things are as egalitarian as could be.
>
> (YG, 20yrs, USA)

While almost all respondents agreed that one is very grateful at first, when starting out, many of them noted how a more veteran approach seems typical for many specialized file-sharers:

> This can lead to different psychological effects, such as the perception that everything artistic is neutral. When nothing becomes hard to get, the value of art decreases substantially. Even more insidious is the perception that because massive archives exist and are accessible at any moment, there is no need to watch anything.
>
> (YG, 20yrs, USA)

Does this experience of having access to superabundance entail a form of exceptionalism, or even a sense of omnipotence? For this user (himself apparently a competent reader of Baudrillard and Bataille) the reflection on such issues seemed to come rather naturally. He admitted to the

exceptionalist yet pragmatist reasoning behind his own behaviour – bordering on the cynical:

> Personally, I don't justify my use politically. In many ways I consider myself to be above the law, even though I acknowledge that if everyone were to take the same actions there may be negative consequences for the cultural economy. It is also obvious to me that I occasionally deprive independent publishers of their due. I think of myself as set apart from the masses insofar as I grant myself the freedom to view anything for my own benefit and knowledge. This may be elitist and unjustified, but at least it is honest, and anyone who continually talks about the utopian potential of P2P is partially fooling themselves.
>
> (YG, 20yrs, USA)

Another user similarly described his own use in very confident terms:

> there is hardly anything i need that i can not find. or to say it the other way around: if i don't find it there, there is a good chance it does not exist.
>
> (CI, 30yrs, Germany)

To me, this appears as a heuristic where one sees oneself as the exception; knowingly breaking the law occasionally, in the confidence that one's personal norms proscribes any wider misuse. It is somewhat similar to the notion that 'I can sometimes run a red light – but if everyone else did, it would be chaos.' This actually evokes the ethical aspect of law: the malleability that norms and morals allow, but that law as a binary system of code does not allow for. It reminded me of how the actuality of *praxis* frequently dispels the myth of law as *logos*, especially when it comes to file-sharing. This aspect of praxis can for example be noted in the courts' interpretations of law, like in the Pirate Bay rulings of 2009 and 2010 where the extent of 'single purpose' was assessed to be significant enough to motivate a guilty verdict. In such examples, the flexible interpretation of law takes precedence over binary categories such as whether any actual copyrighted files are hosted on Pirate Bay servers or not.

Further, this type of reasoning occurs in discussions of improvements of law (*lex ferenda*), as well as in the examples noted above – an everyday heuristic, guided by soft determination (norms, morality, behaviour). What is common to these praxic aspects of law is that they simply have to be reflexive. In the 'red light' example, allowing for behavioural

flexibility of this kind – 'I only run a red light when I've assessed that the situation is totally safe, and my doing so hence being justified' – is an extremely common behaviour, with all the psychological potentials for self-delusion there is to such a thing; subjective assessment is extremely viewpoint dependent. Like so, the potential side-effects of file-sharing are in many ways hidden from view. This was nevertheless accounted for in some of the answers, in that several respondents at least strived towards a high degree of objectivity, assessing potential scenarios and outcomes. Ratio systems can be viewed as boons to such reflexivity, as they require the user to think more strategically about his/her downloading. Yet, the question still remains: Is this critical reflection enough? Does it outweigh the various temptations manifest in file-sharing? Does it outweigh the convenience and ease of access?

Universalization is the strategy of legitimization *par excellence*, Bourdieu (1998, p. 143) has argued. A critical disposition towards the wider economy of cultural exchange (that is, the cultural industries governed by copyright) demands that the subject formulating this critique is guided by a *libido virtutis* (p. 145), an idea of a universal good, transgressing the temporary vagaries of, for example, copyright law. But as any good sociologist would know, such universal principles are always generated situationally, coloured by the subject's own position and perspective.

All members of social groupings employ references to higher principles in their recurring hypocrisy. 'White lies', 'deceptions that deceive no-one' are dutifully employed by representatives and accepted by the group 'because they contain an undeniable declaration of respect for the group's rule, that is, for the formal universal principle (universal since it applies to each group member) that is constitutive of the group's existence' (Bourdieu, 1998, p. 141). A smaller sin is excused, even wholly ignored, if it is seen to prevent a bigger sin. Yet, Bourdieu quips, those who wish to criticize hypocrisies ultimately have to rely on invoking still higher principles as well. Besides revealing the vagaries of second-order reflexivity (critically reflecting on other people's own reflections) the argument reveals the paradoxes of justification – we can only criticize hypocritical claims to universality by yet more invocations to universality.

Conclusion: Bourdieu among the file-sharers

Regarding the online cinephile community in question, a very direct morality is embedded in the infrastructural setup, exerting a hard

determinism: regarding the fields of consumption-production of film in general, my respondents expressed a knowing disobedience, a strategic disavowal from the legal norms of official society – but, simultaneously, an internalization of the norms of the file-sharing world, and the field of film fandom (two fields that, more often than not, seem to overlap). Participating takes a certain strength of mind: one has to be very committed, as the user is most likely committing a crime (or at least supporting criminal behaviour) and the user has to have a very clear conviction that persisting in doing so is the right thing, despite what could happen if found out. Further, the user has to consider the potential that the behaviour would indeed be damaging to the very industry the user is partially reaping the fruits of, even embracing.

Without a doubt, the infrastructural setup accommodates such convictions; to those with the right habitus, it is permissive. The ease and convenience of it is hard to refute. Indeed, the deliberate infrastructural limitations (ratio systems and the like) are not there to preclude file-sharing. Instead, they address the common tendency of over-affirmation, over-grazing. Their role is to be dissuasive of excessive abandon.

Thus, we could read the action taking place in closed file-sharing communities as twice determined. First, behaviour is guided by some very tangible restrictions embedded into the local infrastructure; second, it is guided by the softer determinism exerted by the doxa and norms of the field that action is embedded within. Like Mead (1934) and Wittgenstein (2001), Bourdieu can be said to characterize everyday life as a game. To learn the rules of the game is, at once, a way of becoming individual and becoming social, while rules do not define outcomes in a simple causal way – they can be subverted. Outlining everyday determination as a game which one has to play, or as a number of strategies and tactics that can be employed (de Certeau, 1984) helps to outline a model of hegemonic struggle without succumbing to determinism. 'Games define the players' range of action without determining their moves' (Feenberg, 1999, p. 112).

It has been argued that Bourdieu tends to view radical political activity and movements as an exception to the rule, even as an exception to his own theory (Crossley, 2003). This posits Bourdieu's theory as being rather opposed to activism in the traditional sense, but regarding more novel forms of 'subactivism' (Melucci, 1989; Bakardjieva, 2009) the jury is still out. File-sharing illustrates how subactivist activity is brought up and formulated into activism as such, by novel social movements (Andersson, 2011). Crossley (2003) has argued that Bourdieu's theory

can be applied to social movements – especially, Crossley argues, when the theory focuses on moments of *crisis*. Crises act to bring up legitimations that are otherwise taken for granted; they act to call doxic beliefs into question. Similarly, Boltanski and Thévenot (2006, p. 359) focus the role of *public affairs*: a case where a group of people are constituted as the object of an accusation, and/or subject to legal charges. A public affair tends to designate the actors involved as representatives or potential spokespersons for the collective which they are thought to represent. It forces subjects to formulate positions and invoke (perceived) universals.

Crossley (2003, p. 52) notes that only a very small percentage of the population engages in activism; he asks whether these people might be more disposed towards having a 'radical capital' or 'involvement in political environments generates a motivation towards further involvement' (2003, p. 52). This could explain why some people choose to participate in movements that act to pursue 'public goods' – that is, goods that all members of a particular community will benefit from, whether or not they participate in the work required to bring it about. Such behaviour would be problematic from a perspective based on rational action theory, because such theory holds that all 'rational' agents would be motivated to abstain from participating, as they benefit from these goods regardless of participation. What becomes rather clear when analysing file-sharing sites is that considerable 'resource mobilization' (Crossley, p. 56) is required for instigating and running such sites and forums. However, to be a member can – given the sufficient accumulation of personal habitus and capital – be as easy as 'the click of a button'. This chapter has shown how problematic it is to transfer this ease onto other the assumed behaviours of other people: far from everyone has the capital and habitus to access these sites.

Many of the respondents invoked the 'universal library' metaphor. But the accuracy – and, by extension, political efficacy – of doing so should be questioned. When file-sharing movements defend themselves by invoking this library role, arguably there is stronger political acuity in the ways in which this invocation illustrates the shortfalls of the current copyright regime, rather than as testament to any alleged altruism of the actual sites in question.

Notes

1. More recently, however, 'trackerless torrents' have been introduced, rendering the use of a tracker server unnecessary (this was the case when The Pirate Bay decided to discontinue their tracker function in 2009).

2. These figures are all according to the site's own statistics.
3. In late 2012, BTRACS listed 589 trackers; Opentrackers.net (which lists both open and private trackers) listed 188 trackers.
4. For example, 1337x.org, H33t.com, TorrentBox.com, PublicBitTorrent, OpenBitTorrent.
5. For example, The Pirate Bay, 1337x.org, H33t.com, TorrentBox.com.
6. For example, isoHunt, ExtraTorrent, Kickass Torrents, Torrentz.
7. The WHOIS record of the site shows the server location as being in the Netherlands, while the site owner/administrator is registered at an address in Romania. The email address registered with its Paypal account for donations is a Yahoo address.
8. Out of 32 users approached, 16 responded. Out of these 16, eight people went through the entire interview process.
9. For a further discussion of Bourdieu as a relational theorist, see Potter (2000); Swartz (1998: 61–64); Vandenberghe (1999).
10. Another cinephile tracker/community that I have chosen to anonymize.

Bibliography

Andersson, J. (2011) The Origins and Impacts of the Swedish File-sharing Movement: A Case Study. *Critical Studies in Peer Production* (CSPP), 1 (1).

Andersson, J. (2012) Not Necessarily an Intervention: The Pirate Bay and the Case of File-sharing. In: Howley, K. (ed.) *Media Interventions*. New York: Peter Lang.

Andersson Schwarz, J. (2013) *Online File Sharing: Innovations in Media Consumption*. London and New York: Routledge.

Bakardjieva, M. (2009) Subactivism: Lifeworld and Politics in the Age of the Internet. *The Information Society*, 25 (2), 91–104.

Bolin, G. (1998) *Film Swappers: Video Violence, Cultural Production and Young Men*. [*Filmbytare. Videovåld, Kulturell Produktion och Unga Män]*. Umeå: Borea.

Bolin, G. (2000). Film Swapping in the Public Sphere: Youth Audiences and Alternative Cultural Publicities. *Javnost – The Public*, 7 (2), 57–74.

Boltanski, L. and Theivenot, L. (2006) *On Justification: Economies of Worth*. (Trans. Porter, C.) Princeton, NJ and Oxford: Princeton University Press.

Bourdieu, P. (1991) Några egenskaper hos fälten. In: *Kultur & Kritik: Anföranden av Pierre Bourdieu*. (Trans. Stierna, J.) Göteborg: Daidalos. [Originally a lecture in November 1976 at École normale supérieure, rue d'Ulm, Paris, published as 'Quelques Propriétés des Champs' in *Questions de Sociologie*, 1984, pp. 113–120.]

Bourdieu, P. (1998) *Practical Reason: On the Theory of Action*. (Trans. Johnson R. et al.) Oxford: Blackwell Publishers.

Bourdieu, P. and Wacquant, L. J. D. (1992) *An Invitation to Reflexive Sociology*. Chicago, IL: University of Chicago Press.

de Certeau, M. (1984) *The Practice of Everyday Life*. (Trans. Rendall, S.) Berkeley, CA Los Angeles, CA and London: University of California Press.

Crossley, N. (2003) From Reproduction to Transformation: Social Movement Fields and the Radical Habitus. *Theory, Culture & Society*, 20 (6), 43–68.

Dinsmore-Tuli, U. (2000) The Pleasures of 'Home Cinema,' or Watching Movies on Telly: An Audience Study of Cinephiliac VCR Use. *Screen*, 41 (3), 315–327.

Feenberg, A. (1999) *Questioning Technology*. London: Routledge.

Gray, J., Sandvoss, C. and Harrington, C. L. (eds.) (2007) *Fandom: Identities and Communities in a Mediated World*. New York: New York University Press.

Himanen, P. (2001) *The Hacker Ethic and the Spirit of the Information Age*. London: Vintage.

Lessig, L. (2004) *Free Culture: How Big Media Uses Technology and the Law to Lock down Culture and Control Creativity*. New York: Penguin Press.

Levy, S. (2001). *Hackers: Heroes of the Computer Revolution*. London: Penguin Books. [Originally, 1984.]

Mead, G. H. (1934) *Mind, Self & Society: From the Standpoint of a Social Behaviorist*. Chicago, IL: University of Chicago Press.

Melucci, A. (1989) *Nomads of the Present: Social Movements and Individual Needs in Contemporary Society*. Philadelphia, PA: Temple University Press.

Mills, C. W. (1940) Situated Actions and Vocabularies of Motive. *American Sociological Review*, 5 (December), 904–913.

Star, S. L. and Bowker, G. C. (2002) How to Infrastructure. In: Lievrouw, L. and Livingstone, S. (eds.) *The Handbook of New Media*. London, Thousand Oaks, CA and New Delhi: Sage Publications.

Swartz, D. (1998) *Culture and Power: Sociology of Pierre Bourdieu*. Chicago, IL: University of Chicago Press.

Vandenberghe, F. (1999). 'The Real is Relational': An Epistemological Analysis of Pierre Bourdieu's Generative Structuralism. *Sociological Theory*, 17 (1), 32–67.

Wark, M. (2004) *A Hacker Manifesto*. Cambridge, MA and London: Harvard University Press.

Wittgenstein, L. (2001) *Philosophical Investigations* (Trans. Anscombe, G. E. M.) Malden, MA, Oxford and Carlton: Blackwell. [Original, 1953.]

Part II
Under the Spotlights: Promotion

5

1-18-08 – Viral Marketing Strategies in Hollywood Cinema

Stephanie Janes

Introduction

Viral is a term now commonly used to describe entire marketing campaigns, or elements of promotional strategies for any number of consumer goods, services and media products. This chapter will focus particularly on Hollywood's use of viral marketing, notably, more complex viral campaigns which encourage immersion in and interaction with the world of the film before, during and after viewing; allowing the viewer to shape, or at least appear to shape, their cinematographic experience. It will suggest that viral campaigns mark a shift away from what Justin Wyatt (1994) calls 'high concept' filmmaking and marketing. Campaigns for films such as *The Blair Witch Project* (Sanchez and Myrick, 1999), *Cloverfield* (Matt Reeves, 2008), *A.I.: Artificial Intelligence* (Steven Spielberg, 2001) and *The Dark Knight* (Christopher Nolan, 2008) demonstrate a change in the relationship between producer and consumer to a point where producers encourage consumers to be active, rather than passive, by withholding information on forthcoming releases and daring consumers to follow trails of online clues to get at the information. This move to encourage agency, or the appearance of agency, in the cinematographic experience is often discouraged in other areas of the industry, for example, distribution. This chapter therefore questions the motives behind such elaborate online campaigns, arguing that the deliberate positioning of the viewer as investigator is accompanied by an extension of the filmic world (as opposed to simply an extension of narrative online) to produce a seemingly immersive experience. This can be, but is not always, reflected in the aesthetics of the film itself, and can transform a piece of marketing material into an entertainment experience in its own right.

Defining viral marketing

The term 'viral' is one that has only recently become a part of our everyday media vocabulary. No longer confined to diseases or computer bugs, anything from advertising campaigns to dancing hamsters and videos of cats playing the keyboard have been described as having 'gone viral'. But, when we attempt to define what 'viral marketing' is, it becomes clear that the meaning of this now familiar phrase is somewhat blurred.

One reason for this is that 'viral marketing' tends to overlap with related concepts such as 'buzz' or 'word-of-mouth'. Some definitions specifically attach it to online marketing campaigns, for example: 'A high tech and "impersonal" variation on word-of-mouth ...an Internet-driven strategy that enables and encourages people to pass along a marketing message' (Mohr, 2007, p. 297). Others are more generalized, defining 'viral' as any strategy which 'encourages individuals to pass on a marketing message...creating the potential for exponential growth in the message's exposure and influence' (Chad and Watier, 2001).

What can be agreed is that the term was not significantly used before the 1990s, and so is, at least chronologically, associated with the growth of the Internet as a public and commercial communications network. The implications of the word 'viral' also separates it from the term 'word-of-mouth' as it suggests that the marketing message spreads as quickly as a biological or computer virus, again linking it to the high-speed communications offered by the Internet. One may surmise that viral marketing includes, but is not limited to, online marketing, and that equally not all online marketing can be termed viral.

There is also a general consensus that the key to viral marketing is 'getting customers to pass along a company's marketing message to friends, family and colleagues' (Lauden and Traver, 2001, cited in Dobele et al., 2007, p. 74). This has become easier in the Internet age. The informality of email and the centrality of social networking sites in the lives of many consumers have provided individuals with extensive numbers of friends and friends-of-friends, whose interests we might be familiar with and to whom we might recommend, via a hyperlink, a website, a funny video, a clever advert and so on. The emphasis is on understanding consumer–consumer relationships and knowing your audience well enough to predict their referral behaviour. A working definition of viral marketing could therefore be a marketing strategy which encourages consumers to pass on a message to others, usually, but not necessarily, using the Internet to do so.

Hollywood and online marketing

Viral marketing therefore has strong links with word-of-mouth publicity, which has always been crucial to selling a movie, but with the emergence of blogs and public review websites more people can share more opinions faster than ever before. Yong Liu also suggests that it is not even the quality of the word-of-mouth (that is, negative or positive) that counts; the mere volume of online 'chatter' about a film can be linked to box office revenue (2006). The problem with online word-of-mouth is that it is impossible to control completely and, although Liu's study suggests otherwise, there is evidence to suggest the industry still fears the influence of negative word-of-mouth, particularly from certain demographics such as teenagers (Neuborne, 2001). As a result, Hollywood has often viewed the Internet as a battleground for intellectual property (IP) rights, rather than as a communicative link to its audiences. Well-documented confrontations include Warner Bros.' attempt to close down fan-created *Harry Potter* websites, and New Line's more friendly approach of collaborating with a select number of *Lord of the Rings* fan sites, offering content to be circulated by fans rather than through official channels.

The industry's initial forays into online marketing demonstrated either a disinterest in or lack of understanding about the interactive capabilities of the medium, leading J. P. Telotte to describe early promotional film websites as little more than 'electronic posters' or 'press kits for the digital age' (2001, p. 34). Promotional film websites have existed since the birth of e-commerce in around 1993 (Craig, 2005, pp. 329–330), but if one takes a sample of Hollywood films released between 1996 and 1999[1] it becomes clear that film websites varied in terms of quality, content and interactivity. For instance, the site for *Saving Private Ryan* (Steven Spielberg, 1998) is fairly sparse, with information about the cast and crew, basic details of the story and information on the official book (DreamWorks SKG, Paramount Pictures Corporation, Amblin Entertainment Inc., 1998). Other sites, like the website for James Cameron's *Titanic* (1997), take more advantage of the interactivity provided by the Internet, encouraging users to 'tour the ship'. The *Titanic* site offers video clips, character profiles, interviews with cast and director and details on the history of the Titanic (Twentieth Century Fox/Paramount Pictures, 1997). In contrast, the website for *Twister* (Jan de Bont, 1996) poses as the site for the 'Severe Weather Institute Research Lab' website, calling for the user to join them as a 'storm chaser' via a newspaper advertisement. It then offers a variety of

information on tornadoes which the user will require to pass the 'storm chaser test' (Warner Bros. and Universal Pictures, 1996).

As Telotte highlights, all these sites point away from their own entertainment value and towards 'the film experience ... situating their films in the context of the film industry and pointing to the entertainment power of the movies' (2001, p. 34). The only site that works slightly differently is *Twister*'s. By posing as a real site for a fictional institute within the film, the user is briefly removed from their role as a consumer and is invited into the world of the film to participate as a 'storm chaser'. More obvious promotional information such as cast interviews and stills are available, but links are in a smaller font at the bottom of the page. This information clearly takes a back seat to the storm chaser game. The site is a piece of entertainment in itself and thus a different kind of promotional tool. This may be an earlier and more basic example of the kind of online marketing widely regarded to have started three years later with *The Blair Witch Project* (Sanchez and Myrick, 1999).

Blairwitch.com marked a radical departure from the promotional website as electronic press kit. It positioned the film as a piece of found footage, discovered after the disappearance of three film students in the woods near Burkittsville, Maryland. It offered information on the missing students, positioning the viewer as investigator and directing them back to the film as the final piece of the puzzle. The innovative website was given almost full credit for the financial success of the film (Lyons, 1999, pp. 7–8), which had an initial budget of US$35,000 and took US$1.5 million in its opening domestic box office weekend across a mere 27 screens (Maiese, 2000).[2] Taken as proof that more creative online marketing could seriously affect box office revenue, it placed web campaigns significantly higher on the agendas of media conglomerates.

Blairwitch.com could be taken as an example of an early viral site. Users were encouraged to investigate the case of the missing film students, with the site updating with more information as the release date drew closer. The positioning of the film as found footage shot by the students even had some viewers confused as to the reality status of the film (Schreier, 2004). This not only recognizes an active rather than a passive consumer, it relies upon the consumer to tell others about the website in order to perpetuate this reality premise, a key part of the marketing message.

This acknowledgement of an active viewer is also a movement away from previous Hollywood filmmaking and marketing trends, the most prominent being what Justin Wyatt terms 'high concept' (1994). Wyatt considers marketing strategies in the decades directly before the

emergence of the Internet, positing a connection between economics and film aesthetics. He argues that by recognizing the impact of industrial and economic forces on the industry we can see the emergence of a particular style of filmmaking in the 1970s and 1980s. High concept can be viewed as a form of product differentiation, characterized by 'an emphasis on style within the films and ... an integration with marketing and merchandising' (1994, p. 7). High-concept films are identified by straightforward, easily summarized plots, notable stars, a strong match between image and soundtrack and pre-sold property. They also display a 'reliance on bold images' which 'reinforces the extraction of images for marketing and merchandising' (p. 17). Thus high-concept films are produced with a specific aesthetic in mind: primarily visual and striking, which Wyatt links to the design of contemporary goods advertising (p. 23). Finally, Wyatt argues 'the modularity' of the film's units and one-dimensional characters distance the viewer from the traditional task of reading the film's narrative. Instead, the viewer becomes 'sewn in to the "surface" of the film', contemplating the style and production values (p. 60).

Trailers for high-concept films are therefore often straightforward in terms of their mode of address to the audience. Wyatt cites Steven Spielberg's assertion that 'if a person can tell me an idea in twenty-five words or less, it's going to make a pretty good movie' (1994, p. 13). It will neatly summarize the plot, character types and generic characteristics of the film so that the intended target demographic knows exactly what they will be paying to see. Information about the film is therefore tightly controlled and viewer expectations are more easily met because they have been more clearly outlined in the promotional material.

By contrast, a viral trailer may encourage word-of-mouth rather than attempting to bypass it altogether. It may even withhold central plot information to build up hype and speculation, prompting users to search online for further information. The audience is no longer positioned in relation to the mere surface of the film, but is encouraged to become involved on a deeper level and to discover elements of the narrative for themselves. It anticipates and embraces the prospect of an inquisitive online audience, rather than trying to lock down audience activity.

Almost every marketing campaign for Hollywood films now involves a trailer, YouTube video or website, which has the potential to 'go viral'. However, the kind of campaign I wish to discuss is more complex. It encourages not only referral from one consumer to another but immersion in and interaction with the world of the film, before,

during and after viewing. This allows the viewer to shape, or at least appear to shape, their own cinematographic experience. The campaign for *Cloverfield* is used as a case study to investigate the extent to which such campaigns immerse the viewer in the world of the films they are promoting, and the relationship such campaigns might have with the film's aesthetics. Finally, I will consider a number of possible reasons as to why media conglomerates might choose to utilize such complex marketing campaigns to promote mainstream Hollywood films.

1-18-08 – The *Cloverfield* campaign

The *Cloverfield* campaign was a long and complex affair. Any analysis of the marketing campaign therefore requires at least a brief descriptive overview of the events as they unfolded online. A teaser trailer was released before screenings of *Transformers* (Michael Bay, 2007) in June 2007. It starts with home video footage of a leaving party in a New York apartment for the main character Rob (Michael Stahl-David) who is leaving the city to work in Japan. Suddenly the lights go out, a terrifying sound screeches out of the darkness and as the intrepid party-goers reach the roof of their apartment it becomes clear that something is attacking the city. Remaining behind the camera of the designated party documenter Hud (T. J. Miller), we follow the group of friends into the streets as they, and we, try to figure out what is going on. This trailer contains no title, no recognizable stars, and the bare bones of the film's plot. The only identifiable information attached is the name of producer J. J. Abrams of *Lost* (2004) fame and a release date of 1-18-08.[3] When curious viewers entered this date into search engines they embarked upon an expansive piece of viral marketing, an alternate reality game (ARG) set in the world of the film, as they tried to discover more information.[4]

1-18-08.com began life as an image of a single timecoded Polaroid photograph; an extreme close up of two terrified female faces. More photographs were added as the release date approached. If users waved the cursor over the photograph it flipped over, sometimes revealing further information about the characters. This led to the discovery of MySpace pages for the main characters. These were also updated in real time, giving the sense that the characters existed not just in a fictional filmic reality but in the players' reality as well.

This is part of a key element to ARGs, known as This Is Not a Game (TINAG). A philosophy as much as a set of aesthetics, TINAG refers to the extent to which the game and characters in it appear to be 'real'. Websites must appear as they would do in 'real life', phone numbers

must work and emails must at least provide a plausible auto-response. This is expected to be upheld by players and game designers alike. For example, designers made it possible to contact Rob via a convincingly 'real' MySpace page. Equally, players who messaged Rob in the hope of gaining further information were careful to always address him as if he were a real person.

Rob's page also mentioned Slusho!, his new Japanese employer. Slusho! was one of four subsidiaries of the fictional oil company Tagruato, and both had convincing corporate websites which were fully browsable. Through further online investigations, players could deduce that Tagruato was somehow involved in the creation or discovery of the creature attacking New York. Fans immediately started rigorously searching these and many other related sites for clues as they were updated. Some even led to 'real world' interactions. For example, Tagruato's site reported on an incident at one of its drilling sites. To find out more, players could call the number +81-3-5403-6318. This led to a voicemail message, which changed as the release date approached, offering updates on the situation at the site. Additionally, users who contacted any of the sites by email received sonar images of something underwater, heading towards New York, a few weeks before release.

Fans' responses to this were documented on message boards showing how they followed up every possible route for more information.[5] The game ended when players went to see the film, which posed as 'found footage' from the day of the attack and documentary evidence of the monster, similar to the reality premise posed by *The Blair Witch Project* and its website. The following analysis considers how *Cloverfield* and its ARG could be seen to work together to create an immersive viewing experience.

Immersion, agency and transformation

Telotte argues (speaking specifically about *The Blair Witch Project*) that a website is important in creating a context within which the viewer reads the film. This is shaped by the filmmakers and/or distributors controlling the kind of pleasures the audience might derive from it. However, he suggests that that the effectiveness of *Blair Witch*'s campaign was not the website alone, but the relationship it established between the site and the film, as they worked together to immerse the viewer in an alternative reality (2001). The fact that the film and website are so closely interlinked, he suggests, hints to viewers that the pleasures offered by the website may also be offered by the film.

He then links the pleasures offered by both website and film to those which Janet Murray claims are provided by computer-based narratives, a term which covers computer games, navigation of the Web and hyper-texts, or online fictions (1997).[6] Murray identifies these pleasures as immersion, agency and transformation (1997). Both the viral market-ing campaign for *Cloverfield* and the film itself could be seen to work together to offer these experiences.

Murray defines immersion as 'the pleasure of being "submerged" in the world of the text, a movement into another world or realm' (1997, p. 98). Immersion in the world of *Cloverfield* was, to some extent, created by its reality premise. Shot to look like one continuous event captured on a hand-held camera, it asked audiences to believe that it was a docu-ment of the events of 1-18-08. Events unfolded in the game in real time and the characters 'lived' online via their MySpace pages.[7] Clues leading to 'real world' interaction such as the telephone call and voicemail from Tagruato, also developed a sense of almost physical participation in the world of the film. Importantly, this information was distributed through everyday media channels, accessed by players through websites, mobile phones and email accounts, naturalizing the experience and making it feel as part of the players' day-to-day lives as possible. As Murray points out, 'the more realised the immersive environment, the more active we want to be within it' (1997, p. 126).

With regards to film style, the stated intention of the filmmakers was to make the viewing experience as 'naturalistic and authentic' as possi-ble (Reeves, 2007). Handheld shaky-cam gives an impression of presence and immediacy as well as disorientation, confusion and, for some audi-ence members, nausea and motion sickness. Many reviews comment specifically on the physically involving nature of the film:

> An hour in I started to sweat. I couldn't look at the grim strobo-scopic lighting effects in the final reel and I nearly threw up trying to make sense of the increasingly chaotic and frightening scenes of the gripping climax.
>
> (Christopher, 2008, p. 14)

If the viewer had been following the game online, their sense of involve-ment with the world of the film would have been extended by the film's aesthetics and vice versa if the sites were accessed post-viewing.

Murray defines agency as the ability to participate in the world of the text (1997, p. 126). *Cloverfield*'s campaign asked users not only to find the websites but also to email them and call their phone numbers,

from which they then received a response. What followed was a very specific response from Internet-savvy viewers who interrogated each photograph to the last pixel, checked the veracity of every verifiable fact and most importantly, posted on their blogs and message boards when they found something new to share with everyone else. Word-of-mouth spread and an online community was quickly established. Through their various conjectures they were using this information to create their own backstories to a film they knew little else about. These complex sites recognized an active, inquisitive and highly communicative audience.

In contrast, agency within the film is limited. We can only see what cameraman Hud sees. This frustration of agency adds to the tension and frightening effect of the film as viewers struggle to figure out what unthinkable horrors might lie beyond the frame. Additionally, any experience of agency must be considered illusory, as clearly the audience can have no actual effect on events in the film. However, comparisons have been made between *Cloverfield's* subjective camera style and first-person shooter games such as *Half-Life* or *Call of Duty* (Stuart, 2008). As Hud ducks and dives from unexpected explosions and terrifying creatures, the tension, apprehension and kind of attention required by the viewer to keep up is very similar to the engagement required when navigating a gaming world. It could even be speculated that Hud's unusual name is a reference to the gaming term 'heads up display'.[8] Therefore, the gaming elements offered by the marketing, which are more akin to puzzle solving, translate into a film style which also has a game-play element to it, this time linking to a kind of game in which the levels of agency are much higher. Illusory or not, these pleasures are experienced to some extent by those involved in both the film and the ARG. Together they contribute to an immersive cinematographic experience that viewers feel they have an element of control over.

It is important, however, to recognize that these experiences are constructed and controlled, to an extent, by filmmakers and marketers. Users may create their own narratives but they do so with information fed to them at specific times, in a specific order. It is perhaps for this reason that Telotte refers often to an agency 'effect' (2001, p. 36). This reveals an intriguing tension inherent in the term 'viral marketing'. The 'viral' element specifically requires a degree of agency and autonomy on the part of the consumer. They must take the message and pass it on of their own free will. This way the message often spreads faster and appears more 'organic', resulting in a softer sell which appeals to audiences used to being bombarded by more traditional advertising. But this agency also allows them to take the message and change it or even reject

it, and, more dangerously, advise others to do the same. Marketers are thus caught between the desire to encourage agency and the need to control or limit it to avoid distortion of the message or negative word-of-mouth. This tension leads to a constantly shifting relationship between producer and consumer, which requires further investigation if it is to be understood properly.

Murray's third pleasure, transformation, occurs when the text allows a player to take on another identity (1997, p. 154). The websites provide this in terms of placing the viewer in the role of investigator. Within the film, the viewer is thrust into the role of party documenter Hud and remains there until his unfortunate demise. After this, Rob takes over, but addresses the camera directly in a kind of final testimonial. At this point the viewer returns from the role of documenter and becomes a removed witness of the event. This transformation prevents viewers from being immersed completely in the world at the crucial point when the 'game' ends but also reinforces the status of the film as found footage, keeping viewers immersed within the reality premise. Rob reminds us of our status as spectators when he says 'you probably know more about it than I do'. He does not know how right he is.

Having used Murray's terms as a basis for this analysis, it is important to point out that establishing such a theoretical framework is not without its problems. Even recent scholarship can fall a few steps behind both the constant changes in technology, and a market that moves with the ever-shifting desires of the consumer. Murray's work was published in 1997, in a decade when being online in a virtual world was imagined to require virtual reality headsets, to almost be physically transported into another realm. In 2014, having an almost constant online presence had become a part of daily life for many consumers. Thus it is possible to argue that Murray's sense of the words 'immersion', 'interactivity' and 'transformation' in particular come from a very different frame of reference and may need to be adapted for the Web 2.0 generation. However, even if they do require a little re-contextualization for contemporary audiences and technologies, the fundamental ideas behind these 'pleasures' remain pertinent to an analysis of online narratives today.

Narrative extension and expansion of the filmic world

At first glance, it seems reasonable to suggest that the websites which make up the *Cloverfield* ARG are part of what Jenkins calls a 'transmedia narrative', where the narrative of one film is expanded across several

media platforms. It expands the world of the film but may also fragment the narrative, which, Jenkins argues, allows the consumer to make their own connections between fragments and read the narrative in their own way (2006a, p. 121).

However, upon closer inspection it appears that the Cloverfield sites were only loosely connected to the narrative of the film, and possibly not even enough to be described as 'fragments' of the same story. When the viewer came to the film, having been part of the online investigation, there was no mention of Tagruato and the only reference to Slusho! was by way of a logo on a t-shirt. Few questions were answered about what the creature was or where it had come from. Furthermore, an entire narrative was built around two characters that did not feature in the film past the initial party scenes.

One of the photographs from 1-18-08.com revealed a good luck message to Rob from Jamie, who also appeared on MySpace. It soon became clear that Jamie's boyfriend, Teddy, also worked in Japan. After more searching, the website jamieandteddy.com was discovered. Jamie and Teddy used this site to send each other video messages, again updated in real time. Suddenly, Teddy stopped communicating. Jamie received a mysterious package containing Slusho! merchandise, something wrapped in tin foil and a note from Teddy. He claimed he had been kidnapped by Tagruato, asked her to get the message to someone and told her not to eat the substance wrapped in foil. She promptly consumed the mystery substance and appeared somewhat intoxicated in the next few videos before announcing she was 'over' Teddy and was going to Rob's party, linking the end of the online narrative to the start of the on-screen narrative. Beyond this link, the Jamie and Teddy story is not referred to at all in the film. If anything, the Jamie and Teddy sites constructed a separate but related narrative that ran within the same filmic world as that of the film text.

The idea of immersion in another world or realm has great relevance to film which, as Victor Perkins points out, does not end at the edge of the frame in the minds of the audience. On-screen always presupposes off-screen and beyond the frame there is a world, albeit a fictional one, in which there are many possibilities that may or may not occur within the narrative of the film. We bring to this world knowledge from our own world, as well as knowledge that the film explains for us – 'to be in a world is to know the partiality of knowledge and the boundaries of vision – to be aware that there is always a bigger picture' (Perkins, 2005, p. 20). The *Cloverfield* websites offer an opportunity for viewers to consider the possibilities that might exist beyond the frame, but are

not explicated in the text. They encourage us to consider all the possible realities of this world as if it were just that – real.

Whether or not this expansion of the filmic world actually requires a corresponding aesthetic from the film itself to be effective is debatable, even unlikely. It would seem that films with subjective camerawork like *Cloverfield* and *Blair Witch* are perhaps the exception rather than the rule. Many films shot more traditionally like *The Dark Knight* (Christopher Nolan, 2008) have had extremely successful viral campaigns attached, suggesting that although the link between viral sites and film style is effective, it is equally possible for the filmic world to be sufficiently expanded in the minds of the audience by the sites alone. However, it is possible that they are enhanced or may be more effective when the two are combined, or as Telotte suggests, when they are working towards the same effect (2001).

Why go viral?

Complex viral campaigns like those described here are often expensive and time consuming to create and run, particularly if they involve live events. They can create an enormous amount of buzz around a film, but why might media conglomerates look to immersive campaigns to market mainstream Hollywood films? The answer to this can only be provided by marketing executives themselves, but to conclude this chapter, I would like to offer three possible motivations for Hollywood's use of viral marketing strategies.

First, the *Cloverfield* ARG actively drives audiences into the cinema. The only way to solve the puzzle is to go and see the film. However, it is arguable that the kind of dedicated audience who would follow such a campaign would have gone to see the film anyway. Additionally, such audiences are actually quite small in number in comparison with desired attendance figures. For example, the unfiction.com community had around 30,561 registered users at the time of writing. It is hard to estimate how many 'lurkers' or unregistered players came across the websites, and relating hits on the sites to box office takings is not a perfect indicator of the impact of the site on the takings.

Virals also have the potential to create a cyclical viewing pattern. The websites point to the film as the answer to the puzzle. So the viewer interrogates it, slows down, rewinds it and plays it back. When the film cannot answer questions, for example, about the origin of the *Cloverfield* monster, the viewer goes back to the websites, which in turn point back to the film as documentary evidence. From a pragmatic industry point of

view, this viewing pattern may encourage multiple viewings and therefore increase DVD sales. It also means that buzz can be sustained before and after the opening weekend as people continue to try and solve the mysteries well after viewing. From a more creative standpoint, this could be viewed as an attempt to expand the viewing experience in an imaginative and involving way.

Second, the increasing use of virals could suggest that Hollywood is looking to the pleasures offered by other media (such as the Internet or online gaming) in order to compete with new media technologies, and reach out to an audience which spends an increasing amount of time online. In an era of media convergence it has become something of an imperative to create truly multi-platform viewing experiences, which extend beyond the big screen and, most often, onto the smaller mobile screens where consumers seem to be spending more and more of their time.

John Belton similarly argued that the development of widescreen technologies and 3D film can be viewed as an attempt by Hollywood to compete with other leisure activities by emphasizing its experiential nature (1990). Cinerama and Cinemascope 'engulfed' audiences, or at least appeared to, and engaged them more actively, 'creating for them a compelling illusion of participation in the action on screen' (1990, p. 185). It broke the boundary between active and passive spectatorship, the former often applied to theatre audiences and the latter to cinema audiences. Widescreen occupied a space between the two, its wider ratio providing a greater sense of presence for the viewer, who could no longer take in all the information with one glance but had to actively follow the action on screen to make sense of it. Cinerama is also described as an 'attempt to mimic the theatre in terms of its sense of participation' (p. 193). Similarly, one could argue that the combination of immersive marketing and aesthetics is an attempt to not only compete with the gaming industry and the Internet, but to try and recreate some of the pleasures offered by those media (including those identified by Murray) within the cinematic experience.

However, as Belton notes of 3D and widescreen technologies, that sense of participation has limitations, as he frequently refers to it as an 'illusion'. Although videogames and films may share aesthetic qualities, with many videogames described by reviewers as 'cinematic', what ultimately divides them is that the viewer cannot physically affect anything in the filmic world. Espen J. Aarseth suggests that what makes a game different from a film is the fact that 'non-trivial effort' is required to allow the reader to traverse the text (cited in King and

Krzywinska, 2002, p. 22). As he puts it: 'games raise the stakes of interpretation to those of intervention' (cited in King and Krzywinska, 2002, p. 23).

Aarseth's interests lie in defending the videogame as a worthy medium in its own right and not resorting to theories of narrative which link such games to a medium of higher perceived cultural value in order to validate it. In contrast, one could argue that Hollywood has in fact acknowledged the cultural status of videogames, and has seen fit to adopt non-narrative elements of games in order to emulate the added values that make gaming so different. The borrowing of game-like perspectives can offer an illusion of intervention and some of the pleasures that this can provide. Both *Cloverfield* and its ARG demand more 'non-trivial effort' than films or their marketing campaigns have previously demanded of viewers. This could also point to Hollywood's attempts to appeal to an audience steeped in gaming culture, and therefore willing to make that effort to gain an enriched filmic experience. Bryce and Rutter suggest that gaming offers 'the intimate sense of consumer as producer' (2002, p. 78) that Hollywood cannot, but this seems to be what Hollywood is attempting to provide, via marketing strategies which treat them as agents capable and desirous of producing their own narratives, even if this is within a tight set of limitations.

Third, virals can engage with and gain the trust of a difficult and influential audience group. Public relations and communications firm Burston-Marsteller commissioned research that dubbed this group 'e-fluentials', defining them as consumers 'who have exponential influence shaping and driving public opinion through the Internet and throughout the offline world' (2001). Whether today's e-fluentials are still the same people, doing the same things, or even exist, is debatable. In an age where this audience group is almost permanently connected (particularly via mobile devices) the impulse to investigate, buy or review any kind of product online has become something of an automatic reflex for the average consumer.

Having acknowledged this, there does seem to be a specific target audience for these campaigns. Judging by the online presence, effort and knowledge required by some campaigns, these are not your average surfers. Paramount's creation of these complex sites recognizes an active, inquisitive and highly communicative audience and attributes a certain level of importance to them. Viral marketing could be seen as an attempt to control or negotiate the buzz that this audience group could instigate, and to deliver an online experience that they will talk about positively. It also appeals to them by offering a privileged viewing position. Viewers

who have been involved with 1-18-08 bring a wealth of knowledge and character information to the film that uninitiated viewers will not have. This is not to say that the experience is less valid for non-players, but that it will be dramatically different and richer for those familiar with the ARG.

Pushing this idea of audience management further, it seems important to note the similarity between the audience group described above and cult media fans. Players of ARGs like 1-18-08 are engaging in recognizably fannish or even cultish behaviour. Hours of their time are spent gathering and analysing information that bystanders would probably see as pointless or trivial. Virals encourage this activity and could even be an attempt to create a cult audience. Beyond selling the film, 1-18-08 constructs and then promotes the fan experience itself, by producing something which looks and feels like an active, grassroots community around an unreleased property. It creates the space and conditions for fandom to occur whilst at the same time utilizing it as part of a wider marketing exercise.

However, according to Henry Jenkins, fan communities are by definition, self created:

> Expansive *self-organizing* groups focused around the collective production, debate, and circulation of meanings, interpretations and fantasies [my italics].
>
> (2006b, p. 137)

If fandoms are corporate creations rather than organically formed communities, this has implications for the ways in which we currently define fan communities. Although it appears that ARG communities create these backstories themselves, they do so with information fed to them by producers and their narratives will ultimately arrive at a corporate-sanctioned conclusion. These new fandoms may require us to rethink how we conceptualize cult media fandom.

Viral marketing demands an active and engaged user to interact with these sites, becoming involved in the world of the film before and after viewing in a way that affects their relationship with the text, and ultimately the viewing experience. The positioning of the viewer as investigator creates an immersive experience, which is intensified when used in conjunction with aesthetics working towards the same effect. This indicates a dramatic shift in the way Hollywood is trying to connect with and cultivate audiences both online and offline and may even cause us to rethink ways in which we have previously understood these audiences.

Notes

1. The earliest retrievable year using Internet Archive (www.web.archive.org) is 1996. It is difficult to access film websites prior to this year as they either no longer exist and have not been archived or they have been updated to the point that their original state can no longer be accessed. For example, there may have been a website for *Jurassic Park* (Steven Spielberg, USA, 1993) at www.jurassicpark.com but this is now home to information on the entire franchise. Internet Archive holds an entry for the site in December 1998 but states this is an updated version, suggesting there was a previous version of the site. Films used as examples here are thus based heavily on accessibility to the original official website.
2. *The Blair Witch Project* went on to gross US$140 million in the USA (see http://www.the-numbers.com/movies/1999/BLAIR.php).
3. Trailer accessed at http://www.apple.com/trailers/paramount/cloverfield/.
4. Although it is not within the scope of this chapter to interrogate the shifting definitions of an ARG, the following offers a good description:

 > a cohesive narrative revealed through a series of websites, emails, phone calls, IM [instant messaging], live and in-person events. Players often earn new information to further the plot by cracking puzzles … the players of these games typically organise themselves into communities to share information and speculate on what it all means and where it's all going.
 >
 > (Phillips, 2005)

5. Some prominent ones included: the forum on Unfiction.com archived at http://forums.unfiction.com/forums/index.php?f=232; Cloverfield Clues http://cloverfieldclues.blogspot.co.uk/ and Cloverfield News http://www.cloverfieldnews.com/.
6. These texts use hyperlinks to allow the reader to take a narrative path through the story which is not necessarily linear.
7. Many reviews criticized the lack of character development (Dargis, 2008) but this could be countered by the assertion that for many viewers the characters had already been developing online for months.
8. The term used to indicate the display in a game-play situation which offers information about the character's health levels, weapons held, stage of game-play and so on.

Bibliography

Belton, J. (1990) Glorious Technicolour, Breathtaking Cinemascope and Stereophonic Sound. In: Balio, T. (ed.) *Hollywood in the Age of Television*. Bolton, MA and London: Unwin Hyman, pp. 185–211.

Burston, M. (2001) E-Fluentials. Available from: https://web.archive.org/web/20080820175413/http://www.bursonmarsteller.com/Innovation_and_insights/Strategic_Development/E-Fluentials/Pages/default.aspx [Accessed: 12 June 2014].

Bryce, J. and Rutter, J. (2002) Spectacle of the Deathmatch: Characters and Narrative in First Person Shootem Up. In: King, G. and Krzywinska, T.

(eds.) *ScreenPlay: Cinema, Videogames, Interfaces.* London: Wallflower, pp. 66–80

Chad, T. and Watier, K. (2001) Viral Marketing. Available from: www.watier.org/kathy/papers/ViralMarketing.doc [Accessed: 2 February 2010].

Christopher, J. (31 January 2008) Review – Cloverfield. *The Times (T2 supplement)*, p. 27.

Craig, T. (2005) Cinema Culture on the Internet: A Report. *Journal of British Cinema and Television*, 2 (2), 329–337.

Dargis, M. (2008) We're All Gonna Die! Grab Your Video Camera! *The New York Times*, 18 January. Available from: http://movies.nytimes.com/2008/01/18/movies/18clov.html [Accessed: 18 January 2008].

Dobele, A., Lindgreen, A., Beverland, M., Vanhamme, J. and Van Wijk, R. (2007) Why Pass on Viral Messages? Because They Connect Emotionally. *Business Horizons*, 50 (4), 291–304.

DreamWorks SKG, Paramount Pictures Corporation, Amblin Entertainment Inc. (1998) *Saving Private Ryan – Official Website.* Available from: http://web.archive.org/web/19981206215736/http://www.rzm.com/pvt.ryan/index.html [Accessed: 15 July 2009].

Jenkins, H. (2006a) *Convergence Culture: Where Old and New Media Collide.* New York and London: New York University Press.

Jenkins, H. (2006b) *Fans, Bloggers, and Gamers: Exploring Participatory Culture.* New York: New York University Press.

King, G. and Krzywinska, T. (2002) *ScreenPlay: Cinema, Videogames, Interfaces.* London: Wallflower.

Liu, Y. (2006) Word of Mouth for Movies: Its Dynamics and Impact on Box Office Revenue. *Journal of Marketing*, 7 (3), 74–89.

Lyons, C. (1999) Spooked by 'Witch' – Low-budget Pic Turns Studio Mind-set Upside Down. *Variety*, 9 August. p. 7.

Maiese, N. (2000) Blair Witch Casts its Spell. *Advertising Age*, 71 (12), p. s8. Available from: Business Source Complete, EBSCOhost [Accessed: 12 June 2014].

Mohr, I. (2007) Buzz Marketing for Movies. *Business Horizons*, 50 (5), 395–403.

Murray, J. (1997) *Hamlet on the Holodeck: The Future of Narrative in Cyberspace.* New York: The Free Press.

Neuborne, E. (2001) Viral Marketing Alert! *Business Week*, 19 March. Available from: http://www.businessweek.com/magazine/content/01_12/b3724628.htm [Accessed: 12 June 2014].

Perkins, V. F. (2005) Where is the World?: The Horizon of Events in Movie Fiction. In: Gibbs, J. and Pye. D. (eds.) *Style and Meaning: Studies in the Detailed Analysis of Film.* Manchester: Manchester University Press: 2005, pp. 16–41.

Phillips, A. (2005) *Soapbox: ARGs and How to Appeal to Female Gamers.* Available from: http://www.gamasutra.com/features/20051129/phillips_01.shtml [Accessed: 12 June 2014].

Reeves, M. (2007) Interviewed by Turek, R., 14 December. Available from: http://www.shocktillyoudrop.com/news/topnews.php?id=4027 [Accessed: 12 July 2014].

Schreier, M. (2004) 'Please Help Me; All I Want to Know Is: Is It Real or Not?': How Recipients View the Reality Status of the Blair Witch Project. *Poetics Today*, 25 (2), 305–334.

Stuart, K. (2008) *Cloverfield is Half-Life*, 14 January. Available from: http://www.guardian.co.uk/technology/gamesblog/2008/feb/14/cloverfieldishalflife [Accessed: 12 June 2014].

Telotte, J. (2001) The 'Blair Witch Project' Project: Film and the Internet. *Film Quarterly*, 54 (3), 32–39.

Twentieth Century Fox/Paramount Pictures (1997) *Titanic – Official Website.* Available from: http://web.archive.org/web/19990117024953/www.titanicmovie.com/past/char_index.html [Accessed: 15 July 2009].

Warner Bros and Universal Pictures (1996) *Twister – Official Website.* Available from: http://web.archive.org/web/19970615221219/http://www.movies.warnerbros.com/twister/cmp/swirl.html [Accessed: 15 July 2009].

Wyatt, J. (1994) *High Concept: Movies and Marketing in Hollywood.* Austin, TX: University of Texas Press.

Filmography

The Blair Witch Project. (1999) Directed by: Eduardo Sánchez and Daniel Myrick. USA, Haxan Films.

Cloverfield (2008) Directed by: Matt Reeves. USA, Paramount Pictures/Bad Robot.

The Dark Knight (2008) Directed by: Christopher Nolan. USA, Warner Bros./Legendary Pictures/Syncopy/DC Comics.

Jurassic Park (1993) Directed by: Steven Spielberg, USA, Universal Pictures/Amblin Entertainment.

Saving Private Ryan (1998) Directed by: Steven Spielberg, USA, DreamWorks SKG/Paramount Pictures/Amblin Entertainment/Mutual Film Company.

Titanic (1997) Directed by: James Cameron, USA, Twentieth Century Fox/Film Corporation/Paramount Pictures/Lightstorm Entertainment.

Twister (1996) Directed by: Jan de Bont, USA, Warner Bros/Universal Pictures/Amblin Entertainment/Constant c Productions.

6
Terms of Intimacy: Blog Marketing, Experiential Desegregation and Collaborative Film Value Production

Ya-Feng Mon

Introduction

This chapter analyses communicative activities on the official blog of *Miao Miao*, a 2008 Taiwan queer-romance film, to grasp the film industry–audience relationship in a concrete case of Internet film marketing. The analysis focuses on the way in which Internet-mediated intimacy between the film industry and the audience has been implemented as a marketing strategy.

Theorizing Internet communication as entailing affective investment from the users of the medium, I will argue that *Miao Miao*'s blog-marketing campaign, involving both the film industry and the audience as Internet users, helps to autonomously build a corporeal/experiential bond between the two parties. Through the generation of the experiential bond, the marketing campaign desegregates the audience and the film industry in a collaborative process of film-value production.

New gimmicks for film promotion

In 2008, senior Taiwan film marketer Li Ya-mei wrote an article to outline the creative strategies Taiwan film practitioners had deployed in the crucial task of marketing. Pre-release question and answer (Q&A hereafter) tours and blog marketing, she says, have in recent years become common methods of reaching out to potential/target audiences (Li, 2008, pp. 115–116). Budget-efficient, the two marked strategies have their respective histories in Taiwan film companies' struggle for effective marketing.

Pre-release Q&A tours, frequently coupled in practice with post-screening Q&A sessions or on-campus promotional events,[1] have long been associated with the master art-house director Tsai Ming-liang. Having become an iconic auteur in the mid-1990s, Tsai suffered a huge box office failure in 1998 with *The Hole*. The apocalyptic drama–musical grossed merely NT$320,000 ($11,050) in Taipei despite garnering the FIPRESCI Prize at the Cannes Film Festival (Wang, 1999, p. 68). To avoid another fiasco, Tsai first tried his hand at pre-release Q&A tours when promoting *What Time Is It There?* in 2002. During the marketing campaign, Tsai and the film's main actors attended more than 70 Q&A events around Taiwan. After the film was officially released, post-screening Q&A sessions were held on a daily basis throughout the screening period (Chang, 2004, pp. 56–64).

Interviewed in 2004, Tsai explained that his fundamental strategy behind the Q&A marketing campaign was based on 'physical presence' (*ren yao dao*). As an auteur director, he believed he and his exceptional ideas were the unique selling proposition for his films. Thus he suspected that his presence, his willingness to elucidate in person his thoughts and feelings invested in his films, would hold considerable attraction for his potential audiences. If Hollywood superstars had been instructed in benefiting from contrived mysteriousness, Tsai said, his appeal was on the contrary sustained by closeness (Chang, 2004, pp. 55–56).

Once the Q&A marketing strategy is adopted to sell more populist Taiwan films, the efficacy of such closeness extends to the presence of the actors. Aileen Yiu-Wa Li, who produced and marketed 2004's highest-grossing Taiwan feature film *Formula 17*, articulated the mechanism in terms fairly similar to Tsai's:

> Film 'stars' should never attend Q&A sessions or promotional events. Their status depends heavily on a proper distance that breeds their mysteriousness. But we brought the actors to the potential audiences, hoping the closeness would breed affection. In so doing, we did not help the actors cultivate their stardom. Quite the other way, we worked to make them, the public figures usually seen on screen, seem affably accessible to the public. So the potential audiences would feel related to them, and might eventually fancy seeing a film featuring them.
>
> (2009)

On top of Tsai's theory, Li (re)conceptualized Q&A events as an affective promotional gimmick rather than an intellectual one. While further

elucidation of filmic concepts, as Tsai has understood it, might help draw the audience to certain films, Li suggested the strategy of closeness could prove fruitful just for the reason that Q&A events physically eliminate the distance between 'the public' and 'public figures'. The elimination of distance is apt to produce in 'the public', or in this case in the potential audiences, an effect that can be translated as emotions, feelings or attitudinal change. Such affective reactions then enhance the potential for film consumption.

Film blogs, on the other hand, have often been utilized by Taiwan film marketers as 'information distributing centres' (Li Ya-mei cited in Su, 2009, p. 202). Setting up an 'official blog' has, since the second half of the 2000s, become a 'must' for nearly every Taiwan production released. Steve Wang, another senior marketer in the industry, celebrated blogs for facilitating immediate circulation of newsworthy information by allowing instantaneous updating (Su, 2009, pp. 181–182).

Interestingly, when asked about the operative strategies for blog content management, Patrick Mao Huang, in concurrence with Aileen Yiu-Wa Li, stressed the relevance of affection and the sense of closeness. Huang, who produced and marketed the 2006 box office black horse *Eternal Summer*, therefore underscored the efficacy of personal narratives, observing that blog posts adopting a more personal – or intimate – tone are more capable of bringing the readers closer. For this reason, those same posts are also more apt to 'affect', to generate comments, and subsequently to prompt film consumption (Su, 2009, pp. 192–193).

Sharing the premise of distance elimination, or rather closeness enhancement, Q&A events and blog marketing are, in fact, seldom carried out in Taiwan as separate strategies. Ever since Tsai's campaign for *What Time Is It There?* Internet-mediated intimacy with 'public figures' has regularly been integrated with face-to-face intimacy in the attempt to achieve affective marketing. As the directors and actors hit the road for Q&A tours, shooting diaries or production notes claimed to have been kept by them would turn up online and preview the intimate thoughts or feelings to be shared at face-to-face promotional events. Occasionally, Internet users also gain chances to 'converse' via commenting or instant messaging with the filmmakers, the actors or even the crewmembers. That is, in a drastically different setting, they might as well enjoy a metamorphosed Q&A session.

As the communication value of Q&A events has in practice met that of blog marketing, the question remains as to how Internet-mediated intimacy has worked alongside face-to-face intimacy in affective marketing.

Is computational-networked communication ever able to achieve the same level of intimacy as face-to-face communication? In the article 'Cultures of Production' (2009), John Thornton Caldwell has suggested that face-to-face Q&A discussions work as intermediary spaces to negotiate the boundaries between the cultures of production and the cultures of consumption (pp. 208–209). If this is the case, does Internet communication further negotiate the boundaries already in negotiation?

When interviewed, most Taiwan marketers maintained that Internet-mediated intimacy functions as a supplement, a compensatory service for those who have missed out on, or had less access to, face-to-face Q&A sessions. In my interview with Patrick Mao Huang, for instance, he claimed that face-to-face Q&A events should never be held solely for 'the hundreds who could actually attend', but instead for 'the hundreds of thousands who might as well participate through reading or watching video clips online about the events' (2010). Having acknowledged the power of the Internet as a mass medium, Huang obviously sees the medium's function as to 'broadcast' an event rather than to constitute an event itself. However wide a reach the medium might be understood to have potentially achieved, its efficacy is considered to be that of a by-product.

Analysing communicative activities on the official blog of *Miao Miao*, this article will argue otherwise. Mediated notwithstanding, I would contend, the industry–audience intimacy developed on the Internet enjoys autonomy from face-to-face contact arranged for a Q&A session. Moreover, such autonomy, frequently a result of industrial initiation, (re)organizes the film industry–audience relationship into a collaborative project of film-value production, which it does by correlating affectively the audience and the industry.

Miao Miao, the official blog

Miao Miao tells the story of an unrequited love triangle. In the film, high school student Miao Miao, played by Ke Jia-yan, is an exchange pupil from Japan. She meets Xiao Ai, played by Chang Yung-yung, on the first day of school in Taiwan, and the two girls become best friends. In a street-striding adventure, Miao Miao visits a second-hand record shop and falls for the shop owner Chen Fei, played by Wing Fan. Xiao Ai, meanwhile, finds herself irresistibly attracted to Miao Miao. As the girls' respective affections grow, Chen Fei's aloofness frustrates Miao Miao, while Miao Miao's crush on Chen Fei torments Xiao Ai. The closet

homosexual Chen Fei, for his part, despairingly grieves over the tragic death of his secret boyfriend Xiao Bei.

Before its official release, *Miao Miao*'s local distributor, Warner Bros. Taiwan, regarded the film as a fairly 'saleable' production. With the film produced by Jettone Films, the endorsement from the company's leading executives Wong Kar-wai and Stanley Kwan[2] was expected to constitute an effective, unique selling proposition. Besides, the leading actresses Ke Jia-yan and Chang Yung-yung were deemed to be likable newcomers, although having not yet acted in lucrative local productions. The leading actor Wing Fan, meanwhile, had in the previous decade proved himself as a local pop icon. Consequentially, the labour-intensive execution of pre-release and post-screening Q&A tours was from the outset left out of consideration. An economical operation of online marketing was instead carefully planned in the tours' place, the film's project manager Rachel Chen explained (2010). Such is the campaign conducted on the film's official blog.

If one compared this official blog with KongisKing.net, the model-building promotional website of Peter Jackson's 2005 blockbuster *King Kong*, one would find the former has adopted a very different strategy in addressing its potential audiences. The production diaries on KongisKing.net are published in video form. They document activities at the production locations, in the post-production studios, on the red carpet and inside the publicity office. Although the diary footage (91 posts in total) is produced in the name of Peter Jackson, stories are hardly told from the director's particular perspective. The actors, assistant cameramen, lighting technicians, production design crews, make-up artists, film editors, the special effects team and publicity officers all have their say. Exclusive interviews are presented to shed light on each profession, or in Caldwell's words, on 'the craft expertise behind the illusions and emotional experiences that everybody experiences' (2008, p. 284). Following the diary entries, the website users are encouraged to 'witness' the complete filmmaking process. The information provided, despite being intimate in tone, is expected to in effect be 'objective'.

Miao Miao's official blog, on the contrary, underlines the key practitioners' 'subjective' investment. Take for instance 'Something About *Miao Miao*', a post by the film's director Cheng Hsiao-tse, coming on the blog three days after the film's official release. In the article, Cheng details not only how he has launched into directing a queer romance, but also the help he has gained from the film's producer Stanley Kwan, a veteran director of Asian queer cinema. The production process is thus outlined, yet only as far as the descriptions support Cheng's declaration

that he can only have been so wholeheartedly devoted to this feature debut of his because he believes in 'love'.[3]

As well as engaging 'behind-the-scenes' narratives, these statements by Cheng also serve as appropriate content for 'celebrity journalism'. According to P. David Marshall (2006), a celebrity's innermost belief is meant to be manifested in celebrity journalism after the celebrity is interviewed by a journalist within a private setting. In Cheng's case, of course, his 'innermost self' seems to even bypass the intermediation of professional journalists and speaks for itself (assumedly) through his own writing. This potential for seemingly 'un-mediated' communication defines the distinction of the Internet from other mechanisms of celebrity journalism, which revolves around the audience–celebrity intimacy. To get a full grip on the implication of such distinction, nevertheless, requires a closer look at the intimacy in question as a product of diverse media operations, so to clarify the specificity of Internet mediation.

The sensation of closeness

In his recent publication *Celebrity/Culture* (2006), Ellis Cashmore introduces the psychological terms of 'intimacy at a distance' to generalize the cumulating effect of celebrity cultures on contemporary media users (p. 80). Cashmore observes that the audience–celebrity relationship is characterized by intimacy (from afar) and that the audience–celebrity intimacy is a consequence of ubiquitous mediation. Sharing these observations, P. David Marshall (2006) and Misha Kavka (2010) elaborate on the conditions of possibility of such intimacy by examining, respectively, the operative mechanism of print journalism and television. In Marshall's discussion, celebrity journalism is more than excessive bombardment of celebrity trivia. It is a specific style of reportage, which has evolved since the 19th century into providing an even greater degree of celebrity–audience intimacy. In the 19th century, Marshall writes, newspaper profiles of famous public figures started as 'carefully choreographed studies of public moments involving these people,' and over the course of the century changed to 'revelations about [the public figures'] private lives and how that intersected with their public lives'. But generally speaking, celebrity journalism in its first decades only involved 'reporters piecing together stories from people who knew famous people'. Then from the 20th century onwards, the 'standard structures and motifs for the celebrity profile or feature interview' – which seemingly commit themselves to revealing the celebrity's 'true

nature' although inevitably subject to publicity negotiation – have gradually become sustained by 'direct interviews with famous people in their private homes' (2006, pp. 317–320).[4]

At work (or up for manipulation) here, therefore, is a sense of relocation. The mechanism of print celebrity journalism – comprised at once of the journalist's efforts to attain private meetings with celebrities, the celebrity's consent to self-exposure and a particular format of reportage – virtually relocates the reader, ushering the reader not only into the presence of the celebrity, but, more significantly, into the peculiar setting of the celebrity's daily life. Such relocation is a specific case of space mediation. It activates a sensation of spatial closeness, which, however virtual in essence, comes to constitute the prominent condition of possibility of celebrity–audience intimacy.

Broadcast celebrity journalism, given its usual consumption within the audience's domestic space, alternatively triggers an intimacy-sustaining sensation of spatial closeness by virtually dissolving the distance between celebrity activities and the audience's everyday life setting. Take televisual communication for example. It is now a truism that television 'unites the individual at home with the event afar' (Kavka, 2010, p. 15). Indeed, even more than newspapers, magazines and other print media, televisual communication is from the outset marked by its capacity for space mediation. By its ability to draw the viewer close, to mediate spatial closeness between the viewing environment and the subject broadcasted, and by that ability alone, television qualifies as 'a technology of intimacy', in Kavka's terms (2010, p. 5). Moreover, as often live, televisual broadcast facilitates temporal closeness in addition to spatial closeness. Such temporal urgency, once coupled with spatial proximity, is due to evoke on the viewer's part a sense of immediacy, which, Kavka argues, prompts an amplified sense of intimacy. This is because the sense of immediacy is entangled at once with the sense of reality/actuality and the sense of intensity, both serving to augment the sensation of relating to the event/personality on the other side of the television screen (2010, pp. 19–23). Thus, not merely dissolving the spatial distance between the celebrity and the audience, televisual communication virtually collapses the space-time of celebrity activities with the space-time of the audience's domestic life to achieve a sensation of closeness that forms the pivotal condition of celebrity–audience intimacy.

Print or televisual, that is to say, 'journalism-mediated' celebrity–audience intimacy depends on a sensation of closeness. To activate such sensation requires a communication-triggered possibility of virtually

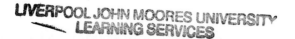

travelling in-between the space-time of the celebrity's private life and the space-time of the audience's domestic living.

Affective virtuality

Both Marshall (1997) and Kavka (2010) highlight the relevance of 'affect' in the experience of celebrity–audience intimacy. Drawing on Lawrence Grossberg's formulation of 'affective economy', Marshall understands affect as an equivalent to the 'a-ideological' or 'a-political'. He hence uses it critically in his own context to examine how contemporary celebrity culture has served to channel public attention away from public issues and into individual achievement, which is embodied by celebrities (1997, pp. 239–240). Kavka, however, reviews the theories of Sigmund Freud and Silvan Tomkins in order to translate celebrity–audience intimacy into emotional proximity, which she defines as a result of affective transmission. Within the context of 'actual' interpersonal interaction, affective transmission fundamentally involves intersubjective exchange of physiological tension (Brennan, 2004). The challenge for Kavka, however, is to outline a comparable mechanism, where the active part within the course of what she defines also as intersubjective affective transmission is mediated, and therefore virtual in essence. Her conception of mediated affective transmission will help ultimately pin down the specificity of Internet communication.

She turns to the sensation of closeness, the pivotal product of celebrity journalism, and argues that the sensation facilitates affective connection. This is because the responses the sensation enables within the audience towards the mediated celebrities are no less physiological than the responses involved in actual interpersonal interaction. In this sense, she maintains, the mediated personhood of celebrities does not in the course of media consumption render affective communication false. Rather, the affective state of the audience renders intimacy with the mediated image 'real'. The virtual state of celebrity–audience intimacy, as a result, bears 'affective reality' (Kavka, 2010, pp. 37–38).

Understood with respect to Brian Massumi's theory (2002), the realness of Kavka's 'affective reality' is buttressed by affective *virtuality*. To provide an operational definition of such virtuality, Massumi analyses Stelarc's performance within which the Greek-Australian artist 'suspended' his body.

[The particular performance involved Stelarc's body] contained between two planks and suspended from a quadrapod structure in

a space littered with rocks. The eyes and mouth were sewn shut. Three stitches for the lips, one each for the eyelids. The body was daily inserted between the planks and in the evening was extracted to sleep among the rocks. Body participation was discontinued after seventy-five hours.[5]

(2002, p. 105)

The performing body was 'suspended' in the sense that it could not move, speak, eat, see or even make itself visible as it could hardly be spotted in-between the planks. 'All bodily expression was closed down', so Massumi describes it. The body was '[d]isconnected from every form of meaningful, need-based, useful function' (2002, p. 105). But it was no less filled with ferment. The force of gravity acted upon it, resonated within it and rendered its effect 'infolded in the sensitized flesh' (2002, p. 107). This transformative force that the body received, however, could not be translated in the particular context into perceptible 'actual' action, since the body was deprived of the possibility to produce an outward, force-unfolding effect. The force therefore existed as an 'activity prior to action', an active potential, within the artist's body. Such state of potentiality is that which Massumi defines as bodily virtuality – a 'suspended animation' or an inward activity that borderlines mind-states and body-states because its inwardness blurs the distinction between mental thought and bodily action (2002, p. 106).

Whether called affect, feelings or emotion, physiological responses of the audience towards mediated celebrities usually take the form of a 'suspended animation'. That is, the very foundation for Kavka's so-called affective reality, which sustains the realness of mediated celebrity–audience intimacy, is in many cases of media communications contained, and only contained, within the audience. It is in the Internet that the audience's inward affective virtuality finally finds a convenient channel into outward affective 'actuality'.

Acts of acknowledgement

Internet communication, Jodi Dean (2010) argues, works on the affective level to an ever-greater degree, compared to cinema, radio, television or other mass media. To capture the particularity of its affectivity, Dean marks Internet communication as 'whatever' communication. She uses the word 'whatever' in two senses. In its literal sense, 'whatever' suggests 'total mediality'. Computational-networked communication constitutes 'whatever' communication simply because it promises a reflexive inclusion of 'whatever' – 'anything can be found,

said, seen on the Internet', and '[e]very aspect of contemporary life is reflected upon, criticized, mocked' (p. 74). In an extended sense, 'whatever' indicates a specific modality of communication. After examining communicative activities on blogs, Twitter and the ever-popular Facebook, Dean notes that an abundance of messages have been transmitted online with their content unattended. This is not to say that Internet communicators do not pay attention to exchanged messages. Rather, as Dean at the conceptual level splits a message into content and 'contribution' ('the fact of its being sent') she observes that a key feature of Internet communication is the prevalence of attention to contribution over content (2010, pp. 101–102). This distinguishes computational-networked communication as affective 'whatever' communication because in vernacular conversation 'whatever' functions as a response that neither accepts nor rejects a communicated message. The response, like most computational-networked communication, leaves the content of the message received but unaddressed, and 'distils the message into the simple fact of utterance'. Although a 'whatever' response does not register the content of communication, it does affirm the fact of utterance. So does 'whatever' communication acknowledge the affective communicative effort made to accomplish communication (pp. 67–69).

When Internet communicators post, bookmark, forward and comment, Dean maintains, they are very much caught up within 'communication for its own sake'. This means, the communicators are affectively, and actively, engaged in communicative activities where the cause and effect of communication pertain more to physiological tendency than to the attainment of 'symbolic efficiency' (2010, p. 77).

Dean's analysis as summarized above critically foregrounds the use of bodily virtuality within the specific context of Internet communication. For this particular communication to reach full function, it is indeed essential that the communicators involved be constantly propelled into actions that facilitate the uninterrupted circulation of information. Consequentially, the requisite affective efforts (to post, bookmark, forward, comment and so on) underline the 'corporeal' aspect of the communication, while the human organism acquires its 'machinic' quality, being prompted relentlessly to advance the circuit of information. To sustain the flow of communication as such, the effect of computational-networked mediation must ideally exceed the generation of sheer inward physiological tension. In full swing, Internet communication entails obvious transmutation of inward bodily virtuality into outward bodily actuality.

This explains why, more than two decades after the Internet first emerged, computational-networked communication remains pretty much attached to the physicality of the flesh. This is even more so if one considers recent development in computer and video gaming. Networked console devices, such as Wii or Xbox, are products of a painstaking endeavour to engage bodily agency. Their design, in fact, pursues a smooth, instantaneous transmutation of communication-evoked physiological tension into tension-catalysed physical action. The imaginary quality once so grandly attributed to the Internet, which promised an escape from the constraints imposed by the flesh, has proved false. Far from excluding the participation of the human body, computational-networked communication has necessitated bodily action to confirm the relevance of its mediated message.

This last point distinguishes Internet communication as a means of enabling intimacy between the audience and the celebrity. Through official websites, personal homepages, blogs, Twitter or Facebook, the eager involvement of celebrities in computational-networked communication has, in recent years, arguably enhanced the possibility of celebrity–audience intimacy. The enhancement results partly from the fact that celebrity journalism nowadays is easily 're-mediated' (Bolter and Grusin, 1999) within cyberspace. Exclusive and more personal information publicized on behalf of the celebrity also helps smooth the path towards the space-time of celebrity activities. In 'network society' (Terranova, 2004), nonetheless, it is the celebrity's physical presence at the far end of the network that has ultimately changed the terms of celebrity–audience relation. Medium specificity considered, a networked reader/viewer is bodily potentialized when accessing celebrity information. A networked celebrity, for his or her part, is no less a potentialized body in reviewing the audience's contribution to online communication. Following Kavka's theorization of televisual broadcasting, the physiological potential/the bodily virtual thus acquired can already, on each side of this audience–celebrity exchange, sufficiently render the intimacy with the body on the other side as real. With Internet communication, potentialized bodies may furthermore act, or react, to acknowledge the relevance of the intimacy in question. Due to the potentiality for action, various acts of acknowledgement have emerged in cyberspace to provide a new foundation for celebrity–audience intimacy. Likewise built upon a physiological state that Kavka deems adequate to render real the mediated celebrity–audience connection, computationally facilitated intimacy bears, however, an alternative affective reality, one to be 'intimately' mobilized, reinforced or

at times dismissed, via actions or inactions, by the audience or the celebrity.

The extra episode

Miao Miao's official blog has been differentiated from KongisKing.net by its use of celebrity self-disclosures, which fulfil their marketing promise through the construction of celebrity–audience intimacy. Following the conclusion of the preceding section, the intimacy is a collaborative product of the audience's and the celebrity's affective communicative action. Potentially effective as part of a marketing campaign, the collaborative intimacy production is in actuality a collaborative (film) value production. In the case of *Miao Miao*, such collaboration takes place on the official blog with two discrete strings of activities, one more contrived than the other. The first string involves the film marketers' intention to blur the distinction between the film actors and their screen roles. The second string concerns spontaneous interaction between the director and the blog's reader-commenters.

When *Miao Miao*'s official blog was launched in August 2008, 'Secret Diaries' became the first section filled with content for reading. The first few diary articles adopted the viewpoints of the two teenage characters and gave interpretative accounts of the characters' mentalities within major scenes. Then, the leading actresses Ke Jia-yan and Chang Yung-yung resumed their own identities and reported upon their experiences as they went through the film's marketing campaign. Thus, before the film's profile made its official appearance on the blog in October, the main girl characters introduced themselves as if they had been two among the numerous teenage bloggers flooding cyberspace. As a consequence, their blog reader-commenters seemed to treat them as though they were fellow bloggers. In response to the post within which the main character Miao Miao revealed herself to be an exchange pupil from Japan, for instance, the blog commenters said they were very impressed by her Chinese writing skills. While Miao Miao (in another post) wrote that she had been wondering where to go sightseeing in Taipei, her reader-commenters replied with various recommendations. Miao Miao, in return, explained how she had learnt Chinese and reported on her sightseeing journeys.

One would think the reader-commenters' misrecognition of Miao Miao as more than a virtual script character had resulted from the marketing effort to 'make believe' and conceal promotional intention. In direct contradiction to such an assumption, however, is the fact that

all readers' comments on the blog appeared after mid-October, that is, after the film's profile had been updated on the blog and the film had started receiving press coverage. Although the lack of efficiency in information transmission might partly account for the misrecognition, a closer look at the readers' comments also suggests that the response to the script characters was complex and multi-layered rather than simply being misled.

A relatively simple case might be found in the comments by a reader-commenter named 'rest80526'. The first comment posted on 2 November 2008 by rest80526 showed that this reader had already known Miao Miao was a film character, yet the diary posts on the blog apparently confused rest80526. Therefore rest80526 asked, 'Are you Miao Miao for real? I didn't know you're an exchange student. How come you are writing in Chinese?' After Miao Miao replied that she had learnt Chinese in her youth, rest80526 said on 14 November, 'So there is a real Miao Miao, who's an exchange student here. Just like the movie!'[6]

Another reader-commenter 'pei' posted a first comment on 30 October 2008. In response to Miao Miao's introduction that she was an exchange student from Japan, pei said:

I surely will go and see your film at the cinema [...]. Back in high school, I had a schoolmate from Japan as well. She spent all three high school years with us. Not like you. You will only be here for a short semester. Xiao Ai should want to say to you, 'Will you stay? Or please take me with you.'[7]

Later on the same day, pei replied to the confession by the other main character Xiao Ai that she had found Miao Miao very charming and that she wondered whether she would succeed in befriending her. Obviously addressing Xiao Ai rather than the actress Chang Yung-yung, pei wrote, 'I think you should venture to pursue the girl you're attracted to. Don't miss out now and regret it later.'[8] Then, on 2 November, pei responded to Miao Miao's question about sightseeing in Taipei, proposing, 'Why not head to the cinema and see a film? In Japan, do you have ornate theatres of a thousand seats?'[9]

There is the possibility that pei, like rest80526, has favoured a realist logic and concluded from the information given that since Miao Miao and Xiao Ai had been 'real' enough to answer all questions posed to them, they might be people 'actually' existing in the world. And since the 'real' Miao Miao and Xiao Ai bear considerable resemblance to the film characters, it might well be the case that those characters have been

based on them. Hence when commenting on Miao Miao's and Xiao Ai's blog posts, pei would have little discomfort at addressing the two girls both as real-life figures and cinematic characters. For as pei wrote in reply to Miao Miao, 'I surely will go and see your film at the cinema', pei could have simply meant 'I surely will go and see the film based on your story'.

Or, as pei never made the point that Miao Miao and Xiao Ai were real-life figures, pei's comments could also have been the product of pei capitalizing on the opportunity to communicate at once with the actors and with the script characters. Those comments indicate neither acceptance nor rejection of the possibility that the actors and the characters are in fact interrelated, but they give a sense of ambiguity that does justice to the marketing strategy's potentiality.

The 'Secret Diaries' section on *Miao Miao*'s official blog prompted the formation of a liminal situation, where the distinction between the actors and their screen roles was eliminated at the outset of the marketing campaign (even if only in a playful manner). The potential implications of such elimination are, however, multivalent. In some cases, as in that of the reader-commenter rest80526, the elimination of actor–character distinction has the screen characters considered biographical. But in others, the elimination suggests more radically the distinction would not communicate significance anymore. The latter, indeed, is what I would argue of pei's case and pei's apparent ease with contradiction.

When considered as a marketing strategy, the intimacy built through the 'Secret Diaries' section on *Miao Miao*'s official blog might, in general, lead to the readers' investment in the actor or in the script character incarnated by the actor. Ideally, each time a reader actualizes his or her communication-invoked bodily potential in the act of commenting, the actualization leads to both investments on one occasion. At the risk of corroding the relevance of the actor in her own particularity, this compound intimacy, or the intimacy with the script character by itself, allows the reader-commenters to 'experience' the film before it is even officially released. Or more accurately, it allows experiences that are in excess of the film itself. This is because via character–reader-commenter connections, which in the context of Internet communication can be genuinely affective rather than purely imaginative, the potential audiences 'live through' episodes that the film has inspired but is never to include. After reporting on her sightseeing journeys on the blog, for example, Miao Miao would have supposedly been to Tamsui, The Riverside Park, The Shilin Main Presidential Residence and other

tourist attractions in Taipei, following the suggestions made by the reader-commenters.[10] Those are the episodes that have only occurred intimately and exclusively between the blog reader-commenters and the script characters. This is how the reader-commenters may potentially be drawn to the film – although containing merely the characters' stories, due to their intimate and exclusive relationships to the characters, the film has become an extension of the reader-commenters' own memories.

Q&As' virtual double

If *Miao Miao*, as an extension of its blog reader-commenters' personal memories, had been successful enough in prompting actual film consumption, the second string of intimacy-building activities might not have taken place on the film's official blog. Unfortunately, after its official release on 14 November 2008, *Miao Miao* grossed only NT$770,000 ($26,550) in Taipei over the first weekend. 'Both Jettone Films and Warner Bros. Taiwan dropped their jaws', the film's director Cheng Hsiao-tse remembered:

> They knew it could not be helped at the box office by then. It was I that would not let go. I thought *Cape No. 7* would not have become the highest grossing Taiwan film ever if its director Wei Te-Sheng had not relentlessly engaged himself in Q&A tours. Naively, I felt confident the same strategy would as well work for us. Warner Bros. Taiwan did not agree but had to yield to my zeal anyway.
>
> (2011)

Hence as of 21 November, Cheng set off on his Q&A tour. Up until *Miao Miao*'s screening period ended on 11 December, he attended three on-campus promotional events and 22 post-screening Q&A sessions at three different cinemas in Taipei.

Around the same time, Cheng also began replying on the official blog to every reader's comment that was addressed to him. His main objective was compared to that of Q&A tours. He said:

> At Q&A sessions, I strove for the effect that a few among the audience would end up writing on their personal blogs about their experiences at the sessions. Or, I endeavoured to make an impression, so some among the audience might at least bother talking to their friends about my movie.
>
> (2011)

The online communication usually took the form of one-on-one interaction.[11] But I had hoped the impact would expend its reach in cyberspace. I aspired to touch those who had not seen the film, and always kept my fingers crossed that once they read my comment replies, the film might suddenly become of interest.

(2011)

To a certain extent, the result of Cheng's effort met his expectations. Some of the audience members who had attended the Q&A sessions did 'blog' about the film or recommend it to their friends. This could only come to one's knowledge because a number of those who had helped advertise *Miao Miao* after attending Cheng's Q&A sessions turned into the most enthusiastic commenters of the young director's blog post. Through commenting, they usually were very eager to publicize their personal involvement in the film's promotion.

A quick browse through the comment pages may well be sufficient for one to notice the close connection between the Q&A sessions and the networked interaction. In response to the blog entry 'Something About *Miao Miao*', the majority of the comments addressed to Cheng appeared after 21 November 2008, that is, after Cheng had started his Q&A tour. Regardless of the diverse content of their contribution, most first-time commenters specified in which Q&A sessions they had participated. All too often, they would even give specific descriptions about what they had done, said or asked at those sessions, so as to remind Cheng of who they were. Many of them kept returning to the cinema, watched the film over and over, took part in the post-screening Q&A sessions, and came back to the blog reporting on their observations, reflections and feelings.

Undoubtedly, intimacy in the celebrity–audience relationship functions as the primary marketing strategy in this case. Rather than merely constituting a product of mediation, the intimacy was encouraged within the context of physical, interpersonal communication. Intriguing, however, is the phenomenon that even if repetitive partaking in the Q&A sessions had earned Cheng's enthusiastic reader-commenters a good chance to enjoy the director's 'actual' presence, they seemed no less keen to, via blog commenting, embrace the director's 'virtual' presence. As stated above, Internet communication buttresses intimacy when potentialized Internet users perform communicative activities to acknowledge and intensify a sensation of closeness among themselves. But how could this sensation of closeness have worked alongside the physical closeness that had in Cheng's case been capitalized on to attain a celebrity–audience intimacy apt for film marketing?

A straightforward argument would be that the networked interaction between Cheng and his reader-commenters works as an extension of the 'actual' Q&A sessions. The extension might appear most observable where the event attendees, through blog commenting, raised questions that they had not been able to bring up during the Q&A sessions. When so doing, some commenters apologized that their questions only occurred to them after they had left the events. Others regretted that the limited event time had not allowed them to satisfy their curiosity. Either case could at first glance suggest the Internet interaction with Cheng was instrumental, a viable remedy for the unfulfilled promise that Q&A sessions answer the audience's need of elucidation. Ironically, it would only take one a second glimpse to see how the more the reader-commenters attended Q&A events repetitively, the more frequently they returned to the blog with additional questions. This indicates the reader-commenters did not engage in the networked interaction solely for further enquiries, as they could always have had their questions answered at the next event they attended. Rather, they engaged to reveal the 'virtual' that had accompanied what would have counted as a Q&A event's 'actual'. Or, by involving themselves in the networked communication, the reader-commenters strove to communicate what had been conceivable or experience-able, but not outwardly perceptible on the occasions of Q&A sessions.

Additional questions constitute but one example of the 'virtual' being later transformed into perceivable actual. Even more common in the readers' comments, however, are descriptions of miscellaneous 'feelings' inspired at the Q&A sessions. On 28 November, a reader-commenter 'Wing' said, for instance, after she/he had seen *Miao Miao* for the third time:

> Having seen the film and participated in the Q&A sessions so many times, I've got to know many scenes had been cut from the film. Although to edit is to present a film in its best version, cutting is much to the regret of the director, the actors and the crewmembers. I am eager to know about every cut scene. Yet once I know about them, will I still relate to the film as much as I did? I am struggling with mixed feelings.[12]

These linguistic renditions of the reader-commenters' 'inward activities' often mingled with selective delineations of what had 'actually' happened at the corresponding Q&A events. Cheng, who also divulged

feelings aroused at the events, would supplement the delineations in his replies.

Ultimately, the expressed feelings and the event descriptions built up unfamiliar *virtual doubles* of the actual events. They would appear unfamiliar, because the doubles contain excess information about the events. These doubles are by nature virtual, because the excess information contained is not about the outwardly actual at the events, but also because the doubles exist as 'the effect of the sign' (Baudrillard, 1993, p. 141) in cyberspace.

Thus, Cheng and his reader-commenters documented their common participation in Q&A sessions. The documentation, in creating unfamiliar virtual doubles of the events, provides 'behind-the-scenes' narratives when exposing and foregrounding the outwardly imperceptible dimension of Q&A sessions. Buttressed by computationally mediated intimacy, a sense of togetherness could have emerged to render irreplaceable the networked communication, in comparison to face-to-face interaction. After all, to be close to Cheng in his physical presence at a Q&A session was to support a director as an audience member when the director industriously shared 'behind-the-scenes' secrets about his works. To be close to Cheng in his virtual presence within cyberspace, nevertheless, could be to take one step further on the path of the filmmaker–audience relationship. That is, to produce, as a colleague of the filmmaker's, 'behind-the-scenes' stories of Q&A sessions.

Experiential desegregation

In the case of *Miao Miao*'s blog campaign, I have argued that as a result of the celebrity–audience intimacy implemented as a major marketing strategy, the actors/characters–audience conversation allows a consideration of the film as an extension of the (potential) audience's own memories. Meanwhile, note comparison on Q&A events translates the filmmaker–audience interaction into a process of comradeship building. All these online experiences have the promise of strongly linking professional production with layman consumption, and, in so doing, to stimulate box office success. The linkage between professional producers and layman consumers has not been achieved solely due to the facilitation by the Internet, as a less industry-centric and more far-reaching vehicle of communication, but the linkage has also been enabled, or even considerably conditioned, by the Internet medium's specificity, comprised by the fact that computational-networked communication autonomously generates, rather than eliminates, 'corporeal' interaction.

Blog-mediated intimacy, as a result of such corporeal interaction, constitutes in this sense no less than a 'lived' bodily experience, 'real' in terms of undeniable physiological intensity. It desegregates the film industry and the audience via experiential commonalities built upon affective involvement, which (potentially) contributes to the success of online marketing campaigns and thus renders film value production a film industry–audience collaboration.

Notes

1. Promotional events are held regularly on university campuses because university students have been considered the major audience for local film productions (Li Ya-mei, 2008, p. 116).
2. Both from Hong Kong, Wong Kar-wai and Stanley Kwan are among the bestselling directors in Taiwan.
3. http://miao.pixnet.net/blog/post/22390134 [Accessed: 4 May 2011].
4. Marshall cites this observation of changes from Charles L. Ponce de Leon, whose book *Self-Exposure: Human-Interest Journalism and the Emergence of Celebrity in America, 1890–1940* was published in 2002.
5. Massumi cites the description from *Obsolete Body/ Suspensions/ Stelarc*, published in 1984 by Stelarc and James D. Paffrath.
6. http://miao.pixnet.net/blog/post/22058156 [Accessed: 4 May 2011].
7. 'Will you stay? Or please take me with you' is a popular cite from 2008's highest-grossing Taiwan feature film *Cape No. 7*. http://miao.pixnet.net/blog/post/22058156 [Accessed: 4 May 2011].
8. http://miao.pixnet.net/blog/post/22142924 [Accessed: 4 May 2011].
9. http://miao.pixnet.net/blog/post/21994335 [Accessed: 4 May 2011].
10. http://miao.pixnet.net/blog/post/21994335 [Accessed: 23 May 2013].
11. By 'one-on-one interaction', Cheng meant that in his replies he would address each commenter and respond to each of his or her comments separately.
12. http://miao.pixnet.net/blog/post/22390134/2 [Accessed: 4 May 2011].

Bibliography

Baudrillard, J. (1993) The Evil Demon of Images. In: Gane, M. (ed.) *Baudrillard Live: Selected Interviews*. New York: Routledge, pp.136–144.
Bolter, J. D. and Grusin, R. (1999) *Remediation*. Cambridge, MA: MIT Press.
Brennan, T. (2004) *The Transmission of Affect*. Ithaca and London: Cornell University Press.
Caldwell, J. T. (2008) *Production Culture*. Durham and London: Duke University Press.
Caldwell, J. T. (2009) Cultures of Production. In: Holt, J. and Perren, A. (eds.) *Media Industries*. Oxford: Wiley-Blackwell, pp. 199–212.
Cashmore, E. (2006) *Celebrity/Culture*. New York: Routledge.
Chang, J. (2004) How Tsai Ming-liang Marketed and Funded His Films. In: *Taiwan Cinema Yearbook 2004*. Taipei: Chinese Taipei Film Archive, pp. 53–65.

Chen, R. (2010) Interviewed by: Mon, Y. (24 August).

Cheng, H. (2011) Interviewed by: Mon, Y. [Skype] (5 March).

Dean, J. (2010) *Blog Theory*. Cambridge: Polity Press.

Formula 17 (2004) [Film] Directed by: Yin-jung Chen. Taiwan: Three Dots Entertainment Company.

Huang, P. M. (2010) Interviewed by: Mon, Y. (2 August).

Kavka, M. (2010) *Reality Television, Affect and Intimacy*. London: Palgrave Macmillan.

KongisKing.net. Available from: http://www.kongisking.net/index.shtml [Accessed: 4 May 2011].

Li, A. Y. (2009) Interviewed by: Mon, Y. (10 September).

Li, Y. (2008) Creativity and the Impasse. In: *Taiwan Cinema Yearbook 2008*. Taipei: Chinese Taipei Film Archive, pp. 112–117.

Marshall, P. D. (1997) *Celebrity and Power*. Minneapolis, MN: The University of Minnesota Press.

Marshall, P. D. (2006) Intimately Intertwined in the Most Public Way. In: Marshall, P. D. (ed.) *The Celebrity Culture Reader*. New York and London: Routledge, pp. 315–323.

Massumi, B. (2002) *Parables for the Virtual*. Durham, NC and London: Duke University Press.

Please Show Your Support for Miao Miao, The Official Blog of *Miao Miao*. Available from: http://miao.pixnet.net/blog [Accessed: 4 May 2011].

Su, W. (2009) *The Study of Taiwanese Movie Blog Marketing*. Master's Thesis. National Taiwan Normal University.

Terranova, T. (2004) *Network Culture*. London: Pluto Press.

Wang, C. (1999) 1998 Yearly Box Office Results for Chinese Language Films. In: *Taiwan Cinema Yearbook 1999*. Taipei: Chinese Taipei Film Archive, pp. 65–69.

What Time Is It There? The Official Website of *What Time Is It There?* Available from: http://whattime.kingnet.com.tw/index.html [Accessed: 4 May 2011].

7
On the Problematic Productivity of Hype: *Flashforward*'s Promotional Campaign

Enrica Picarelli

Introduction

When, in May 2009, American television networks presented their fall line-ups, ABC's schedule was especially ambitious. Compared to the previous year when it had offered few original shows, the network now introduced seven productions based on a 'portfolio approach' that catered to different tastes and cost/production strategies (Berman, 2009). Among the additions to the line-up was *FlashForward* (ABC, 2009), a science-fiction drama that soon became the object of speculation. The series focused on a group of FBI agents investigating the consequences of a blackout that causes the entire world to lose consciousness for 2 minutes and 17 seconds, during which time everyone has a vision of themselves on 29 April 2010.

Launching its marketing debut in the weeks preceding the annual upfront presentation, when broadcasters sell their airtime to advertisers, ABC pursued aggressively *FlashForward*'s campaign as a game-changer in television promotion. The network's marketers believed that multiplexity (promotion through multiple platforms) and interactivity could instigate new practices of audience consumption and bring ABC to the forefront of cross-media promotion. The goal of the campaign was, indeed, nothing less than to revolutionize consumption practices by creating an 'experience' that enveloped prospective viewers, as in a role-playing game. Announcing the upcoming programme that would put the meaning of memory under scrutiny, the campaign set out to train audiences into perceiving not only the fictional universe but also their own world and their relationship with it, in a more intense way.

Through these means ABC hoped to secure a stable following for its production in advance of the premiere. Yet, in spite of a substantial marketing effort and initially positive ratings, *FlashForward* lost favour with the audience and was not renewed for a second season.

Employing *FlashForward*'s campaign as its case study, this chapter addresses the changes undergone by television advertising in its 'beyond broadcast moment' (Evans and Jaye, 2011, p. 105). In this respect, the clairvoyance motif that sustains the narrative, where characters are compelled to act upon their future, works as a metatextual source of analysis of the speculative mechanisms governing television promotion. What do commercial strategies, operating in a chaotic multimedia landscape, suggest about 21st-century television marketing? *FlashForward* offers a starting point to understand how the pre-emptive management of the time of consumption influences current conceptions of audience engagement.

This chapter addresses *FlashForward*'s promotion, mapping its expansion both in terms of ABC's penetration into the viewers' lives by means of ambient promotion, and recourse to multiple technologies of media consumption. This mapping envisions a strategy of anticipative engagement that attempts not only to colonize the lives of prospective viewers with promotional messages, but also to ensure that their expectations become productive for the network's development of the show. In this respect, promotion operates not to impose a single message and set of meanings about *FlashForward*. On the contrary, my analysis reveals that promotion gets productive the moment it becomes inspirational of a potentially infinite universe of 'storyworlds' that the audience is incited to conjure and keep alive. The chapter contends that *FlashForward*'s promotion offers itself as a grid, or web, to capture bottom-up invention, at the same time that it provides audiences with new technologies and techniques of engagement with the series. The conclusions reflect on the shortcomings of this speculative approach, contending that it highlights a discrepancy between ABC's 'brand image' and 'brand identity'.

Surprise effect and 'visceral' engagement in *FlashForward*'s teasers

FlashForward's marketing campaign began five months before the show's US premiere of 22 September 2009, with the airing of four teaser trailers on ABC. The 5-second teasers show cursory views of day-to-day activities, presenting them as if they were amateur videos, followed by a cut to black and a title card (a frame reproducing a typeface writing),

with the question 'What did you see?' emerging in light ink from a black background.[1] The main act of these extremely brief commercials is constituted by the actual 2-second clips, which fill a small portion of the otherwise dark screen, as they are placed either at bottom left, left, centre top, centre right or top right corner. The clips show a foetal sonogram, a man surfing, a couple kissing on their wedding day, a funeral and a group of children leaving school. Their poor quality and unfiltered audio, reproducing contingent noise, give the impression that a casual participant filmed them with a hand-held device. As the clips appear onscreen a noise is heard, similar to the one produced when turning on an old television set, and a voiceover comments: 'Just because we saw these things it doesn't mean they're gonna happen.' These elements establish that the 'amateur' clips are being watched within a presumably classified context of reception, a presupposition corroborated by the sudden cut to black and the title card. The switch sound conveys the impression that the clips are being screened for an audience, while the voiceover's apprehensive tone indicates that they might be related to a situation of some concern.

This puzzling spectacle, and its ambivalent status as an object of entertainment and curiosity, establishes the commercial value of the teasers as clips that persuade individuals into taking an interest in the forthcoming series. Its ephemeral nature is a hook to mobilize the attention of casual viewers and titillate them with a mystery: what were these videos and why were they broadcast on television? The grainy texture and baffling content represent the images as if they belonged to a private archive, while the use of the card, noise and voiceover suggest they might be employed as evidence in an investigation. Furthermore, the televisual broadcasting draws attention to the role played by the promotions within a double process of mediation and the kind of relationship it might incite. Since the screening of the clips inferred in the presentation is, in turn, screened on television, the audience's viewing of the (alleged) findings of unknown sources is implicated as somehow voyeuristic and complicit with their mysterious appearance.

This premise, coupled with the unusually short duration of the commercials (at 10–25 seconds the teasers are much shorter than traditional trailers which last 1 minute or more), implicates them, and the series they advertise, as innovative. Although full trailers were eventually circulated, along with other promotional material, the five teasers first launched the series and for this reason their aesthetics and odd presentational logic acquire a special significance in terms of how ABC built its campaign and how word about *FlashForward* began to circulate.

Michael Benson (2009b), executive vice president for marketing at ABC at the time of *FlashForward*'s production, maintains that the teasers were released as part of an experimental campaign that intended to 'surprise' viewers. To this end, the production purposely eschewed to show the series' logo, so that, on their first airing, the clips would appear unrelated to any programme. Presumably, it was expected that, as atomized narratives floating freely through private and public contexts of representation and reception, their circulation would momentarily trigger a (micro) media event of contagious engagement and curiosity. Emerging fleetingly and intermittently from the metaphorical and material darkness of the screen that embedded them, the teasers performed not the associative law of promotion, but offered viewers an unexpected spectacle, at the same time inciting them to take time to guess its purpose.

The brevity of the teasers was part of ABC's launch of a campaign that circulated through multiple media formats and technologies. Although in the same years other shows (like *Lost* [ABC, 2004–2010], *Heroes* [NBC, 2006–2009] and *Battlestar Galactica* [SyFy, 2004–2009]) were testing various formats to promote and distribute abridged content, *FlashForward*'s teasers offer an interesting example of how video scalability implements virality.[2] Here, scalability refers to the practice of devising cost-effective contents of short duration for shows to circulate through multiple platforms of distribution. This format draws attention to television's current investment in modular productions and its capitalization of textual ephemera (Dawson, 2010). Such a new class of audiovisual formats assists viewers in catching up with shows *in medias res*, offering comprehensive summaries of single episodes or seasons through 3–6-minute videos. The turn to brevity modulates the temporal boundaries of the television text and fits the hard-pressed lifestyle of audiences, generating revenue from compressed storytelling.

FlashForward's teasers, however, did not provide a synopsis of the series. Although ABC eventually resorted to other paratexts to guide the audience's reading of the show, the teasers' broadcasting created a moment-intensive experience devoid of epistemological signposts. Compared to other typologies of video abridgements that summarize intricate narratives for busy viewers, the brevity of *FlashForward*'s teasers was indeed not supposed to qualify the reputation of the series and its format of 'inscrutable complexity' (Dawson, 2010, p. 45). In Benson's intentions (2009a), the campaign had rather to generate a 'visceral' response, sparking spontaneous conversation among interested viewers on the Web and social networks, while not 'giving away too much' of the narrative.

Before the release of the full-length trailers in September 2009, which presented the series' genre/plot as a science-fiction drama, ABC used the teasers' cryptic spectacle to create a perceptual backdrop that enveloped the images in a certain mood. Their amateur aesthetics and lack of associative meanings with the future narrative prevented viewers from familiarizing with the fictional universe, at the same time that they absolved their advertising function of announcing the coming of a new feature. In the minds of the marketers, the scarcity of content, coupled with the aura of mystery surrounding the commercials, would spawn curiosity and pre-emptively build an audience pool. In this respect, the operativity of the teasers diverges from that of regular trailers, offering an immediate spectacle where mood, sound and editing supersede exposition. In fact, whereas as a rule trailers use multiple generic features to 'maintain a relationship to the narrative they promote' and provide information on the advertised show (Kernan, 2004, p. 7), *FlashForward*'s non-expository teasers employ the affects and attitudes associated with its distinctive style to deliver a cluster of almost 'atmospheric' impressions.[3]

Engineering this atmosphere is a core performative aspect of the campaign, as it recurs to sensorial engagement to establish a reciprocal relationship between images and viewers. As Benson (2009b) explains, the goal of the promotion was to 'experience the life' of targeted audiences by creating a campaign that 'surround[ed] them' and made them feel like they were being 'entertained, not pushed'. In this sense, the teasers' impressionistic appeal worked as a social aggregator, where affective resonance supposedly piped attention. The statement reveals ABC's intention to invite a typology of reception where the affective impact of the teasers would initially supersede their epistemological appeal (as a mystery narrative to decode) as a vehicle of socialization. Benson's approach turns to account the viral aspects of communication, seeking to turn viewers into 'ambassadors' (2009b) for his show. In this context, ABC's approach reflects entrenched strategies of advertising that view promotional materials as extensions of an expansive audience experience with a series. Such vision promotes an effort to push viewers to incorporate fictional works in their everyday lives (Abbott, 2010), inviting them to produce their own material on it (Epstein et al., 2006).

Ambient promotion: *FlashForward* goes social and viral

As its first promotional tool, ABC relied on teasers to create an atmosphere of mystery. The teasers were initiators; soon their circulation flowed into a larger campaign that gave substance to the first

impressions, experimenting with a number of strategies to further surround prospective viewers. A major event took place in July 2009, when a video booth was installed at Comic-Con, San Diego's annual popular culture convention, where attendants shot clips of themselves reporting their own 'flash forwards'. The event built on *FlashForward*'s premise, according to which the entire world loses consciousness for 2 minutes and 17 seconds, during which time everyone has a vision of themselves on 29 April 2010. While the initiative exploited Comic-Con's acclaim among pop-culture audiences to gain visibility, it also capitalized on the desire of individuals to participate in the fleshing out of a fictional world. By recording their own visions, attendants appropriated the narrative universe, adapting a scant premise to accommodate their fantasies, at the same time implementing *FlashForward*'s 'storyworld' and providing free content for both the viewers' community and ABC's writers to exploit. Although none of the recorded videos were incorporated in the show, the initiative mined the creative resources of the attendants for promotion and potential narrative implementation (Picarelli, 2010).

Appealing to the attendees' imaginative power and disposition to share their experiences, the Comic-Con booth catalysed the emergence of an 'ethical surplus' (Arvidsson, 2005, p. 237) of social relations, shared meanings and emotional involvement with the series and among the participants. A virtuous word-of-mouth effect was triggered, sparking online conversation and 'live testing' for pre-emptive feedback from a growing mass of enticed fans (Graser and Levine, 2009).[4] To further capitalize on the initiative's promotional potential, ABC also aggregated the videos on YouTube's dedicated channel Join the Mosaic, which, at the peak of its popularity, contained over 500 clips. Subscribers to the channel added their 'flash forwards' to the comments section of each video, using tags to connect their visions to those of other people and follow the flow of updates in real time. Again, this move sought to implement the viral potential of the campaign by addressing individuals not as consumers of pre-made texts, but as conduits for content dissemination.

To this end, ABC further expanded *FlashForward*'s Web presence by creating a number of Internet destinations where users could retrieve material and make individualized experiences of the show. The '*FlashForward* Facebook Experience', for example, employed users' information, such as status updates, to randomly generate visions of their future that could be embedded on other Facebook walls. On 16 August 2009 the site Mosaic Collective appeared as an online video archive containing clips regarding the blackout. The videos were recorded

by professional actors and conceived as part of ABC's ongoing effort to keep up with the show's evolution. By being constantly updated, the page became a companion of the televised event where viewers discussed and deciphered additional clues. Finally, in July 2009 the network established the forum www.weflashforward.com (which was later removed from the Web) to help 'fans from around the world [...] flashforward together [...] sharing news, discussion, theories, enthusiasm and fandom for ABC's new SF/drama series' (WeFlashForward).

Other Web pages were eventually added to ABC's promotional network, including the Twitter profile and video-blog, TruthHack, of the fictional character Oscar Obregon, a journalist who had begun investigating the causes of the global blackout at Comic-Con. Embedding social networking in its marketing strategy, ABC hoped to fuel a sustained, bottom-up buzz about the new feature. Mel Rodriguez, the actor playing Obregon, appeared at the convention, interviewing those coming out of the booth and uploading clips on his blog. The initiative replicated a similar stunt made by Jamie Silberhartz at *Lost*'s panel at 2006 Comic-Con. On that occasion, Silberhartz performed the role of Rachel Blake, a woman who investigated the Hanso Foundation, a corrupt organization from *Lost*'s universe and a major narrative element of the alternate reality game *The Lost Experience*.[5] As Derek Johnson (2008) points out, Blake's appearance was a successful example of the commercial viability of television's hyperdiegisis. The initiative established *Lost*'s institutions and characters as 'coterminous with our own', turning them into 'key institutional players' (p. 38) in the broadcasters' effort to keep viewers engaged.

Both Blake and Obregon's marketing stunts are experiments in 'ambient promotion', a marketing strategy that approaches viewers in an expanded range of everyday spaces. Not too differently from other campaigns launched in recent years, through social networking and initiatives like Comic-Con, ABC aimed at 'getting up close and personal' (Moor, 2003, p. 43) to its desired audience.[6] Engaging individuals as pop-culture enthusiasts, the network permeated their spaces of leisure with sources of entertainment. Coupled with the turn towards atmospheric telepromotion, ABC's ambient marketing substantiates Benson's plan of an intensified media experience. Not only did the Comic-Con initiative attach a concrete identity to *FlashForward*, it also turned it into a 'rich source of sensory, affective, and cognitive associations that result in memorable experiences' for media consumers (Moor, 2003, p. 44).

Ultimately, the spatialization of *FlashForward*'s marketing message contributed to harness and shape the attitudes of would-be viewers

according to the promotional goals of the television network. As the campaign expanded its range to encompass social media, its atmospheric and ambient elements implemented the resonance of the series. Writing a few weeks after the premiere, Stephen Brook (2009) reported that in the summer of 2009 *FlashForward* had been sold to more than 100 territories, becoming the fastest-selling television programme by Disney, ABC's parent company.

Creating hype through paratextual associations: *FlashForward* as 'the next *Lost*'

ABC's promotion of *FlashForward* exploited curiosity and the viewers' ability to fill in gaps of knowledge to build awareness and expectation. However, although the atmosphere of mystery surrounding the show was an important vehicle of word-of-mouth, the network created hype also by letting key information pass that would link *FlashForward* to other successful ABC productions.

The beginning of *FlashForward*'s campaign coincided with the rise of a journalistic interest in the series, after *The Hollywood Reporter* published news of ABC's imminent broadcasting of the enigmatic teasers (Andreeva, 2009). The article stirred the curiosity of influential television critics, inspiring speculations on a *Lost*-like production that would replace J. J. Abrams' island drama during its seasonal hiatus and eventually after its end, scheduled for Spring 2010 (Fernandez, 2009). In the ensuing five months, the purported continuity between the two series produced a framework of interpretation that resulted in the labelling of *FlashForward* as 'the next *Lost*' (O'Connor, 2009). Corporate sources confirmed that the new series indeed shared many of *Lost*'s features: notably, Suzanne Patmore-Gibbs, ABC's executive vice president of drama development, declared that both narratives dealt with the consequences of a collective, life-changing experience (Fernandez, 2009).

ABC needed to replicate its success with Abrams' science-fiction drama and, through the text-specific meanings of *FlashForward*'s teasers, its campaign drew explicit parallelisms between the two programmes. Debuting in September 2004, *Lost* had turned into a global hit, giving ABC its strongest ratings since the late 1990s and constantly figuring as the most-watched programme of its timeslot. In its first two years of broadcasting, the series had averaged 15.5 million viewers, becoming the second most popular show in 20 other countries. It was not by chance then, that the first broadcast of *FlashForward*'s teasers took place during the commercial breaks of *Lost*'s 100th episode 'The

Variable', where a character travels through time facing questions of destiny and free will. A similar concern with transience and impermanence runs through *FlashForward*'s promotion. The fleeting status of the scenes glimpsed at in the promotions implicates viewing as remembering (something that the voiceover also hints at) and television as a medium of recollection and (figurative) time travel. Moreover, the minimalist visual style of the card asking 'What did you see?' imitates *Lost*'s logo, where the title, appearing in white from a black background, swirls to the centre of the screen and sinks back into darkness. The representation of narrative moments of evolution and disruption and of life-changing situations is reflected in the industrial concerns relating to *FlashForward*'s identity as a valuable companion to *Lost* (O'Connor, 2009). Through the serendipitous juxtaposition of corresponding motifs in *Lost*'s diegesis and the ephemeral textuality of *FlashForward*'s promotions, ABC uses the latter's campaign to refer to its own future as a purveyor of quality entertainment (Pearson, 2009).

The insertion of *FlashForward*'s promotion within *Lost*'s special episode therefore emphasizes the role that the former series played in boosting the network's previously plummeting ratings (Kissell, 2004). More than just a symbolic milestone in the evolution of *Lost*'s broadcasting history, 'The Variable' signals a phase of both accomplishment and becoming, of recollection and anticipation for ABC. Since *Lost* had already set a date for its finale, the network needed to secure its audience's loyalty by providing a valuable alternative to Abrams' series. The beginning of *FlashForward*'s campaign took place at a moment of redefinition, where the network probed its post-*Lost* identity as a supplier of competitive entertainment. The teasers reflect ABC's concerns about itself and its place within the crowded and competitive world of US television. Relatedly, they invite an investigation into the role that official and unofficial paratexts, such as commercial videos and journalistic articles, play to instigate a process whereby expressing one's (purportedly informed and acclaimed) expectations about a series produces a form of anticipative branding.

As stated at the beginning of this section, a rich discursive apparatus appeared on blogs and paper publications dedicated to television, further amplifying the circulation of enthusiastic discourses on *FlashForward* (Schneider, 2009). The predominant readings encountered in such literature enumerate different production features as a guarantee of the show's high quality (Metacritic *FlashForward: Season 1*). For example, they underline emphatically that the programme was produced by acclaimed authors David S. Goyer (screenwriter of *Batman Begins* and

The Dark Knight) and Brannon Braga (executive producer of *Star Trek: Enterprise, 24* and *Threshold*); that it would employ a cinematographic, high-budget style; rely on a complex mythological structure based on an original book by Robert J. Sawyer, and hire a large ensemble cast. Commentators favourably speculated on the show's plot, genre and cast. These discourses established layers of relevancy and hierarchies of meaning about the show, in their turn, influencing audience's expectations. Certainly, they enhanced the sense of excited expectation that ABC was building into its campaign, contributing to inflame the industry-induced hype by infusing approval into the meanings they were pre-creating.

Referring to such discursive apparatuses as 'paratexts', Jonathan Gray (2010) argues for the role of critics as pre-decoders who 'hold the power to set the parameters for viewing, suggesting how we might view the show (if at all), what to watch for, and how to make sense of it' (p. 167). Already on its first airing, ABC's promotion foregrounded the intention to predetermine the reception of *FlashForward* by synchronizing its appearance within *Lost*'s broadcasting flow and thematically associating the two series. In the ensuing months, members of ABC's production team and cultural critics alike further coded the show as a 'cult' narrative, presenting it as sophisticated television able to 'cater to intense, interpretive audience practices' (Gwellian-Jones and Pearson, 2004, p. vxi). Benson (2009a) declared that the campaign was predominantly aimed at *Lost*'s '18–54 and younger male audience', while David Goyer, co-executive producer, admitted that they 'would be thrilled with half the rabid fan base of that [Abrams'] show' (O'Connor, 2009). Other critics also enhanced the excitement that ABC had coded into its viral campaign, by focusing on those aspects that presented *FlashForward* as a science-fiction drama/thriller in the style of *Lost*, speculating on its complex narrative involving a disjoined timeline, and elaborate mythology encompassing a large number of protagonists (some of which were played by actors borrowed from *Lost*'s team) and subplots (Poniewozik, 2009).

The ensuing effect was that, prior to its premiere, *FlashForward* became part of a large process of industrial redefinition and intertextual referencing that strove to influence the audience, as well as the series' development. Its paratextual coding as an engaging cult narrative, coupled with its viral spread and experiential feel, accounted for a promotional strategy that redefined ABC's image as a purveyor of 'event' television. Furthermore, by feeding industry-produced hype to interested viewers, both ABC marketing staff and an almost unanimous collective of

critics, pre-emptively channelled and modulated the public response to the series.

Digital marketing

Coded as a companion piece to *Lost*, as well as a genre production incorporating an array of successful motifs, ABC's atmospheric and ambient marketing of *FlashForward* only partially relied on narrative originality to drive ratings. The main vehicle of the promotion was, instead, the multi-media campaign that ABC commissioned to Microsoft. The effort, which played across mobile phones, game consoles and computers, had to maximize awareness among users of competitive leisure platforms and differentiate *FlashForward* from other sci-fi dramas. This was also a further attempt to replicate *Lost's* success, since its multiplex campaign had itself attracted a considerable number of viewers, proving to be an important vehicle of audience consolidation (Abbott, 2009). *FlashFoward's* promotion was similarly predicated on a synergistic vision whereby a positive viewer's response would supposedly derive from a multiplex approach.

In his presentation of the show's campaign at Advertising Week 2009, Scott Howe (2009), advertising executive at Microsoft, argued that ABC's integrated 'rich media execution' approach was motivated by the growth of online media consumption and by the changes that technological evolution imposes on television viewing. Alongside traditional practices of broadcasting connected to fixed industrial schedules, ABC demanded that more personalized solutions would be devised to cater to the idiosyncratic consumption styles and contexts of consumers' reception. *FlashForward's* promotion was conceived to operate in what Elizabeth Jane Evans calls the heterochronic, 'beyond broadcast space' of 21st-century television: a realm where contents distributed on the Internet, mobile phones or game platforms supplement and enhance 'the ephemerality of television's 'broadcast moment' until that moment is only part of the television experience' (Evans and Jaye, 2011, p. 105).

Microsoft's digital solution therefore addressed potential viewers both as spectators of cult shows and technology-savvy consumers (Shields, 2009). This approach sought to foster alternative formats of entertainment by capitalizing on individualistic consumption of media technologies. According to Benson (2009b), the ultimate goal of motivating viewers to tune in to ABC, that they could experience the show as a 'communal event', would be met by engaging the viewers as active controllers of both the contents and contexts of consumption.

Accordingly, Microsoft ran advertisings across the mobile versions of MSN and Windows Live, capitalizing on its partnership with telecommunication company Verizon to provide additional banners for the show on the Verizon mobile homepage. The adverts allowed users to watch a *FlashForward* trailer, download a wallpaper or set a reminder for the show's broadcasting on a mobile WAP site. Additionally, Microsoft placed *FlashForward* banners on the main interface of the game console Xbox Live. Through them, users accessed a 'Branded Destination Experience' containing a 15-minute preview of *FlashForward*'s premiere episode. Microsoft also devised select in-game advertisements that appeared as 'hot titles' while users where immersed in game environments. Figuring in top-selling features, such as *Guitar Hero* and *Need for Speed*, the titles expanded *FlashFoward*'s audience basis by appealing to a burgeoning mass of players. The campaign launched through the MSN home page also incited computer users to tune in for the premiere. The advert showed an animated orb, which consisted of shots of the characters, moving across the page to embed themselves in the right hand ad banner. Eventually, the images would travel to a banner located at centre screen, entitled 'Meet the *FlashForward* cast'. Once clicked, the banner revealed a dedicated site where users could watch footage of the show.

Additional destinations where individuals could engage with *FlashForward* in advance of its broadcasting were also created at Wonderwall and MSN TV. In the first case, the content destination showed a homepage featuring the show's logo, trailer, banners and premiere date. Similarly, Microsoft placed adverts on MSN TV linking users to a *FlashForward* page replete with cast information, videos, a widget counting down the days to the premiere and a comments section. Finally, ABC's interactive marketing included the placement of 'arvertisements' into print magazines. This form of coded print promotion, which ran in the September 2009 issues of *Popular Mechanics* and *Wired*, would provide an interactive engagement with the series so that, when held up in front of a webcam, the codes could be clicked on to show extended clips of *FlashForward*'s episodes. Discussing this promotional solution, ABC's vice president of marketing Darren Schillace maintained: 'Once you watch all the videos, it's a 10-minute experience. In the normal world, you'd never spend 10 minutes with a print ad' (Schneider, 2009).

Deeming the campaign a success, Microsoft linked the quantitative outcomes of the campaign to qualitative results and contended that the convergence of multi-platform advertising and digital marketing positively generated audience optimization and ABC's primary goal of 'mass

reach'. In a case study on ABC's multi-screen advertising, Microsoft notes that, by delivering 'nearly 3.8 million impressions [advertisement views]' and 'more than 1.8 million total consumer interactions' the campaign guaranteed that ABC won the Thursday evening spot. 'ABC captured first place in overall viewership, beating out CBS by 1.3 million viewers. [...] *FlashForward* won the coveted 8:00 P.M. spot contest for viewers and was ABC's best performance in that timeslot in 20 months' (Microsoft 2009). Indeed, the series' premiere rated 4.0 in the desired 18–54 male demographics, attracting 12.47 million viewers (Seidman, 2010).

As with its viral and social media campaign, ABC's multiplex marketing aimed at building audience awareness, investing substantial amounts of capital and creative potential in the deployment of an interactive promotion. Ultimately, Microsoft's multiplex approach can be regarded as the defining feature of the whole campaign as it provided ABC with a particular kind of networked media space in which adopters of digital technologies could be converted into *FlashForward* fans. The recourse to digital technologies as primary platforms of aggregation is, in this sense, explicative of ABC's overall approach and production of both its audience basis and place within a changing media landscape. Addressing individuals familiar with consuming programmes on (relatively) new leisure technologies, the network sought to lead television's industrial transition towards its post-broadcast moment of personalized viewing and interaction. As Steve McLellan (2010) reports in an article on social media's contribution to the recent (and short-lived) rebirth of appointment television, towards the end of the last decade social media and technology changed not only television viewing, but also practices of audience engagement. Tweeting or posting comments on Facebook about television series often takes place at the moment of consumption, inviting live participation more than forms of *a posteriori* commentary: 'Increasingly, the networks are doing 'watch-and-tweet' promotions, where they urge Facebook fans to watch a program and tweet with their friends about it during the telecast' (McLellan, 2010).

Multiplex promotion is therefore conducive of a significant change in communication and consumption practices where display technologies are sold as 'stars' in themselves (Johnston, 2009, p. 21). Increasingly in the last decades, the innovative scale and scope of media spectacles and their technologies of reproduction have paved the way to larger shifts in the way that society interprets and perceives the media experience. Keith Johnston (2009) maintains that advertisements for Hollywood films, for example, have been conceived as arenas of differentiation, where

technological improvements are deployed as commercial weapons and sources of consumer aggregation. With the explosion of available television channels and programmes, and the concomitant fragmentation of the media landscape, the marketing function of technological upgrading has acquired even greater significance. The advent of alternative platforms of viewing has also determined that promotional distribution be freed from the constraints of the television schedule, while, at the same time, the audience has evolved 'from mass spectator to individual participant, from unwilling recipient to willing consumer, and from passive viewer to active controller' (p. 147). Foreseeing the effects of these factors on mass enticement, marketers have struggled to anticipate the uses that potential audiences would make of promotional objects and discourses. *FlashForward's* campaign is indicative of a clash of visions. On the one hand, the promotion relied on familiar processes of codification that emphasize its genre and celebrity appeal, addressing potential viewers as avid consumers of science-fiction's mythology, as well as fans of renowned actors. On the other hand, presenting technology as a star in itself, ABC attempted to refashion both the hermeneutics of viewing and the phenomenology of media consumption. Engaging its public as a community of viewers and media users, the network turned to updated technical and infrastructural means as its main source of revenue.

ABC's digital campaign for *FlashForward* capitalized on these transformations, experimenting as much with new technologies of distribution as with new practices of communication and audience involvement. As an outcome, the nature of the promotion itself changed, shifting towards advertising formats that incited attachment based not on the lure of storytelling, but on entertaining marketing.

Conclusion: Brand identity is not brand image

By moving *FlashForward* into the realm of the everyday, ABC created an expansive universe that audiences could fill with their own expectations and emotions. Its experimental effort and investment in multiplexity (both to produce and disseminate promotion) generated revenue from exploiting alternative leisure platforms and advertising formats. This approach promoted the realization of advertisements for personalized consumption by emphasizing their mobile status, as trailers, teasers and previews could be watched on portable media and disseminated on social networking sites. Relatedly, the campaign shifted its focus from generating knowledge about *FlashForward* to pre-emptively

inviting socialization, in the meantime modulating multiple practices of engagement.[7] The technological appeal of leisure technologies and their networking potential became the preferred means to experiment and extract value from new methods of aggregation. Here, the promotional goal shifted from creating content to modulating the range of best-possible emotions that would guarantee the series a sustained following.

Accordingly, the marketing style became itself a typology of affective delivery based on the modulation of a certain mood where mystery and infrastructural innovation (multiplexity) branded the production as a generator of sensations. The choice to advertise *FlashForward* by digital means was seen as a way to confer value to the show and a particular kind of credibility to audience members. In fact, the goal of Benson's and Howe's marketing philosophy seemed to be that of creating a one-to-one relationship between the audience and the platforms that would also exploit each medium's specific potential, addressing viewers as technology 'fans'. It was hoped that by being identified as technology-savvy individuals, viewers would promote alternative ways of watching and actively contribute to ease ABC's move into its post-broadcast moment by integrating the series into the immaterial realm of social networking. At the same time, by circulating contents and generating engagement through social media, ABC also hoped to motivate viewers to 'change their behaviour' (Benson, 2009a) towards technologies other than television. This would aid familiarization with other forms of media delivery that were being distributed similarly in a multimedia fashion, either by the channel or its parent company Disney.

Yet, ambient promotion, viral marketing and multiplexity proved ultimately unsatisfactory and *FlashForward* was not renewed for a second season. Although these strategies combined to spark interest and build awareness in advance of broadcasting, they were unable to motivate the audience's sustained commitment. Hundreds of users posting on Television Without Pity's forum '*FlashForward* General Gabbery', for example, derogatorily commented on the series' inconsistencies and exaggerated convoluted plot, often lamenting that it did not attempt to 'solve the inherent dilemma of time-travel stories' ('*FlashForward* General Gabbery'). Although the opinions expressed in the forum only partially denote the audience's ultimate disaffection with the series, they indicate an important aspect of ABC's failed attempt to transform its promotional success into a broadcasting hit. In fact, whereas ABC's spokespersons implied that *FlashForward*'s campaign set the ground for an engaging spectacle, the network failed to deliver just that. Audience

frustration with a series that could not keep up with its promotion can be taken as an indicator of *FlashForward*'s quickly deteriorating ratings that, already in midseason, dropped to below 6 million viewers (the premiere had been launched to an American audience of nearly 16 million) (Seidman, 2010).

The failure to deliver content that would keep up with the hype brought to the foreground the ambiguities of ABC's strategy of temporal management. The case of *FlashForward* evidences that promotion and actual broadcasting do not operate on the same level and have different goals. If the former operated within a (relatively) compressed timespan to aggregate audiences and meet the four imperatives set out by Benson to 'build awareness, generate buzz, drive intentive viewers and get people to tune in' (2009b), the latter did not uphold them. As a series, *FlashForward* had, first of all, to deliver narrative appeal, but it lacked just that, as its bad ratings in other countries also attest.

Ultimately, *FlashForward*'s campaign shows the impossibility to predetermine the success of a series based solely on its promotional outcomes. Tapping the potential of social networking to enhance a campaign of viral marketing and contagious word-of-mouth implies endowing audiences with the power to have the last word on a channel's branding strategy. As Adam Arvidsson writes, there is an inherent ambiguity in the concept of 'brand', since whereas ' "brand image" denotes consumers' perception of a brand [...] "brand identity" denotes the perception that management intends to have' (2005, p. 254). In *FlashForward*'s case, once the series was launched, ABC's new multiplex identity as a post-broadcast, post-*Lost* channel did not agree with the audience's expectations about the brand as a purveyor of engaging, mind-challenging narratives.

Notes

1. Since 2009, the teasers have circulated in multiple forms. For my analysis, I'm relying on two abridged versions retrieved on YouTube: http://www.youtube.com/watch?v=ZH0cBn4i7h0 (Leuthen, 2009a) and http://www.youtube.com/watch?v=EexC0XZBczU&feature=related (Leuthen, 2009b).
2. Although the teasers were produced to air on ABC, they instantly found their way onto the Web, where they could be watched on YouTube.
3. Research on atmosphere emphasizes the aggregative and generative dimension of promotional materials. Kathleen Stewart observes that an atmosphere is 'a force field in which people find themselves [...] – a capacity to affect and to be affected that pushes a present into a composition, an expressivity, the sense of potentiality and event. It is an attunement of the senses, of labors, and imaginaries' (2011, p. 452).

4. The same strategy where narrative development and social relations are built into the promotion of an upcoming series has been successfully adapted by other shows, most notably *Lost* (Johnson, 2010).

5. As Obregon, Blake does not appear in the actual televised show, but only in its extra-textual marketing campaign.

6. On ambient marketing see Elizabeth Moor (2003).

7. In the face of this recent evolution of marketing strategy, a further analytical question would be: how are affective economics, and their focus on inclination rather than discursive reproduction, reshaping the field of reception studies?

Bibliography

Abbott, S. (2009) How Lost Found Its Audience: The Making of a Cult Blockbuster. In: Pearson, R. (ed.) *Reading Lost: Perspectives on a Hit TV Show*. London and New York: I. B. Tauris, pp. 9–26.

Abbott, S. (ed.) (2010) *The Cult TV Book*. London: I. B. Tauris.

Andreeva, N. (2009) 'Lost' to Host Stealth Campaign for 'Flash Forward'. *The Hollywood Reporter*, 23 April. Available from: http://www.reuters.com/article/entertainmentNews/idUSTRE53M17Y20090423?feedType=RSS&feedName=entertainmentNews [Accessed: 13 November 2009].

Arvidsson, A. (2005) Brands: A Critical Perspective. *Journal of Consumer Culture*, 5 (2), 235–258.

Benson, M. (2009a) Video Interview at Advertising Week. *Advertising Week*.

Benson, M. (2009b) Interview with Scott Howe. *Advertising Week*. Available from: https://www.youtube.com/watch?v=sSVB3BBHizw [Accessed: 24 September 2014].

Berman, M. (2009) ABC and Fox Unveil Fall 2009 Schedules. *AdWeek*, 19 May. Available from: http://www.adweek.com/news/television/abc-and-fox-unveil-fall-2009-schedules-112325 [Accessed: 10 October 2012].

Brook, S. (2009) FlashForward is Fastest-selling Disney Series Ever. *The Guardian*, 5 October. Available from: http://www.guardian.co.uk/tv-and-radio/2009/oct/05/flashforward-fastest-selling-disney [Accessed: 14 December 2011].

Dawson, M. (2010) Television Abridged: Ephemeral Texts, Monumental Seriality and TV Digital Media Convergence. In: Grainge, P. (ed.) *Ephemeral Media*. London: BFI, pp. 37–57.

Epstein, M., Reeves J. L. and Rogers M. C. (2006) Surviving the Hit: Will The Sopranos Still Sing for HBO? In: Lavery, D. (ed.) *Reading The Sopranos: Hit TV from HBO*. London: I.B. Tauris, pp. 15–26.

Evans, E. J. and Jaye, V. (2011) The Evolving Media Ecosystem: An Interview with Victoria Jaye, BBC. In: Grainge, P. (ed.) *Ephemeral Media*. London: BFI.

Fernandez, M. E. (2009) ABC Hopes You Saw What It Wanted You to See During 'Lost.' *Los Angeles Times*, 29 April. Available from: http://latimesblogs.latimes.com/showtracker/2009/04/abc-hopes-you-saw-what-they-wanted-you-to-see-during-lost.html [Accessed: 12 December 2009].

FlashForward: Season 1 (no date) *Metacritic*. Available from: http://www.metacritic.com/tv/flashforward/season-1/critic-reviews?sort-by=publication&num_items=100 [Accessed: 21 April 2012].

FlashForward General Gabbery (no date) *Television Without Pity.*
Gray, J. (2010) *Show Sold Separately: Promos, Spoilers and Other Media Paratexts.* New York and London: New York University Press.
Microsoft. (2009) Available from: multiscreen-advertising-abc-tv-flashforward-case-study.pd [Accessed: 24 September 2014].
Graser, M. and Levine, S. (2009) TV Biz Tunes in to Comic-Con. *Variety*, 28 June. Available from: http://www.variety.com/article/VR1118005477?refCatId=14 [Accessed: 16 October 2012].
Gwellian-Jones, S. and Pearson R. E. (2004) Introduction. In: Gwellian-Jones, S. and Pearson, R. E. (eds.) *Cult Television.* Minneapolis, MN: University of Minnesota Press, pp. ix–xx.
Howe, S. (2009) Scott Howe: Advertising Week Keynote. *Bing.*
Johnson, C. (2010) Cult TV and the Television Industry. In: Abbott, S. (ed.) *The Cult TV Book.* London: I. B. Tauris, pp. 135–147.
Johnson, D. (2008) The Fictional Institutions of Lost: World Building, Reality, and the Economic Possibilities of Narrative Divergence. In: Pearson, R. (ed.) *Reading Lost: Perspectives on a Hit Television Show.* London: I. B. Tauris, pp. 29–52.
Johnston, K. M. (2008) 'The Coolest Way to Watch Movie Trailers in the World': Trailers in the Digital Age. *Convergence*, 14 (2), 145–160.
Johnston, K. M. (2009) *Coming Soon: Film Trailers and the Selling of Hollywood Technology.* Jefferson, NC and London: McFarland.
Kernan, L. (2004) *Coming Attractions: Reading American Movie Trailers.* Austin, TX: University of Texas Press.
Kissell, R. (2004) ABC, Eye Have Quit Some Night. *Variety*, 24 September. Available from: www.variety.com/article/VR1117910869?refcatid=10 [Accessed: 16 October 2012].
Leuthen2 (2009a) *What Did You See?* [video online] Available from: http://www.youtube.com/watch?v=ZH0cBn4i7h0 [Accessed: 19 April 2012].
Leuthen2 (2009b) *What Did You See? #2.* [video online] Available from: http://www.youtube.com/watch?v=EexC0XZBczU&feature=related [Accessed: 19 April 2012].
McLellan, S. (2010) 'Watercooler' Chats Spread to the Home. *AdWeek*, 29 March. Available from: http://www.adweek.com/news/television/water cooler-chats-spread-home-101950?page=1 [Accessed: 16 September 2012].
Moor, E. (2003) Branded Spaces: The Scope of 'New Marketing'. *Journal of Consumer Culture*, 3 (1), 39–60.
O'Connor, M. (2009) FlashForward: 5 Burning Questions. *TVGuide*, 24 September. Available from: http://www.tvguide.com/news/flashforward-burning-questions-1010152.aspx [Accessed: 24 September 2014].
Pearson, R. E. (ed.) (2009) *Reading Lost: Perspectives on a Hit Television Series.* London: I. B. Tauris.
Picarelli, E. (2010) 'I hope that it Comes True'. FlashForward's Viral Marketing Campaign. *In Media Res*, 31 March. Available from: http://mediacommons.futureofthebook.org/imr/2010/03/30/i-m-hoping-it-comes-true-flashforwards-marketing-campaign [Accessed: 10 June 2014].
Poniewozik, J. (2009) Test Pilot: FlashForward. *Tuned In*, 17 June. Available from: http://entertainment.time.com/2009/06/17/test-pilot-flash-forward/[Accessed: 24 September 2014].

Schneider, M. (2009) 'Forward' Thinking Campaign for ABC. *Variety*, 3 September. Available from: www.variety.com/article/VR1118008120?refCatId=14 [Accessed: 16 October 2012].

Seidman, R. (2010) Updated: FlashForward's Ratings: Blame the Show, Not the Scheduling. *TV by the Numbers*. Available from: http://tvbythenumbers.zap2it.com/2010/03/28/flashforwards-ratings-blame-the-show-not-the-scheduling/46408/ [Accessed: 28 March 2012].

Shields, M. (2009) Microsoft, ABC Team on FlashForward. *AdWeek*, 21 September. Available from: http://www.adweek.com/news/technology/microsoft-abc-team-flashforward-113526 [Accessed: 30 August 2011].

Stewart, K. (2011) Atmospheric Attunements. *Environment and Planning D: Society and Space*, 29 (3), 445–453.

'WeFlashForward' (No date).

Part III

In the Files and Out There: Curation

8
Audiovisual Archives and the Public Domain: Economics of Access, Exclusive Control and the Digital Skew

Claudy Op den Kamp

Introduction

This chapter is situated within a larger research project looking at copyright law, film archival practices, and the accessibility of archival film and orphan works. In what follows, it will focus specifically on the concept of 'digital skew' – an asymmetry between analogue and digitized collections – which seems to inhibit the visibility of important works of film that are arguably crucial to our understanding of the past. Copyright gridlock has been identified as the main cause of the occurrence of a so-called digital skew in audiovisual archives. Some categories of works can be considered 'legally difficult' indeed; they will not be digitized and made available (as a matter of priority) and therefore contribute extensively to this digital skew. As a consequence of examining the accessibility of works that should be free from any legal restrictions – public domain works – it becomes apparent that even in that category the relation between what is potentially available in analogue form as opposed to its digital copy is skewed. By highlighting the varying practices in which both for-profit and non-profit archives provide access to their public domain works, the chapter reveals how the positioning of the digital skew exclusively within the legal paradigm neglects not only certain economics of archival access but also a contributing factor of a human agenda. The chapter argues that a reframing of the debate is needed and highlights how the digital skew is not to be understood as a purely legal issue, but as a more complex issue in which human agency plays a fundamental role.

In an article in which she discusses the 'celestial multiplex', film scholar Kristin Thompson points out some of the reasons why an online repository in which all (surviving) films would be available will not put in an appearance soon (2007)[1] and that what *is* available is always skewed in some way. One could speak of a so-called analogue skew: moving-image archives, housing the so-called filmic evidence, co-construct the way in which film history is understood; film historians describe and analyse film history based on the films that film museums have collected, restored and provided access to over the course of the years (Lameris, 2007). Film professor and founder of the Orphan Film Symposium Dan Streible emphasizes that the visible part of the archive is only a partial picture, as for various (political, economic, curatorial and so on) reasons 'historians are not seeing most of the films that exist to be studied' (2009, p. ix). The scope of this chapter is too narrow to address the process of skewing in general, and so what follows will focus specifically on copyright issues as a potential catalyst of the digital skew (an asymmetry between analogue and digitized collections) and one of the most important ramifications; the inhibited visibility of important works of film that are arguably crucial to our understanding of the past.

In an article in which she addresses some of the detriments for both copyright holders and the public of not being able to clear moving-image material for digital use due to copyright challenges, Sally McCausland, senior lawyer at Australian broadcaster SBS, addresses the digital skew, which she also terms the 'blockbuster skew':

> The sense of history which comes with access to the whole, or a substantial part, of an archive, is of much greater cultural value than a small selection curated through the random prism of copyright clearance [...]. There is a danger that in the digital age the publicly available cultural history [...] will skew: we will remain familiar with ubiquitous blockbuster programs which are available [...] more than we will remember local [...] programs left in the archives.
>
> (2009, p. 160)

The digital skew has been attributed to the gridlock of copyright (Hudson and Kenyon, 2007) where those categories of work perceived to be 'legally difficult' are often not a priority for digitalization. Orphan works, for instance – works to which the copyright owner cannot be located or identified[2] – pose particular difficulties for archives in large-scale digitization projects. Digitization (and subsequent dissemination) entails copying the work; a copyright-restricted activity for which

permission would need to be obtained from the copyright owner. In the case that the copyright owner cannot be located or identified then permission to copy cannot be obtained. Thus, unclear copyright ownership might lead to the work's preservation and digitization being delayed. But even if, in view of the physical deterioration of the film material itself, for instance, an orphan work does get preserved from further decay and subsequently gets digitized, it is mainly its widespread digital dissemination that is affected. Public archives, which house most of these kinds of materials,[3] can often not afford the risks associated with making the works widely available and digital access to orphan works does not take place at all or, after a certain risk analysis, only with a significant delay. As a result, the visibility of important works of film that are arguably crucial to our understanding of the past might be inhibited.[4] It therefore appears to be clear that as a category, orphan works contribute considerably to the disparity between analogue and digital collections.

It seems, however, that also less obvious categories of works are at play in the digital skew. As a consequence of examining the accessibility of works that should be free from any legal restrictions (public domain works) it becomes apparent in what follows that even in that category the relation between what is potentially available in analogue form as opposed to its digital copy is skewed. By highlighting the contrasting practices in which for-profit and non-profit archives provide access to their public domain works, this chapter argues that the positioning of the digital skew exclusively within the legal paradigm neglects certain aspects of the contemporary economics of archival access, such as the exclusive ownership of the physical (source) materials, and the human agency involved in making moving-image material available.

Public domain works and the digital skew

In what follows, three specific factors will be unpacked further in order to highlight how they influence the digital distribution of public domain works in the context of audiovisual archives: the exact legal status of a work (since this may vary from country to country), the exclusive property of a work and the financial responsibility for their continued preservation. These public domain works, despite their lack of legal restrictions, will turn out to, paradoxically, also contribute to the digital skew. Partially because of aforementioned economic factors of access, this chapter argues that a reframing of the digital skew debate is needed in order to move away from its framing in a solely legal context.

(In-)Exact legal status of a work

Public domain works are relevant, in general and for cultural heritage institutions in particular, as a repository of 'raw material'. The materials cannot only be built upon intellectually but can also be re-used materially, for instance, by artists who work with extant material. The real difficulty according to Law professor James Boyle, is not to validate the public domain's relevance – his own position is that the public domain is copyright's very goal as opposed to its residue – but the real difficulty is defining the exact scope of the public domain. And as long as it is hard to define the exact scope, certain uses of the material will remain inhibited. The difficulty has two components: first, it seems to be difficult to determine what is part of the public domain. Based on what one believes is in or out of the public domain, such as certain exceptions to re-use a work, Boyle argues '[t]here is not one public domain, but many' (2003, p. 62). And second, a work can still be under copyright in one country while in the public domain in another based on the different national rules applicable to protection or duration (Dusollier, 2010). In an article in which she tried to map this 'uncharted terrain', Law professor Pamela Samuelson summarized the public domain as being 'different sizes at different times and in different countries' (2003, p. 148). For the online distribution of such works to continue, it seems important to be able to gauge the size or the exact composition of the public domain, since it entails making them available in many countries simultaneously.

In an article in which they analyse digitization practices within Australian cultural institutions, Hudson and Kenyon conclude that: 'Copyright has had a significant impact on digitisation practices to date, including in the selection of material to digitise and the circumstances in which it is made publicly available [...] and has driven the content of online exhibitions, galleries and databases' (2007, pp. 199–200). It is probably safe to say that this conclusion applies to more countries than just Australia and that copyright appears to have dictated what content is available online in both for-profit and non-profit contexts. However, copyright seems to play more roles than just constraining. In what follows, this chapter will highlight several examples of public domain works that either seem to fade from public view or, alternatively, become *hyper-visible*, based on the distinction between being safeguarded in and distributed by a for-profit or a non-profit archive. As a result, it will be suggested that even works that should be free from legal restrictions also seem to affect the digital skew.

Exclusive ownership

After works have fallen into the public domain and are no longer owned intellectually, what is left in the archives is the material property.[5] There seem to be great differences in the ways in which different kinds of archives provide access to their public domain materials, and therefore in the different ways in which these works skew the parity between analogue and digital collections. Commercial archives will often own the copyright to most of their holdings and will therefore frequently exploit those materials in favour of their public domain holdings, as will be illustrated by a studio archive example. Non-profit archives, conversely, own mostly material property and seldom the rights to the films they safeguard (Thompson, 2007), so for distribution purposes, they benefit from the rights to their works having expired.[6] Whether they are commercial or non-commercial in nature, all audiovisual archives have become involved in what Law professor Ronan Deazley in *Rethinking Copyright* characterizes as the 'interplay between the ownership of the physical object…and the ability to control the subsequent use and dissemination' (2006, p. 124).

Aside from the different philosophical shapes the public domain can take based on what one believes is included or excluded from its aegis, there is also the distinction between what could be considered a 'practical' versus a 'theoretical' public domain. The theoretical public domain comprises works that are in the public domain in theory, but as Samuelson demonstrates, in practice do not really 'reside there': 'A painting from the mid-nineteenth century that remains in a private collection or was destroyed in a fire is, in theory, in the public domain as a matter of copyright law, but its non-public nature or its destruction mean that it may, in fact, be there only in theory' (2003, p. 149; n12). Public domain works are subject to appropriation by anyone, as they can be used '*without the need for permission*' from the copyright owner (Deazley, 2006, p. 107; emphasis in original), but exclusive ownership of the physical materials and a resultant control of the works' dissemination seem to influence adversely this situation as they can be made less accessible. This chapter argues that, just like a mid-19thcentury painting that remains in a private collection, some of the public domain works held by audiovisual archives also reside only in the theoretical public domain. They do not reside in the practical public domain because of their non-public nature combined with the archive's exclusive ownership of the physical materials.

For-profit initiatives

The following two case studies show that when it comes to digital distribution in the for-profit environment, fewer public domain titles seem to be made available. As will be illustrated, in the case of an on-demand initiative of a studio archive, public domain titles are fading from public view, and in the case of a specific high-end DVD label, the works will not even be acquired for possible distribution.

Warner Bros.

The holdings of a studio fall into clearly distinguishable categories when it comes to their legal status: they are either in copyright or they are not. In case they are, the studio will probably own the copyright to most of the works and therefore an upfront investment in the preservation of the work can be made relatively easily. In case the works are not under copyright anymore, the materials are said to be in the public domain, either because the rights have expired or because the rights have been forfeited because of legal technicalities.[7] For the studio, it seems to be easier to recoup some of the preservation and access costs when a work is in copyright, so when it comes to providing digital access to the works online, it will be most likely granted to the works that do have a clear legal ownership.[8] Not being able to control the potential infringement of a distributed public domain title seems to lessen the attraction of pursuing the digital or online dissemination of such a title.

In the case of online access to public domain works, it seems that the studio chooses to reduce their availability, as was illustrated by George Feltenstein[9] during his presentation at the Reimagining the Archive conference at the University of California, Los Angeles, in November 2010. While presenting Warner Bros.' new DVD-on-demand website,[10] he outlined that of the approximately 7,800 Warner feature films,[11] some 4,100 were distributed on VHS and, in 2009, 1,700 feature films had come out on DVD. The DVD-on-demand website was launched in March 2009, and what started with 150 digitized titles, had grown two years later to approximately 1,000 titles, including '10 per cent of the library that likely would not have made it to DVD before' (Feltenstein, 2010). An apparently new niche for archival material had been tapped into; the 1,000 titles were not exclusively theatrical feature films that were released before; they also included 'short subject collections' previously not distributed. At the same time, however, while the ultimate goal is to 'make the whole Warner library available to everyone with the best possible quality' (Feltenstein, 2010), the site features hardly any public

domain titles. The lack is most visible in the absence of films with a theatrical release date of before 1923,[12] the cut-off date in the USA before which all creative works are deemed public domain automatically. In the case of Warner Bros., this chapter suggests that in the shift from analogue to digital distribution, fewer public domain titles are being made available and are fading from public view.

Criterion Collection

Another example in which legally secure titles appear to be favoured over public domain titles is in the DVD distribution of the Criterion Collection. An immediate important distinction with the previous example of Warner Bros. is that the Criterion Collection does not own a film collection as such, but is in the business of issuing DVDs of films ('filmschool in a box'; Parker and Parker, 2011), the licensing rights to which they have to acquire from an external party. In his role as advisor and consulting producer for Criterion, Robert Fischer affirmed in his presentation during the 2010 Gorizia International Film Studies Spring School that the label would never distribute public domain titles: of the various selection criteria, a 'secure rights situation' is the very first, only then followed by whether the particular title fits within the rest of the collection.[13] This is not to say that Criterion does not encounter other rights problems: over the years it has become increasingly hard to obtain licensing rights to produce DVDs from popular studio films. 'One unfortunate result of this situation is that many of the excellent supplements [that were] available on the company's laserdiscs languish without an outlet' (Parker and Parker, 2011, p. 184, n72).

Although Warner Bros. currently seems to be making their material available in an interesting 'hybrid' situation between a push ('making available') and a pull ('on-demand access') model (Fossati and Verhoeff, 2007, p. 331), these are but two examples of large-scale digitization efforts in which little or no attention seems to be given to public domain titles. Selling attractive products with which some of the remastering and restoration costs can be recouped requires a clear copyright ownership or clear licensing agreements. An arguably more important result of a clear copyright ownership is the potential protection against possible infringement (by being able to sue the infringer) so an upfront investment in said preservation costs can be made at all. There is, however, a big difference between the business model of a studio and a mandate to making works available of, for instance, a national audiovisual archive.

Initiatives by non-profits

The same possibilities concerning the legal status of the material apply to the holdings of a non-profit archive: the material is either in copyright or it is not.[14] If the material is in copyright, it is possible that the archive itself is the owner of the film's rights. This will most probably, however, only apply to a relatively small proportion of the materials. As mentioned before, non-profit archives seldom own the rights to the material film holdings they own, so the bulk of the holdings of these kinds of archives will consist of material of which the owner is an external party. If the material is in the public domain, archives benefit from the rights to their works having expired, especially in terms of distribution purposes. However, just like in a for-profit environment, selections will have to be made as to what material will be made available. High costs are involved in the restoration, the digitization and the continued preservation of film material, so even if a non-profit archive operates under a mandate that requires material must be made available, it will not provide blindly online access to all the holdings they either own themselves or which are public domain. Not only the commercial archives, but also the public archives appear to be involved in the aforementioned 'interplay between the ownership of the physical object ... and the ability to control the subsequent use and dissemination' (Deazley, 2006, p. 124).

Internet archive

Most of the online access provided by public archives appears to emphasize public domain works in favour of the more 'difficult' copyrighted works and some online initiatives seem to be made up for a large part or even exclusively by public domain material. One example is the Internet Archive, a non-profit initiative established in the mid-1990s in San Francisco, which aside from open access to public domain books also provides online access to historical audiovisual collections, through collaboration with external partners, such as the Library of Congress. The site contains 'only public-domain items, including the ever-popular *Duck and Cover*, allowing ... to avoid the problem of copyright' (Thompson, 2007).

Images for the future projects

Other examples of initiatives by non-profits include projects made possible by the Dutch national digitization project Images for the Future,[15]

such as video-on-demand platform Ximon and online remix contest Celluloid Remix. One of the ideas behind the video-on-demand portal Ximon was to avoid the legal status of the material dominating the character of the portal. However, the most important factor that determined what was presented online first was 'what was available and what was clearable' and therefore included a large proportion of public domain works (Rechsteiner, 2010). In order to determine what was available, various other factors, such as the physical condition of the material or how much restoration a film would need, were also taken into consideration. Celluloid Remix, an online remix contest with early Dutch films, which took place in 2009 (with a second edition in 2012), was made up exclusively of public domain material.

The public domain status of aforementioned film works seems to have facilitated an 'easier' online distribution. One of the consequences, however, is what curator of the Danish Film Institute Thomas Christensen labelled as a 'freak show' in his presentation at the Archiving the Future conference in York in February 2010: the resultant unilateral representation of audiovisual public domain materials on various online platforms seems to have led to a sort of *hyper-visibility* of these titles.

In what precedes, the chapter has tried to argue that sometimes public domain works must be seen as part of a so-called theoretical public domain, for the works are not practically available, whereas alternatively, they sometimes appear to be hyper-visible, for they are the 'easiest' to re-use. It has also argued that all archives seem to be involved in the 'interplay between the ownership of the physical object...and the ability to control the subsequent use and dissemination' (Deazley, 2006, p. 124). If even a legally unrestricted category of works, such as public domain works, appears to play a role in the digital skew, it would reveal that the positioning of the digital skew exclusively within the legal paradigm seems to neglect certain other economic factors of access.

Financial responsibility for continued preservation

Whether an archive's remit is preservation on an economic or on a more-cultural ground, exclusive ownership of materials seems to go hand in hand with the (financial) responsibility for its continued preservation. Furthermore, irrespective of the consequence of archival policy leading to either underexposure or overexposure of public domain works, 'lack of protection cannot in itself impose free access to the copies of public domain works' (Dusollier, 2010, p. 8). In the same World

Intellectual Property Organization (WIPO) study that she prepared, Dusollier continues:

> Access to and use of an intellectual creation will require obtaining access to a material embodiment of such work. Such access can be lawfully controlled by the owner of this tangible copy of the work. Copyright, and its opposite the public domain, only pertain to the intangible work, and should be distinguished, and will normally be exercised separately, from the material property. Controlling access to tangible copies of works is a legitimate exercise of property rights.
>
> (2010, p. 39)

In the case of archival film distribution, this holds true as well: on the one hand, whoever owns the material property can control the access to (and the use of) these tangible works, even though the films' copyright might have expired (as cited above a legitimate exercise of property rights). On the other hand, however, it also means that having access to a material copy of the film to transfer is the main particular that is needed for further distribution of the work when that work is said to be in the public domain (and therefore can be copied and distributed without the need for prior permission of the copyright owner).[16]

In what follows, the DVD distribution of two films will be highlighted; both titles had fallen into the public domain at the time of their distribution, and in both cases it was an outside party rather than the original producing studio that picked up the DVD release, although in both cases, the studios helped in various other ways. In the one case, the DVD of the public domain title was released by Criterion helped by the original producing studio who provided them with the highest-quality film material available; in the other case, it was a non-profit archive, EYE Film Institute Netherlands, in collaboration with DVD label Milestone Film & Video who released a film that had been assumed lost for several decades.

Universal – *Charade* – Criterion Collection

The example of *Charade* (USA, 1963, dir. Stanley Donen) makes transparent the rigour with which copyright law is applied: originally produced and distributed by Universal Pictures, the film became public domain as soon as it was released because strict compliance requirements at the time were not met. Prior to the introduction of the 1976 Copyright Act, all works published in the USA were required to have a visible copyright notice, including the following three elements: (1) the word

'copyright' or the © symbol; (2) the year of first publication, usually in Roman numerals; and (3) the name of the copyright owner of the work. In the case of *Charade*, the post-production facility in the UK that was responsible for adding the copyright notice to the film omitted one of the three compulsory elements on the opening credits of the film. The particular film frames read 'MCMLXIII BY UNIVERSAL PICTURES COMPANY, INC and STANLEY DONEN FILMS, INC ALL RIGHTS RESERVED'. In an article addressing why several classic films from the studio era are part of the public domain, David Pierce explains: 'It is obvious today, but no one noticed at the time that this notice is missing the word 'copyright' or the © symbol' (2007, p. 130).

Access to material copies of the film led to many different VHS and DVD editions, of varying quality. Over the decades, the film has proven to be very popular with audiences[17] and Universal Pictures, as owner of and with access to the highest-quality original negatives, exclusively licensed 'the only authorized professional transfer' (Dessem, 2006) of the film to Criterion in 2004, rather than releasing a DVD edition themselves.[18] The specific lay-out of the DVD including all the extras is protected, so the DVD seems to function not only as a way to disseminate the film widely, but also as a way to try to 're-protect' (a version of) the public domain work. The main feature itself, however, remains public domain and it is possible that the main film gets 'ripped' for further distribution by someone else. Not being able to protect themselves against possible infringement as well as a relatively small circulation are arguably some of the reasons why the studio deemed it not worthwhile to invest in their own release.

Paramount – *Beyond the Rocks* – EYE/Milestone

Another example, in which the original distributing studio did not pick up the digital re-release of one of their film titles once the film had gone into the public domain, is *Beyond the Rocks* (USA, 1922, dir. Sam Woods). The film had a theatrical release in the USA before 1923 and is therefore automatically considered to be public domain. For decades, the film was considered to be lost (even the studio did not have any material anymore).[19] Approximately 80 years after its first release, however, the only known surviving material was rediscovered in the national film archive of the Netherlands. During the film's digital restoration, the Dutch intertitles were replaced by newly designed English ones[20] and the film was provided with an originally composed musical score. This new, restored, version of the film was registered for copyright in the USA by the distributor who was licensed to release the film's DVD,[21] although the

company's director acknowledged that this presents an 'untested' legal construction that 'would not necessarily hold up under court' (Doros, 2010).

Exclusive ownership of unique originals certainly seems to foster restoration projects and either commercial or non-commercial in nature, archives appear to find themselves entangled in a complex web of what can be seen as 'circumventing' scenarios when trying to distribute public domain film titles on DVD. They see themselves forced to protect their investment, especially when much money is invested in digital restorations of these film titles and (part of) the investment needs to be recouped, if only because of certain funding obligations. Particularly in the situation in which source materials are unique or when they are the highest-quality source materials available, not only the commercial archives, but also the non-profit ones have seen themselves compelled to circumvent what can be seen as the sometimes unforgiving rigour of the law.

Reframing the debate

By examining the various practices in which digital access to public domain works is provided – a category of works that should not pose any legal restrictions – but also by demonstrating how exclusive ownership of source material and the financial responsibility for the material's further preservation can sometimes lead to varying circumvention scenarios, the chapter has argued that a reframing of the digital skew debate is needed. Certain factors in the debate have been neglected and it seems to have been underexposed that even when there are no legal restrictions, digitized collections are skewed as opposed to their analogue sources, which reveals not only certain economics of access but also a contributing factor of a human agenda. Making moving-image material available involves human agency. Even making orphan works available – works that seem to be gridlocked only legally – involves human agency. In light of the argued reframing, it would be worth revisiting the orphan works problem as not exclusively situated within a legal paradigm either.

Although the digital skew seems to be partially rooted in a legal paradigm, the chapter has highlighted how the digital skew is not to be understood as a purely legal issue, but as a more complex one in which economics of archival access and human agency play a fundamental role. In terms of the promotion of the visibility of important works of film that are arguably important to our understanding of the past, and for our perception of film history and film historiography in general and

film heritage more specifically, perhaps the first thing to assume then is that just as there are multiple incarnations of the public domain, there are also multiple incarnations of the digital skew.

Notes

1. Some of the reasons mentioned are sheer volume; financial restrictions; lack of a coordinating body; lack of a list of all surviving films; technological compatibility as well as language and cultural barriers.
2. In their 2006 *Report on Orphan Works*, the US Copyright Office defines 'orphan works' more precisely as 'a term used to describe the situation where the owner of a copyrighted work cannot be identified and located by someone who wishes to make use of the work in a manner that requires permission of the copyright owner' (p. 1).
3. As will be addressed later on in the chapter, the works housed by commercial archives, such as studio archives, will most likely have a clear legal ownership.
4. For a specific case study in which untraceable copyright owners, and the consequent inability to clear the rights in the resultant orphan works, can significantly delay the distribution of extant audiovisual archival material, see Op den Kamp, 2010.
5. There are several ways in which works can become public domain. 'Copyright in any given work we know comes into existence from the point of creation' (Deazley, 2006, p. 102) and one of the most straightforward ways in which a work is said to enter the public domain, is when that copyright expires. Alternatively, the copyright in a work might have been forfeited because of a failure to comply with the technical formalities of copyright in effect at the time or the works might be non-copyrightable at all because they are categorically excluded from copyright protection, such as some governmental works (Samuels, 1993).
6. There are also examples of business models that are built entirely on the economic interest in the public domain, such as public domain stock footage company Footage Farm.
7. For numerous classic studio film examples, see Pierce, 2007.
8. As for works with unclear legal ownership, most for-profit archives will have no or little 'true' orphan works. Some of the rights to the underlying works of film, such as a play, might belong to an external party and the costs for renewal of those underlying rights can be prohibitive to the extent that the work, although physically available, might be considered to be legally 'lost' *within* the archive. But in most cases it will be likely that the legal owners have been identified (Allen, 2010).
9. Senior vice president, Theatrical Catalogue Marketing Warner Archive Collection Online.
10. What started as www.warnerarchive.com now redirects to http://shop. warnerarchive.com/, where other Warner Bros.' products are sold, such as clothing and toys. 'The DVDs are created on demand, professionally authored, and ship within two or three days' [currently to the US only] (Feltenstein, 2010). [Last accessed 9 October 2012].

11. These titles are not exclusively Warner-produced feature films: several mergers and take-overs have led to what is currently a quite eclectic film collection, including several other film libraries, such as pre-1986 MGM.

12. More research would be needed not only to establish whether any of the later titles featured on the site are in the public domain (there are several ways in which a film can become public domain) but also to establish more precisely how many titles currently owned by Warner Bros. were released pre-1923 and still survive. As Warner Bros. was officially incorporated in 1923, pre-1923 films would include such titles as produced by First National Films, which later merged with Warner Bros. (Finler, 2003). Additionally, titles that can be purchased on the same website from both the MGM Limited Editions and Sony Pictures Choice Collection do also not include any pre-1930s titles.

13. Obvious exception to this policy seems to be *Nanook of the North* (USA, 1922, dir. Robert Flaherty), which was released on DVD by Criterion in 1999 (as no. 33). The title is a US film with a release date before 1923, the defining reason that makes the film a public domain title.

14. Public archives also house numerous orphan works, which can be seen to make up a third, somewhat 'grey' category. Only after what can sometimes be extensive research, can it be determined whether a film is still in copyright at all or that it is in the public domain.

15. Participating partners included large national film and television archives.

16. Provided there are no further underlying rights that apply to the work.

17. The film's popularity might have been helped possibly by its heightened visibility due to its public domain status.

18. Allegedly based on an exclusive deal permitting the use of the still-protected Henry Mancini score.

19. The question that can be raised here is whether the film would have been a 'lost' film at all had it still been in copyright.

20. For this activity, Paramount approved the use of the original continuity script, which is held in the Academy's Margaret Herrick Library in Los Angeles.

21. EYE Film Institute Netherlands claims the theatrical rights as well as the DVD and television rights of the film for the Benelux; licensed distributor Milestone Film & Video for all other countries.

References

Allen, B. (2010) Interviewed by: Op den Kamp, C. (4 November 2010).

Boyle, J. (2003) The Second Enclosure Movement and the Construction of the Public Domain. *Law and Contemporary Problems*, 66, 33–74.

Deazley, R. (2006) *Rethinking Copyright; History, Theory, Language*. Cheltenham: Edward Elgar Publishing.

Dessem, M. (2006) '#57: Charade', *The Criterion Contraption*, 2 July. Available from: http://criterioncollection.blogspot.com/2006_07_01_archive.html [Accessed: 19 February 2012].

Doros, D. (2010) Interviewed by: Op den Kamp, C. (5 November 2010).

Dusollier, S. (2010) *Scoping Study on Copyright and Related Rights and the Public Domain*. Namur: WIPO.

Feltenstein, G. (2010) 'New Platforms', *Re-imagining the Archive. Remapping and Remixing Traditional Models in the Digital Era*, UCLA, 10–12 November 2010.

Finler, J. (2003) *The Hollywood Story*. London and New York: Wallflower Press.

Fossati, G. and Verhoeff, N. (2007) Beyond Distribution: Some Thoughts on the Future of Archival Films. In: Kessler, F. and Verhoeff, N. (eds.) *Networks of Entertainment: Early Film Distribution 1895–1915*. Eastleigh: John Libbey Publishing, pp. 331–339.

Hudson, E. and Kenyon, A. (2007) Digital Access: The Impact of Copyright in Digitisation Practices in Australian Museums, Galleries, Libraries and Archives, *UNSW Law Journal*, 30 (1), 12–52.

Lameris, B. (2007) Re-exposed; the *Pas de Deux* Between Film Museum Practice and Film Historical Debates [*Opnieuw Belicht; de* pas de deux *tussen de filmmuseale praktijk en filmhistorische debatten*]. PhD Dissertation, Utrecht University.

McCausland, S. (2009) Getting Public Broadcaster Archives Online. *Media and Arts Law Review*, 14 (2), 142–165.

Op den Kamp, C. (2010) *De overval*, the Film and Its Dissemination: Courage, Resistance and the Orphan Film. *Transtechnology Research Reader 2010*. Plymouth: University of Plymouth, 245–256.

Parker, M. and Parker, D. (2011) *The DVD and the Study of Film; The Attainable Text*. New York: Palgrave MacMillan.

Pierce, D. (2007) Forgotten Faces; Why Some of Our Cinema Heritage is Part of the Public Domain. *Film History*, 19 (2), 125–143.

Rechsteiner, E. (2010) Interviewed by: Op den Kamp, C. (5/6 November 2010).

Samuels, E. (1993) The Public Domain in Copyright Law, *Journal of the Copyright Society*, 41 (2), 137–182.

Samuelson, P. (2003) Mapping the Digital Public Domain: Threats and Opportunities. *Law and Contemporary Problems*, 66 (1/2), 147–171.

Streible, D. (2009) The State of the Orphan Films, Editor's Introduction. *The Moving Image*, 9 (1), vi–xix.

Thompson, K. (2007) The Celestial Multiplex. *Observations on Film Art*, 27 March. Available from: http://www.davidbordwell.net/blog/2007/03/27/the-celestial-multiplex/ [Accessed: 11 February 2012].

United States Copyright Office (USCO) (2006) *Report on Orphan Works*. Washington, DC: Library of Congress.

9
Live Audiovisual Performance and Documentation

Ana Carvalho

Introduction

The document is situated between the ephemerality of the moment and the possibility of its fixity. Ephemerality is key to live audiovisual performance, which we define as 'art-moment'. The term 'live audiovisual performance' describes an event of sound and image manipulation. Besides being ephemeral, events of live audiovisual performance share other common features, such as the use of technology for production and exhibition and the dynamic participation of performers and audience. Each performance is part of a continuum of time, marked by other performances and encounters, which together form the contemporary artistic context, thus contributing to future possibilities. To further describe the interrelation between the artists' performances and other actions, we will look at concepts of time in the philosophy of Alfred North Whitehead. The chapter proposes a theoretical structure to define live audiovisual performance based on a series of relations rather than hierarchies. This structure will provide the basis for the consideration of a number of issues about documentation.

The definition of what a document is changes according to the apparatus of each epoch. In our contemporary landscape, technologies make it possible for documents to be both digital and physical objects. A series of considerations will take into account the structure we intend to draw and the definition of document, and develop from the relationship established between the ephemerality of the event and the fixity of the document by taking as an example the performance works of Granular Synthesis, Aether9 and Tiago Pereira, among others, as well as their related documentation.

The central aim of this text is to highlight the relationship between ephemerality and document, exploring how this relationship can contribute to the development of studies on live audiovisual performance, the construction of its memory and the development of an informed history of the audiovisual as a medium in performance.

Live audiovisual performance

An artwork of digital media can be experienced through a physical or digital object – 'art-object' – as a time-based event – art-moment – and through engagement with a specific network – 'art-system'. When the result of the process is art-object, it can be presented as a DVD, a painting or a sculpture, to name just a few examples. The produced object is itself evidence of the artistic expression and all documentation related to the making process (drawings, diagrams, photographs) will be useful to better present, preserve and study that very same object. When the result of the process is art-moment, both artists and audience are part of a unique and unrepeatable experience, which can take the form of theatre plays, dance events, music concerts and live audiovisual performances. Given its ephemerality, no evidence of the artistic expression remains. The major concerns of documentation related to art-moment comprise the identification of complementary elements of the event that can provide information for its eventual re-presentation and study. 'art-systems' potentially present endless possibilities not only of combining ways to engage the artists and the public, but also of combining process, moment and objects, as is the case of online multiple user games, especially those based on mobile technologies. Considerations on documentation of art-system works are complex and combine features from both art-object and art-moment. Thus, this text will mainly be concerned with documentation related to the art-moment practice of live audiovisual performance and its possibilities.

Live audiovisual performance[1] is a term that refers to a group of intermedia works described by Dick Higgins as 'works which fall conceptually between media' (2001, p. 52). While some works are presented in the broad context of live audiovisual performance, others are presented in specific contexts. The context of VJing is the club scene, usually a dance party. Moving images, manipulated live by the VJ, react spontaneously to the music selected by the DJ. Although most VJs develop a solo career, some gather in collectives (United VJs)[2] or AV duos (Chika and Bubblyfish)[3]. The context of live cinema is more flexible, varying from concert spaces to galleries and museums. Live cinema uses

the same technological tools, vocabulary and techniques of VJing. The collaborative exchange between artists in live cinema is often extensively developed, especially when compared with the exchange between VJ and DJ. As Mia Makela explains,

> [M]any Live Cinema artists work in close collaboration with musicians and form AV-groups (Rechenzentrum, Telcosystems, Pink Twins, and so on), symbolizing that their approach has gone far beyond creating visual wallpapers to accompany the DJ. To sum it up, the driving force behind the Live Cinema movement might well be the endless discoveries within the mysterious language of AudioVisuals that has kept so many creators fascinated with this art form from the beginning, and against all the odds.
>
> (2009, p. 7)

Two other practices are interrelated with live audiovisual performance: visual music, where connections between musical composition and moving images are highlighted, and expanded cinema, where experiments with cinema and video apparatus inform the aesthetic experience.

Documents are a primary source to understand today's practices, contributing to their sustained study, further research and memory construction. The need for specific documentation of live audiovisual performance extends beyond the event. We have identified the following aspects to be addressed through documentation, although many others may arise from each individual performance: the aesthetic results of the performance, that is, the diffused sound and the projected image; the understanding not only of the dynamics between artists who are performing, but also between these artists and their audience; the process of creating a performance that involves, for example, technological developments related to the construction of an instrument or the schematic relations between several instruments of an audiovisual setup; the dynamics between works and individuals that constitute what we understand as the contemporary artistic practice.

At the basis there is the understanding of an event of live audiovisual performance as ephemeral, that is, as impossible to document. All possibilities for creating evidence are understood as extensions, connections, but always as independent works. To address the problematic of documentation, we will begin by describing a theoretical structure, which is implicit in the definition of live audiovisual performance, by relating elements with moments. The structure is defined by two dialogical elements which are essential to these artistic practices – *sound* and

moving image. The live manipulation of projected image and diffused sound is crucial to the proposed structure. However, two other elements are also relevant to express the connections both between the artists and between the artists and the audience: 'experience', which refers to the dynamics of the artists' presence, and 'fruition' (Cologni, 2005), referring to the audience's perception of the performance. 'Experience' results from the relationships established between the artists, while performing, and the resultant sounds and images, as well as between the artists, the environment and the audience. 'Fruition' results from the relationships established between the audience and the work; between each individual in the audience; and between the audience and the artists. The focus on experience and fruition allows for a better understanding of how it 'feels to be performing' and how it 'feels to be experiencing the performance'.

A performance consists in a length of time which is part of a series of sequences formed by performances and other events. This series of sequences ultimately defines live audiovisual performance in contemporary terms. According to the philosopher Alfred North Whitehead, nature is a process and time is an element of nature. Transitoriety is a feature of time and it is essential to nature (the passage of nature). Whitehead's understanding of time is rather useful to present live audiovisual performance as a series of moments, that is, as a process. In order to do so, it is also necessary to understand a few other concepts and the relations established between them. As Whitehead explains, what we perceive, as humans, is what is specific to a place and time, that is, an 'event', which is a relational term in the structure of time ([1861] 1993, p. 64). Within the structure of time, Whitehead calls the shortest duration a 'moment'. It is nature as a whole within an instant ([1861] 1993, p. 71). A 'moment' is simultaneously the present (the fleeting fixity of 'the now') and part of the continuum of time. Therefore, the group of moments occurring within a performance – each one a unit of time – is part of the structure. Influenced by Whitehead's understanding of time as process, three moments can be defined: 'performance', 'creative process' and 'community gathering'. Each of them is defined by a number of distinguished features. To understand the relationships established between each moment as part of a continuum, we must refer to the 'event'. As described before, an 'event' is defined by the properties which are specific to a space throughout a length of time. Relationships between 'events' (past and future) shape the continuum of time, while the relationship between 'events' and the whole nature shape the continuum of space. 'Events' extend over other 'events'. Translated to our context, an 'event' is a

specific period, defined by its time and space, which can be identified as unique in the existence of the practice. An 'event' may be defined by a specific style or technique related to an instrument that can be situated within a time and a place. Simultaneity is the relationship established between events, that is, between styles, contexts, techniques, taking place in different cities or being shared between groups of artists. 'Duration' is the perception of this simultaneity of 'events' that allows for a sense of development. We can describe it as a complex of simultaneous events. It is not possible to identify each 'duration' in its individuality, neither to determinate its extension, since we can only notice its effects. Live audiovisual performance as we know it today results from a series of developments which have taken place throughout the years, and to which each 'moment' and each 'event' have contributed. 'Moments' and 'events' overlap and affect each other, forming interconnected relationships in which the present of live audiovisual performance is influenced by what precedes it, as is the case of visual music abstract works or expanded cinema experiments, and they will influence all future related practices. The three moments of the structure we propose for live audiovisual performance form an intricate continuum of development and change, which includes connections such as individual–collaborative–community and performance–document–memory.

The first moment of the structure, the 'performance', refers to a length of time between the start and the end of the event, taking place with the presence of the performers and the audience. The space where the performance occurs is not constrained to its physicality; it can also be a virtual one or a combination of the virtual and the physical. What we are able to know about an event is often the result of the event itself. Some of the works of the group Granular Synthesis[4] will help us to understand the possibilities of documenting fruition and experience, as well as the diffused sound and projected image. Granular Synthesis' works often use the possibilities of media to explore the limits of visual and sonic human perceptions, that is, the gap between what is visible and audible and what is invisible and inaudible. In such cases, documentation of projected image and diffused sound is not sufficient, because they are not faithfully capturing these elements as they were presented at the event. These events require the description of fruition, namely through interviews with the audience, so that they can be fully understood.

A performance moment does not exist without a period for its development. The second moment, therefore, is the 'creative process',

that is, the period when the development takes place. It is during the creative process, before the occurrence of the performance, that the artists explore the techniques for playing an instrument: by rehearsing synchronized performances or by practising towards improvisation. Both techniques imply different ways of playing, either with other performers or solo. At this stage, research and content collecting takes place in order to develop not only video and sound, but also strategies of participation. Some performances need a longer period of preparation than others. The process is clear in the work of some performers, such as Aether9[5] artistic collective. Inspired by the pioneer works in telepresence from the 1980s and 1990s, the collective explored 'ways of thinking the spirit of those projects with the context of today's omnipresence of data exchange and media consumerism' (Aether9, 2009, p. 7). Taking their geographical multilocation into account, the artists developed the concept of a functional framework for a transnational group of video performance. The collective's members maintain recorded communication, during the process and while performing, exclusively via the Internet, exploring the possibilities of online communication, as well as of audio and video live manipulation and transmission. The combination resulting from each of the artists' distinct aesthetic approach to live manipulation becomes a feature of the collective's performances. These very same performances, where artists are present (although not physically), require further understanding of the concept of presence itself, in order to distinguish it from a pre-recorded event.

Artists like Granular Synthesis and Aether9, who work in collaborations or collectives (which we can describe as the joint effort of two or more artists), form nodes, points of intersection that envisage a net of connections between artists, programmers, scientists and many others. When extended, these connections form the community, which is, thus, constituted by those who actively participate in the creation, in the critical and theoretical reflection, and in the experience and fruition of the live audiovisual performance.

The third moment, the 'community gathering', occurs when those involved in the performance come together. Community gathering often translates into festivals such as Mapping Festival (Geneva),[6] Sonic Acts (Amsterdam),[7] or meetings such as LPM (Live Performers Meeting) (happening in multiple locations)[8] or LaptopsRus (a nomad event).[9] The gathering moment is when individuals, who come from diverse locations and cultural backgrounds, meet. As stated by Manuel Castells and Cardoso (2006, p. 468), in those moments connections are developed based on shared ideas and interests among individuals that meet

online or within a closer geographical location. Gatherings in physical spaces strengthen these connections. Nevertheless, online initiatives also have a relevant impact that extends beyond these gatherings. Through blogs and forums, those interested come across technical and technological information (hardware and software reviews and manuals), practical information (shared image and sound databases), videos of performances, announcements of events, platforms to connect physical and virtual spaces for performances, and theoretical information (publications and research projects). The community develops from the exchange that occurs online, as much as from the exchange that occurs in each other's presence. Festivals (and other similar gatherings) are places for demonstration, experience and exchange, where practitioners also become the audience. By playing this double role, they are potentially transforming the practice. Each festival is defined by its own time of the year; its regularity, duration and programme; the venues in which it takes place, that is, the social and historical codes defined by each place (the open space of a club allows different expressions than, for instance, a gallery or a cinema); the interaction between performers, organizers and attendees; and, finally, the connection between different editions of the same festival and other festivals. The community gathering moment is key to understand the ephemeral process of the artistic practice. Simultaneously, by reading the changes in the gathering moments along the years and by acknowledging what it is today, changes in the practice become noticeable.

The three distinct moments – performance, creative process and community gathering – underline a continuous process of development which translates creativity into artistic experience. Going back to Whitehead, we can say that each creative process moment, each performance moment and each community gathering moment are unique. Through 'duration', in Whitehead's terms, creativity and novelty are revealed. Documents enable contact with these traces of the artists' work and allow them to be left as evidence for future study. Applying the proposed structure of time is relevant because it allows bringing documentation into other moments of the practice besides the performance moment. Through documentation related with the three moments, we hope to establish a connection between contemporary practices, transitory as they may be, and the possibilities of their future study.

The document

The definition of document has faced changes and adjustments according to each epoch's cultural apparatus. Susanne Briet identifies four rules

that define 'document' and which suit our digital and physical media diversity: it is constituted by materiality (resorting to objects and symbols), it has intentionality (it is evidence of something – abstract or physical), it follows a process of documentation (from registration to documentation) and it is perceived by the user as such (Borges, 2002). On a similar perspective, Anne Bénichou identifies 'document' with a set of values: the value as a trace or witness of something, the didactic value of informing about something, and the value of authenticity (2010, p. 47). Given the similarities found between the two authors, we can draw a definition which will guide the present argument: the document requires materiality (in digital or physical format) and a process to follow (from recording to document), which sets its intentionality, and, finally, it needs to be evidence. Videos and photographs, artist's books, scores for performance, diagrams and patents are some examples of documents made by artists. To establish a distinction between recording and documentation means to consider the act of documenting as intentional. To register is to capture or to create material information. It is often spontaneous: registering a thought, an idea for a model, the result of an experiment or a diary of observation and progression. These registrations can be expressed through drawing, writing, video, photography and others. Registrations, as well as recordings, can be kept as they are, for personal recollection, or they can be source material, a departing point from which to follow organizing procedures for the creation of documents. The process through which recordings become documents is easily understood when we look at the process of converting video recordings into a video file which may be available to an audience online: it starts with captures (recordings) of the event; these are later transferred from the camera to the computer and submitted to the editing process; then they are exported to a final format in order to allow a broad group of people to access the information contained in the video (documents). Another example would be the process through which a series of drawings are organized as a book: a group is selected from a large number of drawings, then scanned, captioned and organized in the book's page layout. The book is finally printed. In both cases, there is intentionality, a process, and the resultant documents are evidence. Documents are therefore the (virtual or physical) objects resulting from the organization of what previously existed as recordings or registrations.

There are common issues regarding the study and memory construction of artistic production across digital media, such as the obsolescence of the technology used in the production and presentation of the works (hardware and software), the need to re-make and re-present the work

and the fragile nature of data and its storage. Some materials are as ephemeral as time-based art and all the objects that may complement technology in an installation or performance may not survive a long length of time. In these cases, re-enactment is not possible. Although live audiovisual performance has to deal with similar problems, it also faces several other problems which are specific to the practice itself: for example, capturing the event in all its complexity, which often goes beyond sound and image outputs; capturing experience and fruition as a particular part of this complexity; capturing the process of creating as a valuable source of information to understand intermedial and collaborative connections; dealing with the lack of descriptive information about the authors' tools and instruments, amongst others. We suggest that documentation be approached as part of the artist's practice and the collective's process. The trajectory to identify the possibilities for documenting will not be guided by a fixed set of rules but rather by following the structure previously presented.

There has always been an interest in documenting the event throughout the history of performance. Influenced by the avant-garde movements of the period between the late 1950s and mid-1970s, several individual artists and groups have developed a dialogue between art-moment and documentation. One of these artists is Allan Kaprow. His performative body of work has been based on a dialogue between documentation and the ephemerality of the moment as artistic expression. Throughout his career, the role of documentation in performative actions shifted from being part of the creative process (in the form of notations or instructions) to becoming a registration of the performance through photographs (Rodenbeck, 2010, p. 95). The connection between publications and events established by Fluxus artists[10] is also relevant to the development of this dialogue. Bertrand Clavez (in Bénichou, 2010, p. 227) shows how relevant Fluxus publishing projects are to the construction of their own history and inclusion in the history of art. The performative and the ephemeral are rather visible in Fluxus' publishing projects, especially the unusual Fluxyearboxes. Each Fluxyearbox gathers several items in a wooden box (from 20 to 40 items, among printed documents and a series of objects) and interaction is required so that it may be accessed, expanding the user's experience to other senses than sight. This invitation to participation implies performance to some extent and it fulfils one of the defining elements of the group's identity. Other Fluxus publications include scores for events as a series of descriptive actions. Editorial projects have been central to Fluxus, as well as several other publications, such as exhibition

catalogues and the publication of articles in specialized journals and magazines.

Across the arts, the need for expression by combining objects and moments arises out of the possibilities implied in the relation between the ephemeral and the document. This need is translated into objects that may be stored or archived (such as correspondence, drawings, records, photographs), published (texts that contextualize or offer a perspective over a given artwork) and passed on orally (stories) (Clavez cited in Bénichou, 2010, p. 24).

Similarly, documentation within live audiovisual performance can work simultaneously as a point of fixity and reinforcement of its ephemerality. Furthermore, it can also be evidence of the artist's intentions and expressions, as well as of the intentions and expressions of their collaborators, curators, event organizers and audience.

Document and live audiovisual performance

As artistic expression, live audiovisual performance only exists within the determined length of time during which it is presented to the public, that is, during the performance moment. Documenting of such moments is important in order to keep the related community informed, establishing connections between each performance and the practice as a whole. Documents of contemporary live audiovisual performance do exist and most of them are related to the performance moment. Among them, the most common are short videos, disseminated via video-based social networks. These videos present a summary of certain moments of a performance and are important as an overview of its aesthetics; however, they lack the ability to demonstrate its complexity. Going back to Granular Synthesis' work, the DVD called *Immersive Works* (published by ZKM) shows the group's immersive audiovisual performances presented between 1991 and 2001. A distinctive feature of this document is its descriptive nature, when compared to short videos accessible through YouTube and Vimeo. The videos on the DVD allow a full insight into the projected and diffused outcomes, and include views of the space and the position of the audience within the space. Despite focusing on media outputs, this is a document that provides descriptive evidence of the group's work.

Although video documentation generally allows a good and fair insight into the performance event, this process of documenting is neither sufficient nor applicable to all its dimensions or to all performances. Video documents, such as *Immersive Works* DVD, fail to describe the

effect of composing with inaudible sound modulations or flicker, as well as with stroboscopic lights and colours. This is the case of some of Granular Synthesis' performances and installations, because the video does not provide information about presence or the description of fruition. The latter is fundamental to understand the complexity of these performances. Therefore, two other elements related to the performance moment, besides the physicality of the space and the outcomes, need to be addressed: the fruition of the audience and *the* experience of the artist. These can be expressed through interviews or through the inclusion of some sort of participative activity that may result in information, consequently becoming 'document'.

The documentation of the dialogue between Aether9's members carried out through Skype during the creative process and the performance moment took the shape of two books published by Greyscale Press.[11] With this process of documentation, Aether9 provides information about the performance which helps us understand it, since we have access to the interaction between the artists and we have an insight into their experience. Analysing the possibilities of documenting the creative process starts with the performance moment. We should include in the documentation of the process considerations on the interdisciplinary qualities of the audiovisual performance, as well as on the technological investigations and developments in hardware and software. These documents, arising from the intersection of different areas of knowledge (engineering and art, for example), provide research material that may be valuable to all the included areas. Intersections of audiovisual live performance with other artistic practices, such as theatre, dance and music, also provide a look into the possibilities for shared methods of documentation. Theatre and music are especially valuable as a source for exploration of methods, especially because both separate composition from performance. Theatrical scripts and musical scores are documents that result from the authors' creative process – they are not the performance itself but made for the purpose of being performed. Documents that register composition are not very common in live audiovisual performance, although there are some examples: the performance *True Fictions*, by The Light Surgeons,[12] and the performance *To Be Given a Title after Its Performance*, by Naval Cassidy.[13] Artists who develop notations as part of the creative process are able to establish connections between ephemeral and document.[14] Notations open up the possibility of reinterpretation. Documenting the creative process reveals intermedia connections and allows a better understanding of the performative moment in its aesthetic and interactive forms.

If we look at the presentation of several performances at the community gathering moment, we will find another moment to give attention towards its possibilities to be documented. The community gathering, the specific moment and location when the practice can be understood as a segment of a whole, encompasses all the previously mentioned moments and the related documenting activities. Furthermore, it stands as a unique moment worth being registered and documented in specific ways in all its diversity and complexity. Documentation of this moment may be as ephemeral as the event itself (updates available on the website, promotional material and posts on social networks), as well as long lasting (catalogues, video archives and documentaries).

In order to understand the process, the resultant moment and its impact upon the practice as a whole, documents should be developed by individuals and by the community using tools, technologies and knowledge of the practice. The participation of the community, through interviews or documentaries, allows for new layers of information to develop and to surface. Their participation expresses the dynamics of the different relationships: between the artists themselves, between them and the audience, between the elements of the audience and between all the professionals involved in the development and production of an event.

A closer look into live audiovisual performance unfolds an existing series of blurred works between ephemeral practices and documents in contemporary contexts. They are perceived as an insight into new possibilities and perspectives. Some of these works raise interesting questions. The first question worth asking is: can a database (for example, a video database) created for live manipulation during the performance be already considered documentation? Tiago Pereira's performative body of work presents itself as a good example of this situation. Following a process that starts with ethnographic captures of sound and moving image from Portuguese hidden (and almost lost) popular rurality, Pereira is continuously feeding a database with his collected videos. The name of this database is *A Música Portuguesa a Gostar Dela Própria*[15] [Portuguese music loving itself] and it is organized as a blog, containing a growing amount of videos whose broad theme is Portuguese musical traditions. Each video registers folk musicians playing (evidence); it then undergoes a process of editing and is kept in the database as a unique record for the future. It is, therefore, a document. These same videos are also used in the artist's performances. They are the source for live mixing. Another question arises from here: can a performance moment be also a document? Considering the extensive research Pereira and his team

are doing, the performance is always composed under a title, which is related to the content of the clips, as for instance *Mandrágora* (2008) and *Arroz Negro* (2010). The performance called *Mandrágora* presents several perspectives on the plant with the same name, its uses, medicinal qualities and associated rituals within Portuguese culture. The performance *Arroz Negro* is about the traditional techniques around salt in the region of Aveiro. Although the concept of documentary belongs to a linear cinematographic tradition, we can relate it to Pereira's process of researching, collecting and organizing. The live performance element adds new qualities to this process, clearly turning it into a performed documentary. In Pereira's case, the documents enter the ephemeral arena so that the narrative in each performance may acquire broader meanings: a database is simultaneously documentation which is available as part of an archive and as part of an element of the performance. Following a similar process, the concept of documentary comes into the arena of ephemerality. Pereira's body of work questions the boundaries and simultaneously suggests new possible answers by using different methods in his practice.

Conclusion

Documents are a primary source for study, research and memory construction. Historical documents have been of great importance for the contextualization, identification and understanding of today's practices. Contemporary interest in documenting the performance actively contributes to the construction of an identity specific to live audiovisual performative art forms, within a diversity of contexts. Parallel to the institutionalized efforts and procedures, documentation of live audiovisual performance is a subject that concerns the community. Its processes and results cross several areas of knowledge, highlighting and optimizing the endless possibilities of interdisciplinarity which are already present in the works. Considering the dialogic relation established within Fluxus' performative and publishing activities, this movement may be an inspiration for new possible forms of documentation as part of the artistic process.

The intense inclusion of documentation activities into the practitioners' methodology may affect the practice as we experience it today. If, at the moment, the emphasis on the performance moment hides an unknown process, emphasizing this process will perhaps diversify the outcomes. The separation between spontaneous improvisation and synchronized performances may eventually become more clearly defined. Conceptual possibilities may also arise, encouraged by what has been

done and learnt through the process of documentation. Drawing further into the speculative possibilities of documenting, artists may find interest in the registration of performances that never took place through photographs, video and scores. These will separate the role of the composer from the role of the performer. Some of these possibilities may reveal an undesired artificiality but they may also open the practice to other conceptual approaches.

Theoretical understanding of the audiovisual in performance arts has been done mostly from an inside perspective, one that looks at nuances and details. Documentation, in its multitude, will provide data for well-informed theoretical work to be developed, both from within and from the outside. History, as a reflective perspective over the development of the practice, allows a deeper understanding of what and why artists produce. Documents are a means to retain, remember and understand the art-moment. In many cases, this is how the work has reached its audience, often in a much broader scope than the event itself.

Notes

1. A general approach to audiovisual practices can be found in several publications, such as *See This Sound – Audiovisuology Compendium* (2010) and *Audio.Visual – On Visual Music and Related Media* (2011).
2. United VJs define their work as a commitment: 'We are for the Arts and the evolution of man and womankind through unique multimedia sensory experiences. We create a new kind of media art without the distinctions that raises barriers between technology and the artists! Let us wish, craft and crack the new media': http://www.unitedvjs.com.br/about [Accessed: 25 September 2014].
3. Chika expresses the relation established between her visuals and Bubblyfish's music in the following way: 'My simple graphics are creating powerful visual elements, which meet Bubblyfish's deep dramatic 8-bit sounds, and together, we, the audience, inspire people to dance and take their mind to an unexpected place': http://imagima.com/BUBBLYFISH [Accessed: 25 September 2014].
4. Granula Synthesis are Kurt Hentschlaeger and Ulf Langheinrich. They were active as a group between 1991 and 2010, and their work ranges from sound and image installations to performance: http://www.granularsynthesis.info.
5. Aether9 – Remote Realtime Storytelling: http://aether9.org.
6. Mapping Festival: http://www.mappingfestival.com.
7. Sonic Acts: http://www.sonicacts.com.
8. LPM: http://www.liveperformersmeeting.net.
9. LaptopsRus Meeting: http://www.laptopsrus.me.
10. Within a conceptual frame, rather than simply within an historical movement, Fluxus can be understood as a community and as a philosophy (Smith, 1993).
11. Greyscale Press: http://greyscalepress.com.

12. True Fictions: http://www.lightsurgeons.com/art/true_fictions/.
13. http://navalcassidy.com/2011/04/18/to-be-given-a-title-after-its-performance/.
14. In contemporary process-based practices, documents may be presented or interpreted as works of art, sometimes even as an autonomous object, independent of their origin. The ambiguous connections between ephemeral and document are interesting to explore, and have been explored since the late 1950s. Process Art has been extending the exploratory field of conceptual, theoretical and practical relationships between the ephemeral and the documentation of the process.
15. *A Música Portuguesa a Gostar Dela Própria*: http://amusicaportuguesa. blogspot.pt.

Bibliography

Aether9 Collective (2009) Aether9 Communications: Proceedings, 3 (1). TK: Greyscale Editions.

Bénichou, A. (ed.) (2010) *Open the Document: Issues and Practices of Documentation in Contemporary Visual Arts*. [Ouvrir le Document: Enjeux et Pratiques de la Documentation dans les Arts Visuels Contemporains]. Dijon: Les Presses du Réel.

Borges, M. M. (2002) *From Alexandria to Xanadu*. [De Alexandria a Xanadu]. Coimbra: Quarteto Editora.

Castells, M. and Cardoso, G. (eds.) (2006) *The Network Society: From Knowledge to Policy*. [A Sociedade em Rede: Do Conhecimento à Ação Política]. Lisboa: Fundação Calouste Gulbenkian.

Cologni, E. (2005) Present-Memory: Liveness Versus Documentation and the Audience's Memory Archive in Performance Art. *International Conference Consciousness, Literature and the Arts*. Cambridge Scholars Press. Available from: http://www.elenacologni.com/memory/CoscPaper.pdf [Accessed: 13 June 2014].

Dieter, D. and Nauman, S. (eds.) (2010) *See This Sound – Audiovisuology Compendium*. Vienna: Ludwig Boltzmann Institute.

Higgins, Dick and Higgins, Hannah. Intermedia. *Leonardo*, Vol. 34, 1, 2001, 49–54. MIT Press. Available from: https://muse.jhu.edu/journals/leonardo/v034/34.1higgins.html [Accessed: 25 September 2014].

Lund, C. and Lund, H. (eds.) (2011) *Audio.Visual – On Visual Music and Related Media*. Stuttgart: Arnoldshe Art Publishers.

Makela, M. (2009) *Live Cinema: Audiovisual Creation in Realtime* [Live Cinema: Creación Audiovisual en Tiempo Real]. *Aminima Magazine*, (22), 4–7.

Rodenbeck, J. (2010) *Nearly-painting, Almost-ritual, Place – Alan Kaprow and Photography*. [Presque-peinture, Quasi-rituel, Place – Alan Kaprow et la Photographie]. In: Bénichou, A (ed.) *Ouvrir le Document: Enjeux et Pratiques de la Documentation dans les Arts Visuels Contemporains*. Dijon: Les Presses du Réel.

Smith, O. (1993) Fluxus: A Brief History. In: Armstrong, E. and Rothfuss, J. (eds.) *The Spirit of Fluxus*. Minneapolis, MN: Walker Art Center.

Whitehead, A. N. [1861] (1994) *The Concept of Nature* [O Conceito de Natureza]. São Paulo, Martins Fontes.

10
Public Screenings Beside Screens: A Spatial Perspective

Zlatan Krajina

Introduction

This chapter seeks to establish a spatial perspective on screens in the post-cinematic context, which concerns screens outside their conventional habitats like home and cinema. If contemporary urban living is increasingly reliant upon the use of various communication technologies (both 'public' and 'personal' media, such as mobile phones, tablets, information panels, computer terminals, billboards, media façades) this means that, whatever the device, interaction is mediated by one elementary form, the screen. It has served rather different kinds of communications in various epochs. Ever since the inventions of canvas and lampshade, up to the deployment of photography, cinema and television, dominant cultural forms of screens have been 'the window, the frame and the mirror' (Casetti, 2013, p. 29). Contemporary media environments now also include screens like touch pads, surveillance monitors and interactive interfaces, which means that the definite space of cinematic projection is now paralleled by convoluting surfaces of data (Casetti, 2013, p. 30). In turn, the showcasing of cinematic narratives concerning 'electronic representation', a space structured for sustained reflection, is increasingly supplemented with the streamlining of information, which is essentially about 'electronic presence' (Robins, 1996, p. 141). The screen becomes 'a surface across which travel the images that circulate through social spaces' (Casetti, 2013, p. 23). Our questioning of the screen as a trope for a variety of modes of seeing and being (Friedberg, 2002, 2006), and of the social adaptation of screens into unusual contexts such as building façades (Colomina, 1994, 2013), thus involves us in 'displacing' the screen itself from the focus of enquiry.

From a grounded viewpoint, we need a simultaneous orchestration of all key elements involved in the changing forms of public screening: material, symbolic and experiential. Think of a sudden appearance of an electronic billboard in your local area, mounted onto an existing façade – a familiar development in many world cities. The screen can be expected to become the building's integral symbolic surface (part of how the skin of the building is perceived) but with definite material quantities (inserted in-between windows, ventilation and ornament) and with limited display possibilities (in many places, still images are preferred to videos, which are held to be a hazardous distraction for drivers). The screen will often show messages relevant to the international advertising industry's calculations of local niche markets; and it will supplement the passer-by's sightline with images of some rather different spaces, like faraway holiday resorts. And then, just as those images become a familiar presence for the daily onlookers, the visuals are, at any moment, to be changed with some other ones, as decided from a hidden control station. The place becomes a layering of different spatial formations (symbolic and material) and of encounters between different spatial occupants (service economies and citizens).

Such multidimensionality is an established assumption within critical and human geography (Soja, 1989, 1999; Lefebvre, 1991; Massey, 1991, 2005; Castree and Gregory, 2006), and more recently, though still exceptionally, also within media and cultural studies (Couldry and McCarthy, 2004; Morley, 2006, 2011; Moores, 2006, 2012; Cronin, 2010; Wilken, 2011). The former group of writers have shown that the work of power and possibility for resistance in the contemporary, urban era is most effectively captured through *spatial* lenses. Spatial change (in our case, the increasing instalment of various screens in public spaces) is not merely a *sign* or *reflection* of social change (the rise of the service sector) but its prime *articulation* (more lucrative segments of metropolitan areas are, as a result of growing public advertising, being more lit, and thus, for their users, potentially a safe source of illumination in the night-time and a flattering piece of *décor* during the daytime; see Krajina, 2014). The latter researchers have successfully moved forward a long-lasting debate about whether the presence of technologically reproducible screen signage within specific locales destroys place and produces globally standardized non-places (as has been argued, among others, by Augé, 1995 and Relph, 1976). Pursuing what Morley (2009) has termed a 'non-media-centric' approach to the study of media, the emphasis is rather on understanding how place is being re-constituted

through the changing technological connections and disconnections between that which is far and that which is near.

From that perspective, screened presence comes to co-create, rather than obliterate place, and how that happens in different locations is precisely what makes different places unique. This is a 'progressive' (Massey, 1991) vision of place, one which appreciates the extensiveness of place through technological practices and accounts for how different elements (both stabilizing and disruptive forces) coexist and produce contextual specificity. Thus, there is a working definition of social space as a process – a constant negotiation – rather than a frozen thing, and space as contingent configuration of macro pressures (networks, ideologies, infrastructures) and micro responses (bodies moving, doing and feeling), rather than merely a storage. The challenge now is to develop an analogical, spatial understanding of those mushrooming *electronic slices of space* – screens – so as to better understand how their diverse presence co-constructs the locales people inhabit.

Adopting the 'non-media-centric' approach (see Krajina et al., in press), my intention in this chapter will be to conjoin a concern with screen media (rarely addressed by the above geographers) with urban spatial analysis (not yet entirely taken on within media studies). This dual approach should afford us better understandings of the particular status screens have in the arrangement and negotiation of the everyday spaces in contemporary cities. Drawing on my Negotiating the Mediated City project (Krajina, 2014), I also refer to the ethnographic research I did on the architectural moving image screen emplaced into the refurbished pavement of the promenade in Zadar, Croatia – the Sun Monument.[1] This screen was designed intentionally to provide both a material space for civic encounter and an attractive piece of architecture for visitors, but is usually used for very different purposes: visitors enjoy it as a strange, displaced emblem of everyday media environments they normally inhabit at home, and locals seek an escape from what they call an 'underdeveloped' homeland into 'Western spaces' of technological progress and a utopian space of absolute social harmony. The outlined multidimensionality of Zadar's Monument makes it a pronounced case of the spatial complexity, I argue, to define contemporary screen cultures. I will conclude that given the growing formal diversity and ever-surprising social adaptation of screens into particular locations, screens are increasingly to be investigated as a form of what Soja calls 'thirdspace' (1999): a dynamic composition of the relevant material environments, technological formations, institutional histories and users' biographies.

Towards a spatiality of screens in public

There is an established notion within contemporary urban geography that if most people now live in cities, they live in highly contrasted, socially produced and contested spaces (see Burdett and Sudjic, 2011). One of the leading figures of this intellectual development, Soja (1989, 1999) has consistently argued for a 'reassertion' of space in critical social thinking, a thinking through space. His elaborate but still underused notion of 'thirdspace' emerges out of his attempt to overcome the reductionism ingrained in binary thinking about space (material–virtual, objective–subjective). Drawing on Lefebvre's (1991) theoretical precedent, the spatial triad (representations of space, spaces of representation and spatial practices), and Foucault's (2002) concept of spatial alterity, the heterotopia (such as prison, cemetery, theatre or garden), Soja (1999) urges us to marry in our analyses thus far disparate components of urban living: geography, history and sociality ('the trialectics of being'), that is, the material, the represented and the lived space ('the trialectics of spatiality'). Such perspective requires us to appreciate both the multidimensionality of space as it exists in any given moment and location, and the structuring effects of power.

What this means for a study of public screens, is not merely that a 'geographical' dimension is added to an understanding of technology. To spatialize a study of screens would mean to simultaneously consider various, often conflicting, temporalities (history and biography), spatialities (the space of the material screen, its material surroundings and the space of the screen's imagery) and socialities (interactions, non-interactions and senses of place). A spatial investigation of screens considers those three components together, as they emerge out of never-ending power games of top-down spatial design (planners) and bottom-up spatial appropriation (users). Public screens are never only about screens, or urban experiences or cities per se. *Space* connects those elements into a meaningful formation: screens at once occupy physical space, show images (representations of other spaces), and their changing presence challenges their incidental spectators' senses of place (a sense of where they are and how they are, as the basis of how they might act in that space). Only such interlinking of apparently incommensurable elements can adequately elucidate screens in context. Engaging in a critical, three-dimensional exploration of screens is essentially to do with dismantling dominant, and listening to alternative, spatial visions of contemporary cities.

In that sense, the conventional definition of cities merely as population agglomerations is hardly sufficient. One important form of urban specificity is communication across distance – once encompassing infrastructures like elevators, trams, electric light and telephones, and now, in addition, multi-screen trading, biometric transport control and GPS (global positioning system) monitoring. Mobilized unevenly within the 'power geometry' of urban growth (Massey, 1991), screens establish a shifting topography of economic and social activity, punctuating masses of space with signals of connection (be it wireless data transmission or audiovisual 'electronic landscapes', Morley and Robins, 1995). Though screens tend to be mostly concentrated around 'busy' traffic points, screens are not merely a serial, standard object like traffic lights. Screens are designed and positioned 'site-specifically' (McCarthy, 2001), in-between buildings, where they often remain malfunctioned or visually obstructed by vehicles, construction work or litter (Cronin, 2013). Though images are positioned so as to be discerned at certain distances (larger screens in wider spaces), and speeds of movement (walking or driving) (Venturi et al., 1977; Friedberg, 2002; Krajina, 2009), the strategic brevity, repetitiveness and continuity of messages encourage passing rather than sustained response (Krajina, 2014). In fact, the uninterrupted showcasing of images has a certain role in supporting the unquestioned flow of urban daily life (Krajina, forthcoming).

Public screen cultures are thus hardly conceivable outside issues of mobile urban perception. Cinema responded to the post-war rise of automobility and the quotidian viewing of urban sceneries through the windshield, by institutionalizing the 'drive-in' (Friedberg, 2002), while television (a flow of displaced segments connected via announcements of where the viewer is taken 'next') formed a curious system of spatial distraction, along with freeways (a material elsewhere designed for the seated reaching of remote locations via 'next' road exits) and malls (out-of-town recreations of downtown shop windows) (Morse, 1990). As cars and television jointly became mass means of transport – one offering more corporeal mobility, the other predominantly virtual mobility – they provided a technological infrastructure for the transformation of the suburban home into a 'mobile privatization' (Williams, 1976/1990; Morley, 2011). As Morley demonstrates, domesticity itself has been on the move too (2006). Mobile phones and Skype allow familial coordination and intimacy to stretch beyond the confines of the household (pp. 199–234), articulating, in the context of media, matters of flexible employment and migration (Spigel, 2005; Moores and Metykova, 2010). To conclude, the 'thirdspace' of screens is best conceivable by tracing

particular forms of dis-placement and re-placement screen technologies sustain. As I show below, an urban location can become a 'stretched', polyvalent place when a familiar screen form (pixelized moving images) merges with vernacular architecture (a stone promenade) in the play of international iconicity, tourist performance and intimate escapism.

Inhabiting an electronic 'thirdspace'

Zadar, a town in Dalmatia, Croatia, finds its old centre (a former ancient Roman *municipium*), on a peninsula, where a long stretch by the sea, the promenade ('riva'), provides a central social space for inhabitants. Processual evening strolls from one promenade's end to another afford locals 'a gracious opportunity [...] (not necessarily so graciously, in their minds) to check each other out' (McCullough, 2004, p. 135). In 2007, after years of dereliction, the northern end of the promenade was transformed. The City Council commissioned an infrastructural clean-up and a construction of a monument that would salute the ritual function of that site as a frequented vantage point for observing sunsets (Zadar Herald, 2002). The incentive tapped well into the overall orientation of the town's economy towards the tourism industry, currently the prime source of income. For many Europeans, Zadar is a popular tourist destination and planners preferred to link the necessary restoration with the tertiary sector's endorsement of expanding sightseeing offers. A local architect Nikola Bašić won the competition with a project which included the construction of Sea Organ (perforated steps in the promenade which produce different chords when wind blows through) and nearby Greeting to the Sun/Sun Monument, a permanent screen installation.

The screen is a 22-metre-wide, horizontal circle, positioned at the same level as the pavement, featuring abstract moving images. The projection technology is made of photosensitive cells that collect the sun's energy during the daytime and convert it into electricity, which is used to show computer-generated imagery during the night-time. This two-dimensional monument (a flat surface with changing images) with an unconventional dedication (gazing at sunsets) was created for a dual purpose. First, it was envisioned as an architectural icon. The production of a unique spatial form is assumed by many urban planners to be an effective means of urban branding and fostering international recognition (cf. Jencks, 2006).[2] Second, it was intended to draw local inhabitants back to that long, derelict promenade's end, by making explicit what the rest of the old, stone promenade, for many, is about: recreational outdoor interaction, confrontation of opinion and

encounter. The formation of the Sun Monument thus signals a strong intentional orientation of architecture in encouraging certain forms of living. As Tuan put it, architecture aims 'to give sensible form to the moods, feelings, and rhythms of functional life' (1977, p. 166). Indeed, the screen in the pavement showing images over which people can walk, along with the performances of the Sea Organ, has become a key tourist attraction: a place to admire the unusual audiovisual scene or to engage in unplanned fun (jumping, dancing or laughing) in the presence of unknown others. The town also frequently uses the screen for all manner of festive gatherings, always free to visit, fenceless and non-branded – a public visual park.

The construction of a walk-over, moving image screen exemplifies 'aformal' urbanism (Solomon, 2013). It was created formally, top-down, but for less than scripted, informal use and a bottom-up re-definition. Rather than merely observation of images, the screen invites all kinds of considerate play. Evoking the 'postmodern' architectural rehabilitation of 'pleasure' in spatial design (Tschumi, 1996), Bašić sought a materialization of 'urban hedonism', and an amplification of the 'drama' of the promenade (Vjesnik, 2007). To this end, the architect chose to create an 'immersive' environment, by using a circular form, by operating the screen only during night-time when imagery is most easily contrasted to surrounding darkness, and by blurring the dividing line between the screen and the adjoining stones (the rim lights up and disappears from view frequently, without order). Mimicking a pond in a garden, which, due to its shape, does not privilege a particular viewing position, the Monument invites a seamless drift into the world of imagery. What all this might mean for users can best be captured only by a further layering of our spatial analysis: we now need to move beyond the assumed status of the screen as architectural icon and communal site. It is the transformation of the two-dimensional screen into a three-dimensional place, which results from the interaction of locals' and visitors' trajectories through the site, that can show us how different practices, conceptions of space and temporalities meet in what is a usual evening in Zadar's renovated promenade.

Beyond the 'place ballet'

Sunset and sunrise mark the beginning and the end of Sun Monument's daily performance. Its projections are a seamless succession of unrelated moving shapes (pulsating circles, diverging lines, multiplying squares and so on), akin to decorative devices like 'novelty', 'lava lights' or 'computer screensaver' illustrations. Having been traversed during the

daytime by locals, who visit the site for relaxation, and by rare visitors, who normally remain at beaches, the site becomes a crowded location in the evening. First, the elderly and parents with children arrive (and stay until around 10pm), and then later, young people pass by, along with portable music systems and beverages, on their way from nearby college dorms to clubs (until around 3am). Those rhythmic interchanges of trajectories through the site which make the screen a stop, or a significant background to movement, change the screen's morphology from lively coloured scenery, similar to flower markets or ice skating venues, to a more desolate site of exhibition or aquarium observation. These different visits include the locals' habitual evening promenading and visitors' pre-planned pilgrimages to this site of attraction.

This is how the screen turns from a piece of iconic architecture and a meeting location into a *place*. According to Seamon (1979), place is a construction of embodied habits. As people cross each other's paths at a particular site in the pursuit of daily routines, they can make a range of 'environments', such as 'streets, neighbourhoods, [and] marketplaces' into places (pp. 54–57). Such mundane activities make up what Seamon calls the 'place ballet'. It emerges through a 'mix' of 'body ballets' of particular tasks (such as arranging to meet a friend in the promenade) and 'time-space routine[s]' (like evening strolls) (1979, p. 54). However, it is necessary, to move beyond the assumption that different trajectories simply mingle in an 'ease and flow' (Seamon, 1979, p. 147). The renovated promenade's end does become a place out of an interaction of trajectories, but this is a mediated interaction, which is 'extended' in space and time and which brings different users and their conceptions of that space in touch (cf. Moores, 2005).

Notwithstanding its unique design, the Monument is actually never divorced from familiar screen cultures, to which visitors (both Croatians and internationals) relate and compare the Monument. Not only does this screen circulate as an image through other screen media (like social networks and tourist brochures), but its visitors also make sense of it by relying on their rich ethno-expertise concerning everyday media back home. Though their gaze – encompassing anything but indifference – might have already been informed by media promotions of this site as 'attractive' (cf. Urry, 2002), upon arrival, visitors first look around for written verification of the location, and for instructions about 'how ... this work[s]', as they usually do with unknown media gadgets. Having not found any written explanations, many venture to test whether the screen is 'interactive' via footsteps. The screen quickly turns out to be non-responsive, and many visitors then attempt to identify a logical

'narrative' that organizes the imagery, or they play the game of guessing the next image pattern. Realizing that the screening is not a 'story' to be 'viewed' from a distance but a random interchange of images to be played with, newcomers join others in activities characteristic of daytime beaches. People from different parts of the world are heard laughing and cheering with their peers, dancing to the music they play themselves, or acting as if walking the red carpet, under flashlights. Many document their being there via mobile phones and then post images online, thus informing the future gazes of their friends. Responding to my request to voice their preliminary definitions of this site, visitors instantly showed a keen interest to make this unfamiliar interface familiar by defining it as versions of their quotidian media worlds.

Not once was the screen dubbed as it was conceptualized by the designer, a unique, 'contemporary architectural salute to the Mediterranean promenade culture of sunset gazing'. Rather, the screen was all conceivable variations of: science fiction cultures ('something from outer space', 'SF film set', 'spaceship control panel', 'immense depth', 'smooth and shiny surface'), music and television entertainment ('enormous television set', 'running signals', 'virtual flying and skiing console', 'old music videos scenography', 'disco floor'), circus toys ('play of lights', 'flashes', 'spinning', 'colours', 'blinking lights', 'spinning wheel', 'something extraordinary') or simply, a site of 'disorientation'.

Of course, such responses were in part informed by the particular material design. As we learn from Rasmussen's studies of 'experiencing architecture', smooth and translucent surface – as in the work of Le Corbusier and Mies van der Rohe – is usually used to suggest a weightless space, whereby walls can 'appea[r] [...] merely [as] thin screens' (1959, pp. 9–30, 96). Lack of 'cavity' requires other elements (sky, sea, the promenade) to be taken by users as nearest frontiers, while a juxtaposition of rather different elements ('raw and refined material' – stone and glass) is thought to arouse the senses (pp. 42–43, 48, 78). Cities like Rome can invite a 'dramatic' experience, such as 'com[ing] from the dark, narrow passage out to the sunlit courtyard' (p. 70). In that sense, '[built] architecture is interpreted as forms which swell, press, push out, and so on – all motion phenomena' (p. 71). Such various dispositions of different elements in space (screen, promenade, Sea Organ) can 'in a manner analogous to music ... establish a physical cadence in the viewing modes' (Malnar and Vodvarka, 2004, p. 104). In Zadar, the nearby Sea Organ, rhythmically and harmonically attuned to winds, forms a pulsating sonic component to changing interactions with the screen.

The Monument was not merely a multi-sensory appearance, it was also an emblem of the multi-screen formation of everyday media environments. Its constant stream of visuals, which is never observed in focused contemplation en face (due to its horizontal position) or as unobstructed by others (given its public exhibition), is a metonym for post-cinematic image cultures like online news, blogs and social media posts. In both cases, images 'are not [...] addressed directly to anyone in particular'; 'it is th[e] flow more than their capture that defines them' (Casetti, 2013, p. 28). Colomina (2013) traces the origins of this kind of media environment in the Eames brothers' 1959 Moscow World Fair 'Glimpses of the USA' project, a 12-minute presentation of videos and photographs of an 'American way of life' simultaneously shown on seven 20 × 30-foot projection screens. As Colomina explains, the intention of that project was decidedly to stir awe amongst the Soviet audiences, rather than to inform them, by attempting a sensory 'overload' through a multiple, large and non-linear screen presentation.

Similarly, Zadar's ex-mayor, who had advocated the new construction, envisioned the Monument as a kind of 'luminous firecracker', a show that would 'greet' tourists upon their arrival with a sense of 'sensation'. He consciously drew on the widely shared assumption amongst urban planners of 'the power of artificial light to fascinate people'. This rhetoric of divine electric lighting has been a familiar urban development ever since the industrialization of artificial light in the late 19th century (cf. Schivelbusch, 1995). 'Flooding' reflective surfaces of buildings with light, whether for purposes of spectacle or control, meant creating virtual carvings in dim material spaces, while the electrification of urban vistas extended social life well into the night (Ackermann, 2006). According to Rasmussen, one important way for planners 'to make a strong impression [upon users] is to employ familiar forms that have been given an eccentric turn which will take the spectator by surprise' (1959, p. 59). At the Monument, visitors alleged they both found it 'hard to express using words' how they experienced the site and that it was like being in 'some other time and space' from that of the seaside promenade, like being in 'some faraway metropolis'.

The image of thrilling city lights as a symbol of urban modernity is still very much with us as part of popular distinctions between urban and rural spaces. Drawing on this metaphoric stranglehold, many Croatian visitors accentuated that walking onto the centre of the screen afforded them a pleasurable feeling of standing 'in the centre of the world', whilst actually being in a 'small country' (see Figure 10.1).

The attraction of the Monument for them is that it brings 'within reach', under foot, something of the desirable 'shine' and 'glam' familiar

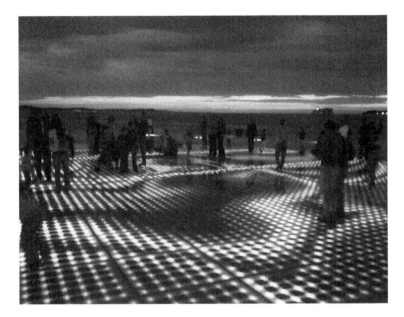

Figure 10.1 In the centre

from televized representations of places like New York's Times Square, London's Piccadilly Circus or Tokyo's Shibuya District. The attraction for those visitors was in the ability to virtually 'enter' the 'splendour' of the 'West', epitomized in 'the massive billboards in America and Europe'. As Neumann put it,

> No other artistic medium, of the twentieth century has crossed the boundaries between art and commerce, technological display and utopian vision, easy entertainment and demagogic politics as effortlessly as the architectural application of electric light in the urban environment.
>
> (2006, p. 28)

There is an aura of amazement that surrounds urban illumination. It goes back to the 'ideological' celebration of electricity (Carey, 2009) – currently evoked in the context of the Web (Mitchell, 1995) and digital architecture (Flachbart and Weibel, 2005) – as the technology that will unite dispersed citizens in a transparent communication and thus heal social ills. There is a sensible, visual presence, via light, brought by an imperceptible, celestial energy (Carey, 2009). Similarly, commentators of first demonstrations of directing search lights into skies at the 1893

Chicago World Columbian Exhibition 'ascribed spiritual power to nocturnal illumination' (LaVardiere, 2006, p. 111). Much later still, in 2002, the 'Tribute in Light' New York commemoration of the 9/11 victims offered 'a sheltering illusion', evoking a luminous 'cathedral or rotunda' (LaVardiere, 2006, p. 111).

For the locals in Zadar too, the Monument is an exit from the promenade into another, better world. In my interviews, the screen was rarely ever referred to as a place 'where I can see other fellow citizens' – the architect's conception – but as versions of 'beautiful exhibit', 'magical space', 'like stars in the sky', 'all the lights of the spectrum' and 'another dimension'. Putting up a display screen, a media form that invites a spectating subject position, into the space of traditional interpersonal gaze, encouraged unanticipated use. Though insisting in my interviews that the screen merely serves as a tourist spectacle and that locals are committed to the traditional promenade culture, locals also kept glancing at the screen, even 'entering' it individually, almost secretly. Inside the 'lights', as one lady noted in her diary, 'thankfully, . . . no one seems to be looking at others'. It is difficult for those standing outside the screen to pinpoint who is standing 'inside' the flashing and moving images, and for many locals stepping onto the screen means leaving the old promenade – the arena of inter-personal inspection – and relieving the dread of customary glancing. As one local male student noted in his diary: 'as I come closer to the end point, I feel more on my own . . . like, I can think on my own or talk to myself'. This search for 'anonymity' is paralleled by a professed sense of 'relaxation', which locals seek by focusing on the steady exchange of images, as similar to observing the predictable movement of 'sea waves'.

Thus, if the Monument is a piece of 'digital ground' (McCullough, 2004), it is a mediated place, the relevant practices and meanings of which extend well beyond its location or material design. As I will show below, the screen-place is not only extended through space. It is also an encounter of different temporalities, a situation which poses a question about whether spatial design can ever assume a particular relation with use, even when, as in this case, variety of use was actively sought.

The social space of the public screen: An 'eventful' place or a 'place' of event?

'No architecture without event', proclaimed one of the often-cited theses by Bernard Tschumi, heralding his call for a creation of environments

that assume unplanned uses (1996, p. 255). This was a far cry from another, earlier famous dictum, that of Le Corbusier (1922/1931): 'architecture or revolution', which positioned architecture at the forefront of modernist social ordering (and control). Tschumi has shown that there is a permanent 'disjuncture' between architectural form and use, particularly given that modernist functionality proved itself unable to fulfil its promise of producing a 'healthy' society simply by way of spatial design. According to Tschumi, if urban spaces are best defined as contingent, the design of future constructions should do a better job of appreciating the inherent and never entirely calculable variety of use. Tschumi sought to disable the reductive modernist presumption of one-way causality between construction and use, which assumed, by analogy to the old 'hypodermic needle' model in media audience studies, that one will behave only as the architectural construction requires. The alternative Tschumi has advanced is a rather different spatial composition, that is, a 'superimposition', consisting of 'the point grid, the coordinate axes ... and the 'random curve" (1996, p. 199). As exemplified in his 1987 Parc de la Villette project in Paris, such spatial organization favours indeterminate use ('programmatic madness', a 'folie'; p. 196), that is, incalculable events. In this vision, architecture aims at *creating* unexpected situations (namely, 'events') which, so the argument goes, may have the potential to transform the broader social status quo and to renew the progressive role of architecture in society. And, while there is a lot to be learnt from Tschumi's deconstruction of dominant urban and architectural spatial ideologies of the 20th century, his outline of 'eventful' architecture somehow fails to also dismantle entirely the presumption of *causality* itself (see also Massey, 2005, p. 113).

The visual component of Zadar's Monument – a constant succession of random moving images spread over a circular surface – resonates with Tschumi's advocacy of incorporating some of the logics of film montage into the production of incidental space, by creating 'random curves'. A local young man's diary reads the Monument as the place where there is 'always something different to see' because 'people shine; the light bounces off them' (see Figure 10.2). In such situations, the screen becomes a three-dimensional street cinema where neither the performers (international visitors) are entirely aware of the audiences (local strollers) nor are the audiences always conscious of the show. The cinematic lure of light and the pleasure of voyeuristic gaze form the basis for this serendipitous screening. My ethnographic exploration of such situations, however, suggests that the source of the locals' escapist pleasures lies *besides* the material and symbolic organization of the screen itself.

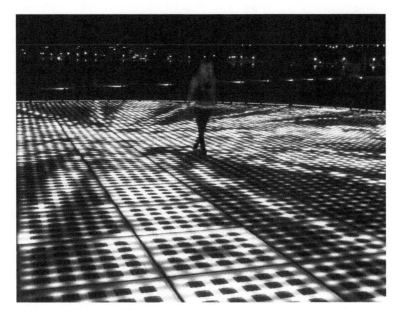

Figure 10.2 Inside the Monument

The everyday abstract screening in Zadar as a form of street cinema is significant to locals in as much as it poses a stark contrast to the horrors they experienced in their recent history, during the Yugoslav war in the early 1990s. Visitors' play with images unintentionally creates for the locals a utopian vision of social harmony, where, as locals put it, 'people seem to be so happy' and 'differences cease to exist'. Locals welcome this view as a way of rehabilitating what suffered most in times of war: a working coexistence of cultural difference within the traditional space of encounter, the promenade. Not merely for Croatians in general but particularly for the ethnic Serb minority, this is a valued scene, available every night during the summer tourist season, a resource to which they can contrast past events and which they can consult in negotiating those to come. The screen-place for locals is a heterotopia, a utopian, 'inverted' place, one located in but at the same time external to the surrounding space (Foucault, 2002, p. 232). According to Foucault, heterotopia involves both a technological 'space of illusion' and a social component, a 'compensation' for the 'space that remains', by providing one of the 'absolutely perfect other places' (2002, p. 235). The electronic Monument is a place where the desired social harmony presents itself as

if already accomplished, before it has actually been restored. Observing, as locals said, 'visitors mingle there in peace and quiet', affords locals a sense of having a sort of 'crutch' that can 'help us feel peace in ourselves again'.

'Architecture', Tschumi alleges, should be 'about the design of conditions that will dislocate the most traditional and regressive aspects of our society and simultaneously reorganize these elements in the most liberating way' (1996, p. 259). Notwithstanding this applaudable commitment to difference, it is a romantic vision of emancipation. It assumes that architecture is in the best position to relieve society of its burdens, because it can somehow operate outside the selective work of discourse, with the power to 'reorganize' its components. Indeed, whilst 'inside' the architectural screen, a local woman described in her diary that '[there is] something that cuts you off from everything. It's [...] something I haven't really felt yet [...] a feeling of some kind of fulfilment, of contempt'. This is 'a feeling of equality', she specified. 'All you can see [on the screen] is that there are some people there. Nothing else exists, how they look like, if they're sad, what age they are, how they're dressed, how they behave; everyone's just thinking their things.' To read this situation of a momentary heterotopian displacement from the webs of social inequality, as produced merely by the particular spatial design, would be missing the point. As another woman goes on, the war was a 'terrible' time, not only because of long periods of 'living without electricity and regular water supplies' but because 'suspicion' and 'fear' crawled into communal spaces. Whereas 'no one used to lock doors' before the war, a sense of 'fragil[ity]' moved in. Repeatedly marvelling at how 'fascinating' it is 'that someone was able to invent [the Monument]', locals ascertained that at the screen, there is 'nothing to worry you'. After years of destruction, that location offers a repetitive scene of serene encounter between strangers. Recalling the many different ways in which my respondents defined the screen, the abstract imagery seams to speak many languages to different visitors, but its attraction is in their impression that it speaks no language at all. The illusion of it remaining outside the selective work of communication and sociability (cf. Morley, 2000, p. 111) gives it an escapist allure.

As Hall put it, 'nothing meaningful exists outside of discourse' (1997, p. 12). Though specific in its materiality, architecture is also about the selection of certain 'codes' of communication, which can only ever be particular, that is, organized by discourses (cf. Hall, 1994). In other words, architecture might have the potential to create spaces more appreciative of difference than others, but without users' recognition

(a decoding) of some meaningful structures inherent in their material surroundings, there would be no communicative action there at all (cf. Hall, 1997). It is thus difficult to imagine architecture, other than utopian, which assumes 'non-coincidence between meaning and being, movement and space, man and object' (Tschumi, 1981/1994, p. 7). Studies of everyday media consumption have made commonplace that both producers and consumers are discursively positioned; the former offering 'preferred' versions of the social world and the latter negotiating the offered meanings (Hall, 1994), by bringing into the encounter their pre-existing knowledge, and by drawing upon the actual constrains within which they live (Morley, 1992). By analogy, to quote Massey, urban spaces are always made up of both 'chaos *and* order' (2005, p. 116, original emphasis), or, incalculability and repetitiveness, and we will do better to critically examine their everyday interplay rather than put aside their structural contradictions.

In the case of the Sun Monument, it was the particular code of the spectacular urban luminosity that was chosen to 'hail' (Althusser, 1971) people into a seemingly disordered space of wonder and play. The resulting heterotopia was not an 'effect' of indeterminacy produced by the material design but an outcome of the interaction of users' specific trajectories in Zadar's promenade. The screen is a meeting place of visitors' uncommitted passages concerning pleasures of vacation, and locals' traditional promenading that involves their recent experiences of war and present cultural aspirations. The abstract language of display did not create disorder; it informed a novel articulation and negotiation of pre-existing local issues. My interviewees' responses were not merely anecdotal but patterned by their inter-discursive positions (cf. Morley, 1992): as media users, as war victims, as international consumers of tourism services and as admirers of 'Western' image-spaces of techno-progress. As Massey put it, rather than simply emerging from a 'space of chance' (which would imply that chance is inconceivable outside spaces which are intentionally designed to invite chance), the 'multiplicity of trajectories', as described above, offers rather 'the chance of space': or, 'complex mixtures of pre-planned spatiality and happenstance' (2005, pp. 111, 116). These potential situations reside within various ordinary environments and can crop up where and when they are perhaps least expected.

Conclusion

If the proliferation of screens in ever-surprising forms and locations forms a post-cinematic context for their distribution and consumption,

in everyday urban spaces this involves a challenged, technologically reconfigured *spatiality*. Screens are always emplaced; they co-constitute (and thus also modify) the space in question. Screens are more than a spatial metaphor (a space of representation/representation of space) – their presence involves particular kinds of seeing (responding to the lure of light, defence from overstimulation), interaction (gazing at or avoiding others) and materiality (a redesign of space). Advocating a non-media-centric consideration of screens in public, I drew on my ethnographic research on Zadar's Sun Monument (Krajina, 2014), to show that the multiplication of screens in contemporary urban spaces matters most in spatial terms. Their unexpected presence can offer surprising juxtapositions of times and spaces from beyond and beside the locations of screens (here, tourist industries, imaginaries of technological progress and unresolved recollections of war agonies), thus complicating their incidental users' senses of place.

Rather than being specially programmed to create unpredictability, social space is always a changing constellation of the particular production (or destruction) of its material and symbolic ground, different forms of mobility (people, goods and information) that traverse, and specific meanings different users make of, the space. This is why, to return to Soja, we may be able to 'map' what 'thirdspace' consists of in a given moment, but can 'never' expect to 'captur[e]' its entire 'lived' existence (1999, p. 276). The screen-space results from ceaseless encounters between materials, symbols, technologies and people addressed, which only a multidimensional and grounded, non-media-centric study can hope to untangle.

Notes

1. The project encompassed participant observations, interviews and 'walking diaries' during the summer seasons in 2009 and 2013, with 50 diverse participants, both locals and tourists, whom I met in the promenade. Drawing from International Situationist's practice of psychogeography, which involved people in writing down their feelings about spaces they move through (Coverley, 2006), I devised 'walking diary', which asked participants to say into a voice recorder what they experience as they move around. My aim was to explore the spatial component of interactions with the screen, and I acknowledge the underexplored relevance of other sociological issues at stake, like gender, ethnicity and generation in this context. For a full account of the project see Krajina (2014).
2. According to Lefebvre, the spatial significance of tourism industries is that they turn space from a mere location into the object of consumption. In the European modernist tradition, tourism serves the everlasting 'urbanites'

'nostalgia for towns dedicated to leisure, spread out in the sunshine' (1991: 352–353).

Bibliography

Ackermann, M. (2006) Introduction. In: Ackermann, M. and Neumann, D. (eds.) *Luminous Buildings: Architecture of Night [Leucthende Bauten: Architektur der Nacht]* Kunstmuseum Stuttgart and Ostfildern: Hatje Cantz Verlag, pp. 12–14.

Althusser, L. (1971) *Lenin and Philosophy, and Other Essays.* New York: Monthly Review Press.

Augé, M. (1995) *Non-places: Introduction to an Anthropology of Supermodernity.* London and New York: Verso.

Burdett, R. and Sudjic, D. (eds.) (2011) *Living in the Endless City.* London and New York: Phaidon.

Carey, J. (2009) Technology and Ideology. In: Carey, J. (ed.) *Communication as Culture: Essays on Media and Society.* New York and Abingdon: Routledge, pp. 155–177.

Casetti, F. (2013) What is a Screen Nowadays. In: Berry, C., Harbord, J. and Moore, R. (eds.) *Public Space, Media Space.* London: Palgrave, pp. 16–40.

Castree, N. and Gregory, D. (2006) *David Harvey: A Critical Reader* Malden, MA: Blackwell.

Colomina, B. (1994) *Privacy and Publicity: Architecture as Mass Media.* Cambridge, MA: MIT Press.

Colomina, B. (2013) Multi-Screen Architecture. In: Berry, C., Harbord, J. and Moore, R. (eds.) *Public Space, Media Space.* London: Palgrave, pp. 41–60.

Couldry, N. and McCarthy, A. (2004) Introduction: Orientations: Mapping MediaSpace. In: Couldry, N. and McCarthy, A. (eds.) *MediaSpace: Place, Scale, and Culture in a Media Age.* London and New York: Routledge, pp. 1–18.

Coverley, M. (2006) *Psychogeography.* Harpenden: Pocket Essentials.

Cronin, A. M. (2010) *Advertising, Commercial Spaces and the Urban.* Basingstoke: Palgrave Macmillan.

Cronin, A. M. (2013) Publics and Publicity: Outdoor Advertising and Urban Space. In: Berry, C., Harbord, J. and Moore, R. (eds.) *Public Space, Media Space.* London: Palgrave, pp. 265–276.

Flachbart, G. and Weibel, P. (eds.) (2005) *Disappearing Architecture: From Real to Virtual to Quantum.* Basel: Birkhauser.

Foucault, M. (2002) Of Other Spaces. In: Mirzoeff, N. (ed.) *The Visual Culture Reader.* London and New York: Routledge, pp. 229–236.

Friedberg, A. (2002) Urban Mobility and Cinematic Visuality: The Screens of Los Angeles – Endless Cinema or Private Telematics. *Journal of Visual Culture*, 1 (2), 183–204.

Friedberg, A. (2006) *The Virtual Window: From Alberti to Microsoft.* Cambridge, MA and London: MIT Press.

Hall, S. (1994) Reflections on the Encoding/Decoding Model: An Interview. In: Cruz, J. and Lewis, J. (eds.) *Viewing, Reading, Listening: Audiences and Cultural Reception.* Boulder, CO: Westview Press, pp. 253–274.

Hall, S. (1997) *Representation & the Media.* Northampton, MA: MEF. (Media Education Foundation Transcript) Available from: http://www.mediaed.org/assets/products/409/transcript_409.pdf [Accessed: 13 May 2013].

Ivićev-Balen, Lj. (2007) *Razgovor – Nikola Bašić* [An Interview With – Nikola Bašić]. *Vjesnik*, 22/23 December, pp.22–23.
Jencks, C. (2006) The Iconic Building is Here to Stay. *City*, 10 (1), 3–20.
Krajina, Z. (2009) Exploring Urban Screens. *Culture Unbound: Journal of Current Cultural Research*, 1, 401–430.
Krajina, Z. (2014) *Negotiating the Mediated City: Everyday Encounters with Public Screens*. London and New York: Routledge.
Krajina, Z. (forthcoming) From Non-place to Place: A Phenomenological Perspective on Everyday Living in 'Media Cities'. In: Markham, T. and Rodgers, S. (eds.) *Conditions of Mediation*.
Krajina, Z., Moores, S. and Morley, D. (in press) Non-media-centric Media Studies: A Cross-generational Conversation. *European Journal of Cultural Studies*.
LaVardiere, J. (2006) Light Cathedrals. In: Ackermann, M. and Neumann, D. (eds.) *Luminous Buildings: Architecture of Night [Leucthende Bauten: Architektur der Nacht]* Kunstmuseum Stuttgart and Ostfildern: Hatje Cantz Verlag, pp. 110–111.
Le Corbusier (1922/1931) *Towards a New Architecture*. London: J. Rodker.
Lefebvre, H. (1991) *The Production of Space*. Malden, MA and Oxford: Blackwell.
Malnar, M. J. and Vodvarka, F. (2004) *Sensory Design* Minneapolis, MN: University of Minnesota Press.
Massey, D. (1991) A Global Sense of Place. *Marxism Today*, June 1991, pp. 24–29.
Massey, D. (2005) *For Space*. London, Thousand Oaks, CA and New Delhi: Sage Publications.
McCarthy, A. (2001) *Ambient Television: Visual Culture and Public Space*. Durham, NC: Duke University Press.
McCullough, M. (2004) *Digital Ground: Architecture, Pervasive Computing, and Environmental Knowing*. Cambridge, MA: MIT Press.
Mitchell, W. (1995) *City of Bits: Space, Place and the Infobahn*. Cambridge, MA: MIT Press.
Moores, S. (2005) *Media/Theory*. London and New York: Routledge.
Moores, S. (2006) Media Uses & Everyday Environmental Experiences: A Positive Critique of Phenomenological Geography. *Particip@tions*, 3 (2). Available from: http://www.participations.org/volume%203/issue%202%20-%20special/3_02_moores.htm [Accessed: 6 February 2009].
Moores, S. (2012) *Media, Place and Mobility*. London: Palgrave Macmillan.
Moores, S. and Metykova, M. (2010) 'I Didn't Realize How Attached I am': On the Environmental Experiences of Trans-European Migrants. *European Journal of Cultural Studies*, 13 (2), 171–189.
Morley, D. (1992) *Television, Audiences and Cultural Studies*. London and New York: Routledge.
Morley, D. (2000) *Home Territories: Media, Mobility and Identity*. London: Routledge.
Morley, D. (2006) *Media, Modernity and Technology: The Geography of the New*. London and New York: Routledge.
Morley, D. (2009) For a Materialist, Non-media-centric Media Studies. *Television and New Media*, 10 (1), 114–16.
Morley, D. (2011) Communications and Transport: The Mobility of Information, People and Commodities. *Media, Culture and Society*, 33 (5), 743–759.

Morley, D. and Robins, K. (1995) *Spaces of Identity: Global Media, Electronic Landscapes and Cultural Boundaries.* London and New York: Routledge.

Morse, M. (1990) An Ontology of Everyday Distraction: The Freeway, the Mall, and Television. In: Mellencamp, P. (ed.) *Logics of Television: Essays in Cultural Criticism.* Bloomington and Indianapolis, IN: Indiana University Press, pp. 193–221.

Neumann, D. (2006) Luminous Buildings – Architectures of the Night. In: Ackermann, M. and Neumann, D. (eds.) *Luminous Buildings: Architecture of Night [Leucthende Bauten: Architektur der Nacht]* Kunstmuseum Stuttgart and Ostfildern: Hatje Cantz Verlag, pp. 16–19.

Relph, E. C. (1976) *Place and Placelessness.* London: Pion Limited.

Robins, K. (1996) *Into the Image: Culture and Politics in the Field of Vision.* London: Routledge.

Schivelbusch, W. (1995) *Disenchanted Night: The Industrialization of Light in the Nineteenth Century.* Berkeley, CA and Los Angeles, CA: University of California Press.

Seamon, D. (1979) *A Geography of the Lifeworld: Movement, Rest and Encounter.* London: Croom Helm.

Soja, E. W. (1989) *Postmodern Geographies: The Reassertion of Space in Critical Social Theory.* London and New York: Verso.

Soja, E. W. (1999) Thirdspace. In: Massey, D., Allen, J. and Sarre, P. (eds.) *Human Geography Today.* Cambridge: Polity, pp. 260–278.

Solomon, J. D. (2013) Hong Kong – Aformal Urbanism. In: El-Khoury, R. and Robbins, E. (eds.) *Shaping the City: Studies in History, Theory and Urban Design.* London and New York: Routledge, pp. 109–131.

Spigel, L. (2005) Designing the Smart House: Posthuman Domesticity and Conspicuous Production. *European Journal of Cultural Studies,* 8 (4), 403–426.

Rasmussen, S. E. (1959) *Experiencing Architecture.* Cambridge, MA: The MIT Press.

Tuan, Y-F. (1977) *Space and Place.* Minneapolis, MN: University of Minnesota Press.

Tschumi, B. (1981/1994) *The Manhattan Transcripts.* London: Academy Editions.

Tschumi, B. (1996) *Architecture and Disjunction.* Cambridge, MA and London: MIT Press.

Urry, J. (2002) *The Tourist Gaze.* London and Thousand Oaks, CA: Sage.

Williams, R. (1976/1990) *Television: Technology and Cultural Form.* London: Fontana.

Wilken, R. (2011) *Teletechnologies, Place, and Community.* London and New York: Routledge.

Venturi, R., Scott Brown, D. and Izenour, S. (1977) *Learning from Las Vegas: The Forgotten Symbolism of Architectural Form.* Cambridge, MA and London: MIT Press.

Zadar Herald [Glasnik Grada Zadra] (2002) The Acts of the City Council of the City of Zadar [Akti gradskog vijeća grada Zadra]. Volume 10, 356–362.

11
Interactive Video Installations in Public Spaces: Rafael Lozano-Hemmer's Under Scan

Elena Papadaki

Introduction

Under Scan, described as an 'interactive video art installation for public space',[1] was presented in Trafalgar Square, a tourist attraction in central London, from 15 to 23 November 2008 as part of the Relational Architecture series by the artist Rafael Lozano-Hemmer. Apart from its credentials as the largest interactive video installation and the longest-running event to be presented in Trafalgar Square (Vanagan, 2009, p. 86) it constitutes an interesting case study for this chapter in order to demonstrate the ways in which screen-based works can function in a 'media city' (McQuire, 2009). Moving away from an art exhibition milieu (such as a museum or a gallery) or a cultural space where they can interact with various arts genres (such as a projection space, a music concert or a theatre performance) screens that operate 'out in the open', especially when they are meant to serve a purpose of interactivity, need to entertain and engage a very heterogeneous crowd.

In this chapter, I will present the exhibition practices employed in Under Scan and address issues of locality, interactivity and participation in the field of new media art, in an attempt to map out a paradigm shift from the conventional ways of presenting the moving image (cinema space, black box, exhibition space) towards more inclusive – and public – approaches. Lozano-Hemmer has stated that, for him, 'a piece is successful if the behaviours and relationships that emerge from participation manage to surprise the artist/designer' (Graham, 2007, p. 254), explaining how multimedia works that feature interactivity for groups are usually out of control. However, how does the projection network affect and direct the viewing regime of the audience? Why is

the unpredictability of the exhibition event an essential factor of its essence? And finally, how could an interactive public work create a new cinematographic ontology in the media world? These are the questions I will attempt to answer, hoping to offer a useful insight into the field of curating screen media in public spaces.

Under Scan

One of the most striking realizations about Under Scan is that it involves a lot of light: covering 2,000 metres of public space, it employs two projectors with 110,000 lumens light intensity each; Trafalgar Square is thus lit throughout. As demonstrated in the diagram below (see Figure 11.1), a tracking camera (positioned on the left of the installation) detects people's movements, evaluating their next trajectories; it then passes on the information to robotically controlled projectors (surrounding the area and installed onto three sets of scaffolds creating a ⊓ shape) that

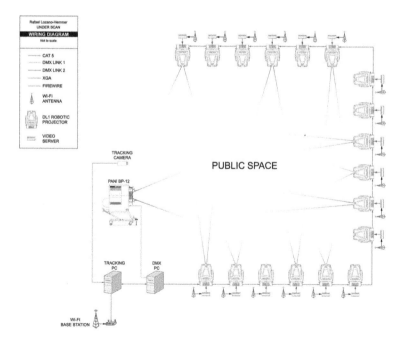

Figure 11.1 Rafael Lozano-Hemmer, Under Scan – Relational Architecture 11, 2005. Wiring Diagram (courtesy of the artist and Antimodular Research)

screen pre-filmed images onto the individuals' shadows and within the enclosed square of the exhibition milieu.

The scaffolds are set up on the north side of the square, while the images are portraits of volunteers who were recorded lying down, having received as instructions only to 'begin the sequence facing the camera and to end facing away' (Vanagan, 2009). In short, the shadow of a passer-by triggers the appearance of a 'video-portrait' of another person onto the former's shadow. Thus, the work *needs* the audience to physically exist in space in order for the projection mechanism to operate. As the pre-filmed images are scheduled to correspond, as much as possible, to the movements and shadow size of the persons casting them, it takes a while for the passers-by to realize that depending on the speed of their movements and the ampleness of their gestures they are presented with different portraits. Every seven minutes, the grid of the system that runs the work becomes apparent in order to be calibrated and reset the circuit; the surveillance matrix is projected on the floor, thus partly revealing the tracking mechanism and the way in which the work functions.

As the willing – or not – participants are not required to do anything in order to interact with the work initially (the first trigger for interaction comes from the machine) they react in different terms. Some of them, unaware that there is an event taking place in Trafalgar Square at that very moment keep on walking, after having paused for a bit to examine the situation, because they are probably on their way back from work.[2] Some others seem to have come specifically to witness the installation and adopt varying approaches, from standing outside the grid contemplating the synthesis of the piece and then going into it, to interacting frantically with it (legs and arms moving in different speeds, a number of people standing very close to each other in order to 'provoke' a larger video portrait and so on). The portraits are programmed to move and turn their heads facing straight at the pedestrian casting the shadow, thus creating an interesting instantaneous bond with that person.

> The key is to develop pieces that offer some degree of intimacy within an intimidating scale. Also to find participation metaphors (ways of taking part that are understandable) that are relatively familiar or self-explanatory.
>
> (Lozano-Hemmer in Graham, 2003, p. 29)

In this respect, the behaviour of the work is to initialize the first contact, but then to let the participants be free to act as they wish and adapt to

their needs. In a public space as vast as Trafalgar Square, which also constitutes one of the main tourist attractions of a metropolis, the statistics of passers-by varies dramatically from one day to the other and from a certain time of day to another. In its scheduled nine-day duration, all-inclusive nature and changing image(s) (thus differentiating itself from all the permanent landmarks of the square), Under Scan functioned as an ephemeral monument that unified the heterogeneous crowd that walked through it.

Exhibition practices – Relational architecture

Rafael Lozano-Hemmer was born in 1967 in Mexico and studied physical chemistry in Montreal. He has worked in the theatre, in radio and with new media. One of his first 'participatory light projects' was when he asked hundreds of people to direct their searchlights towards the city of Mexico.[3] As he often states, it is the active participation of the audience that shapes the final outcome of the artwork, thus defining his role as a type of 'orchestrator' or 'coordinator' of the piece, that is then handed over to its audience (Gabbatt, 2010). In this respect, Lozano-Hemmer moves away from traditional concepts of the artist (who hands a finished piece of work to the audience) or the curator of the moving image (who has a scheduled programme and ideal image synthesis to follow); in the majority of Lozano-Hemmer's works, the audience becomes the co-author and co-curator of the exhibition event.[4]

Initially commissioned by the East Midlands Development Agency (emda),[5] Under Scan, as part of the Relational Architecture series, had been staged previously onto the ground in the main squares and pedestrian routes in five cities in the UK (Derby, Leicester, Lincoln, Northampton and Nottingham) and Europe (Venice) before arriving in London. It was produced by ArtReach, with partnership support from Arts Council England, the Canadian High Commission, the ICA, the Mexican Embassy, the National Gallery, the Science Museum, the Tate (Media and Modern), Quebec Government Office, Arts Lights London, Haunch of Venison and the Jumex Foundation, while the Zabludowicz Trust supported the realization of the public portraits. Instead of building one more permanent public monument – with all the controversies and legal complications that this might involve[6] – the local authorities decided to commission a work that would bring people into the square. It was an expensive production which, in the words of the artist, was 'intended as a public takeover of a city by its inhabitants' and this was possible by 'linking high technology with strategies

of self-representation, connective engagement and urban entitlement' (Stoel, 2008, p. 115). Technology, however, was 'not meant to intimidate', but to 'allow the public to regain a sense of ownership of shared spaces' (Lozano-Hemmer in Vanagan, 2009, p. 86). True, the works cannot function without an interaction from an audience. When preparing a new artwork, Lozano-Hemmer researches the physical area where he plans to exhibit, thinks of how the public could interact with the work and often collaborates with a group of technical experts in order to create the user interface, while always preferring to employ free software for his artworks (Graham, 2003, p.30).

Adapting to geographies of space and population characteristics, Under Scan constituted an ephemeral monument that focused on the idea of an *event* open to all as public art. It was both contained *and* open, since everyone could walk into and away from the grid, while the latter was exposed every seven minutes, thus defining the borders of its reach. Ethnographic research on the work showed an impressive 21 minutes' average-use time and patterns of audience behaviour that 'moved from observation to interaction and discussion between participants' (Mounajjed, 2007; Mounajjed et al., 2007 in Graham and Cook, 2010, p. 187). Lozano-Hemmer does not merely present a screen-based work, but orchestrates a series of processes that relate technology to people, geographical spaces to human relations, tourists to the local population. 'What the artist presents,' he says, 'is an interpretation of space as a scenario to be explored and perceptively expanded thanks to technology.' Technology in his case is perceived as an element of 'immediate impact' that 'creates interaction and original reflections with the general public', as well as the 'visualisation of what in many cases is presented as immaterial; the real and virtual images of members of the public, their shadows that have been carried or extracted, their heartbeats or the words contained in their messages are lifted and released in a new lightweight and captivating dimension' (Lozano-Hemmer in Fagone, 2009, p. 128). He thus goes beyond the traditional screen installation of film or video. The viewer-participant does not need to be confined to a chair for the duration of a work (as in a cinema setting) nor stand for a short while (certainly much less than the above 21 minutes) in front of the work before walking off towards the rest of the presented works (as in an indoor exhibition setting). It has been suggested that the advancement of technology marked a merging between the languages of video and film, with the detachment of the video work from the monitor – as an object – resulting in the liberation of the image into a closer encounter with the surrounding space (Iles, 2002). With Under

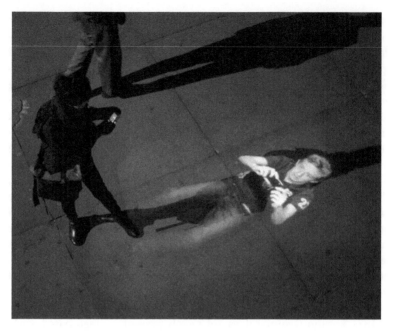

Figure 11.2 Rafael Lozano-Hemmer, Under Scan – Relational Architecture 11, 2005. Shown here: Trafalgar Square, London, United Kingdom, 2008. (Photograph by: Antimodular Research)

Scan, this surrounding space comes to also include the participants who give form and shape to the visual synthesis of the work. Persons with mobile phones or cameras in their hands will probably trigger the projection of other people with mobile phones or cameras in their hands (see Figure 11.2 below).

Furthermore, compared to conventional moving image exhibition practices, Under Scan marks a shift towards a more inclusive sensory involvement. Moving on from the sculptural properties of bulky monitors to single, large-scale projections and from the theatrical use of the physical environment (as in the 'black box') to the illusory merging of the viewing subject and the projection (Iles, 2002, Büchler and Leighton, 2002), screen media projections have come a long way to achieve the embodiment of the viewer within the script of the exhibition event.

Lozano-Hemmer defines his art not as site-specific but as 'relationship-specific'; his focus is on the temporal relationships that arise from the creation of an artificial situation and speak – each time – to a particular audience and place (Lozano-Hemmer in Fagone, 2009; Graham,

2003, p. 29); it was with the above rationale in mind that he called a series of works Relational Architecture. For Under Scan, local filmmakers in Derby, Leicester, Lincoln, Northampton and Nottingham took more than 1,000 video portraits, while in London more than 250 new ones were filmed additionally.[7] The public were 'invited to participate in the work by contributing their video portrait from 19 to 21 September at Tate Modern'.[8] On the Facebook page of the project, the invitation 'if you want to participate, we want to film your video at the preliminary event at Tate Modern. Follow the links to book your space' offered simple steps for any willing adult on what to do in order to become part of the project.[9] I was not filmed myself, but later found out from volunteer Londoners that the process ran smoothly and in an uncomplicated way, the only instructions they received being that they need to face the camera that was suspended above them while they laid down and to face away from it at the end. Apart from this, they had three minutes each (and full freedom) to act as they wished during the moments of their recording and to do what they thought represented them best. As it is reminded on the Tate website:

> This approach to engaging the public within the creative process is fundamental to Lozano-Hemmer's vision, with the content of the installation to be centred on self-representation by local people; their movements and gestures providing a unique contribution to the work.
>
> (http://www2.tate.org.uk/intermediaart/underscan.htm)

Moving on to the next level of the project's realization, the video portraits were programmed to 'interact' with the pedestrians in a pre-set manner. When a shadow triggered the apparition of a portrait, the latter faced straight into the shadow, thus –one could suggest – creating instantly and unexpectedly an intimate relationship with that person. When the passer-by walked away, the pre-filmed person appeared to be looking away, drifting into total disappearance (i.e. switching off) if nobody arrived to re-trigger its next appearance.

New media use (and consequently, the use of moving image projection) here does not seem to constitute an object of study per se, but rather a *method* of curatorial practice. If the aim is to relate passers-by to the people inhabiting a city and to the public space, then the tracking cameras and computer, the Wi-Fi base station and the projectors constitute the vehicle for achieving the above interaction. The curating process, thus, passed through different stages: the recording of the video

portraits, the setting-up of the scaffolds and the equipment in each location, and the orchestration of the event. Even though during the first stage there was a certain control and instructions given on the production of portraits[10] and during the second stage decisions were taken by the artist and his team, Antimodular Research, the third stage of the work, which also marked the culmination of the project, depended on the public for its existence and visual synthesis. The screened portraits and the individuals on whose shadows they appeared constituted the new ephemeral monuments of the square, the new Nelson's Column and fourth plinths[11] which, even for a short while, defined the image of this specific space. Furthermore, having as a reference point the National Gallery and the National Portrait Gallery located just on top of the north square, it could be suggested that they served as a conceptual contemporary 'continuation' of a history of portraiture that can be found on the walls of these institutions. With this logic in mind, the new kings, queens and aristocracy who deserve to have their portraits painted are now the general public, with no discrimination against anyone or a selection process to follow. Moving away from the idea of the public monument that will remain on a specific milieu forever, Lozano-Hemmer chooses to activate the relations that potentially exist between people and other people, people and places, people and machines. In this framework, the technology employed 'facilitate[s] a platform for kinds of interaction between human and human', while the artwork 'act[s] as a host or platform for human interaction' (Graham and Cook, 2010, p. 113). The screened images do not merely serve as static visual offerings to the people who cast their shadows on the square, but present a high level of engagement with their gestures, physique and movement. The playful involvement of the live participants[12] stands as a proof of how the presentation of these pre-filmed portraits can create new relations and ways of directing an audience towards a certain practice of interaction with a new media work. The artwork's content depends upon them, changes with them and achieves its existence *through* them. In comparison to more traditional moving image projections, the audience here is also a participant and co-curator of the work.

Locality, interactivity and participation

Titled 'the world's most famous electronic artist' (Gabbatt 2010), Lozano-Hemmer's experimentation presents particular elements 'in a scenario that examines the role played by technology even with regard

[to] a rearrangement of the theoretical and aesthetic apparatus' (Fagone, 2009, p. 127). The artist claims that it has become impossible to think of our world without technology, since technology has by now become 'the language or the unavoidable medium for our thoughts'. Referring to Walter Benjamin's 'The Work of Art in the Age of Mechanical Reproduction', he explains that with digital technologies, the aura 'has returned, and with a vengeance'. The potential multiple readings, the unexpected elements that might arise with the participation of the user, the idea of the open work that 'requires exposure in order to exist', the computer as a 'unif[ying] and amalgamat[ing] [force behind] the different means of communication' and the capability of the machine to 'captur[e] algorithmic conditions [producing] an unexpected outcome that will even surprise the author himself' (Fagone, 2009, p. 128) all coexist in a work of art using technology resulting in the above-mentioned vengeance of the aura.

Lozano-Hemmer identifies two main areas of research running throughout his practice: first, 'interactivity intended as the possibility of expanding new parallels with the physical space' and second, 'the "technologies of the fixed stare", which derived from the theories of Michel Foucault, panoptic and post-optic, surveillance closed-circuit television, computerized control systems where the fixed stare of the general public can be reflected in/compared to the fixed computerized stare' (Fagone, 2009, p. 128). In this respect, what matters is the relations that are being formed through and with the help of the medium, and not the medium itself. It would not be an exaggeration to suggest that Lozano-Hemmer creates a 'made-to-measure' screen experience, since one encounters a double (or not), stays in the grid (see Figure 11.3 below) and exchanges stares with the pre-recorded portrait of an unknown person and 'provokes' the appearance of a different portrait by choreographing moves with a crowd of unknown passers-by. What this means, in relation to more canonical projection practices (in the cinema or the exhibition space, for instance) is that the centre of the focus moves from the actual screen to the activity of the audience. Moreover, the participation of the latter constitutes the trigger that gives life to the work.

Furthermore, even though Lozano-Hemmer's projects tour the globe, there is always a local element preserved. In Under Scan, for instance, local filmmakers recorded portraits of the local population, which were then projected onto local public spaces. Or, when interviewed, Lozano-Hemmer often mentions how the reactions to his work differed greatly from one part of the world to the other. There is thus a cosmopolitan *and* local character in his series of installations, one that raises questions

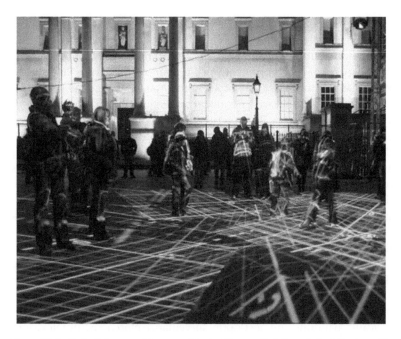

Figure 11.3 Rafael Lozano-Hemmer, Under Scan – Relational Architecture 11, 2005. Shown here: Trafalgar Square, London, United Kingdom, 2008. (Photograph by: Antimodular Research)

about what Richard Sennett would call 'public culture' and 'everyday cosmopolitanism' (McQuire, 2009, pp. 56–57). Public space per se as the exhibition milieu of choice, rather than an art gallery or museum atrium, explains a great deal about the 'target crowd' of the artist, who believes that the work benefits a lot from people who just encounter it rather than from an art audience who comes to a specific location in order to see the work (Lozano-Hemmer in McQuire, 2009, p. 58).

McQuire suggests that Lozano-Hemmer's works are indicative of some situations that often occur when exhibiting a public-space, media art piece. First, the interactivity asked from the audience means that one can never predict the outcome or how the people will react to it.[13] Second, it produces 'complex combinations of personal intimacy and civility'. In Under Scan, the audience were not merely called to click on a mouse and watch a screen but to *physically* participate in an embodied interaction.[14] Third, the work depends upon the presence of the public in order for *anything* to happen. Even though there are tracking monitors and pre-filmed images, the installation cannot really reach

its existential reason for being unless there is participation from a live audience. In this respect, the audience co-produces the work while at the same time forms an inseparable part of it (McQuire, 2009, p. 58). This fascination with people and their recording constitutes an element that appears a lot when referencing the work of Lozano-Hemmer (Gabbatt, 2010). According to Graham, what differentiates Lozano-Hemmer's work from various so-called 'interactive' new-media artworks (or even, to widen the scope, from traditional screen projections) is specifically this idea of a *creative* participation. Whereas more often than not, choices presented to the user are very simple, Lozano-Hemmer favours a practice where 'the audience can make their own ideas visible' (Graham, 2003, p. 28). However, in order to make people participate, or even make complete strangers act out a bizarre choreography in order for different portraits to appear, Lozano-Hemmer needs to offer interfaces that 'are capable of commanding immediate attention' but without being 'immediately comprehensible' (McQuire, 2009, p. 59). In this way, people may initially stop because they look at a beautiful image or at the calibration grid, but in the process are intrigued to check for themselves and see 'what happens if'.... In Under Scan, participation existed in three different stages: the people who were filmed for the pre-recorded portraits, the participation of the crowd in Trafalgar Square in response to the work, and the participation of individuals between them for a different version of the work. Video technology here is employed in the name of a playful city and in the creation of new roles of the individual within the urban environment (Stoel, 2008).

Conversely, as it has been remarked acutely, one might not help but wonder whether this affects in any substantial way the social dynamics and life of a city (Menotti, 2013). It is true that not much is left after the work is dismantled and packed away, and that the relationships formed throughout its duration no longer exist once the lights are switched off. However, if we keep in mind that Under Scan was initially commissioned by emda [*sic*] in an attempt to mark the beginning of a new vision for East Midlands, the idea of a work that could make the residents of Lincoln and Nottingham get out of their houses and into the public squares is still a positive step towards the future success of similar initiatives in social interaction.

Lozano-Hemmer's interventions seem to put the citizen of the city in a very central position within the body of the work and in the sketching of the contemporary urban landscape.

The public can have a substantial amount of creative input to the artwork. Although interaction may be a discarded debate, in certain new media situations the artists and the curator are undeniably much less in control of the artwork, and have to trust the audience as much as the location.

(Graham and Cook, 2002, p. 44)

The idea of an artwork that makes one think but also entertains seems to constitute a focal point in Lozano-Hemmer's body of work. Nevertheless, it could also be suggested that it is precisely through the 'employ[ment of] video technology for play rather than control' that he brings the 'condition [of the] contemporary public space [as] overwhelmingly privatised and scripted, [with] constant surveillance [being] now the normative condition' (Stoel, 2008, p. 114).

Screens out in the open

The co-existence with screens on a daily basis constitutes, by now, a mere self-proved statement for most individuals in the developed part of the world. Screens themselves, with the advancement of technology and reduction in prices, have gradually entered the household (television), the workplace (computers) and the palms of our hands (mobile phones). In public spaces, there are instances where a particular place in a city becomes a gigantic multiple-screen advertisement (such as Piccadilly Circus in London or Shibuya in Tokyo) or where it is used as an artistic or informative platform (such as the subway public art commissions in New York City or the gigantic screens on Federation Square in Melbourne). In a way, it could be suggested that the more mediated our life becomes, the less thrilled we can be with the apparition of screens in the public space. If we take it even further and abandon the idea of the screen as an object or of a specific projection, the illumination of public spaces equally holds a great historical tradition. From Brooklyn Bridge in 1870 to the Electric Palace of the 1889 Paris Universal Exposition and from the New York Singer Tower in 1908 to the Dome of Light in Nazi Germany in 1935, lighting constituted a way in which electricity could become visible as a form of energy (Canogar, 2004, pp. 9–10).

 In this respect, there is nothing innovative in the existence of screens and projections in the contemporary city. As McQuire notes, their proliferation during the last ten years 'has become one of the most visible signs of contemporary urbanism' and is 'symptomatic of the emergence of what [he] call[s] "the media city" '.[15] He uses the term in order

to suggest the destabilization of traditional urban hierarchies and the uncertainty towards the idea of the city functioning as a symbolic centre on one hand, while underlining the change in the use of media with the arrival of endless digital possibilities on the other hand (2009, p. 47). One of the symptoms of the latter is the 'mobility' of the media. Screens no longer denote the cinema or the TV screen in a living room, but an object (or two) that we carry with us at all times: mobile phone (and tablet and/or laptop). With digitalization, the same programmes used by a filmmaker could be accessed (and used) by an amateur wishing to record his visit to Trafalgar Square. The term 'media city' is used here in order to describe how one experiences the urban space in social life, that is 'through a complex process of co-constitution between architectural structures and urban territories, social practices and media feedback' (McQuire, 2009, p. 48). The success of Under Scan could be traced precisely in its ability to capture the essence of the above elements. By mobilizing projections in the public territory, the latter acquired the dual nature of both exhibition pieces and – at the same time – interaction materials.

Conclusion

> I am never going to make a sculpture of one guy and put it in a spot. My projects are platforms; they are like the pedestal for people to overtake the space. As such they are projects that change over time.
> (Lozano-Hemmer in Galilee, 2009, p. 37)

Not only over time, could one add, but also over space. Lozano-Hemmer's works function as platforms for social interaction, and as such adapt accordingly to the environment. In Under Scan, the pre-recorded images followed a specific life trajectory in order to end up interacting creatively with passers-by in Trafalgar Square. Cinema technology was employed in this case in order to assign a portrait to each person who moved inside the grid of the installation and to create a moment of intimacy and discomfort at the same time. There are manifold localizations in the work; local filmmakers from the UK cities where Under Scan was previously installed (Lincoln, Leicester, Northampton, Derby, Nottingham) recorded portraits of the local population; in London alone an extra 250 people were filmed. Furthermore, in each city where Under Scan was installed, the geography of the open space was taken into account and the size of the work was adapted to it. For the Trafalgar

Square version of Under Scan, it felt that the video portraits and the participants acted as the new, democratic version of a long history of class and wealth-based portraiture out of the National Gallery and National Portrait Gallery and into the non-enclosed public sphere.

Additionally, the work brings forward questions concerning the current perception of screen media and their use as a communication vehicle between urban and living agents. The projected images are regulated by their audience and dependent on it; if there is no person casting a shadow there will be no projected video portrait, or someone moving their hands will probably be presented with a portrait of a person also moving their hands. In a nutshell, Lozano-Hemmer employs practices of projection that are dynamic and inclusive, having as an ultimate target to 'produc[e] experiences that interrupt normal narratives', experiences that are 'eccentricities' and 'exceptions' (Lozano-Hemmer in Galilee, 2009, p. 37). Furthermore, he presents an art project that, compared to traditional screen projections, is not just about sitting, standing and looking but about networks, interaction and participation; the emphasis remains on behaviours and context (Graham and Cook, 2010, p. 5). Within this framework, high-end technology and interactive practices of projection become a tool in order to make people move, participate, interact with each other and be entertained. To conclude, the Tate website probably gives the best description of Lozano-Hemmer's practice: 'his installations aim to provide "temporary anti-monuments for alien agency"'.[16]

Notes

1. http://www.lozano-hemmer.com/under_scan.php [Accessed: 11 April 2012].
2. Lozano-Hemmer found that the foot traffic in Trafalgar Square benefited greatly the 'experimental aspect' of the work, since 'people would just "encounter" the work as they went home after work, for instance, rather than having to go to a specific location to see it'. (Email interview with Scott McQuire, 2009, cited in McQuire, 2009, p. 58.)
3. Vectorial Elevation, Relational Architecture 4, 1999. http://www.lozano-hemmer.com/vectorial elevation.php [Accessed: 26 September 2014].
4. See, for instance, the description of the 'Relational Architecture' and 'Subsculpture' series on the artist's website. http://www.lozano-hemmer.com/projects.php [Accessed: 26 September 2014].
5. Under Scan was the first major artistic commission undertaken by the East Midlands Development Agency (emda) with Arts Council England, within the framework of over £140 million investment in new buildings for culture and creative work in the East Midlands. (François Matarasso [chair, Arts Council England East Midlands] and Ross Willmott [emda board member] in Lozano-Hemmer and Hill, 2007, p. 6).

6. Richard Serra's Tilted Arc (1981) spontaneously comes to mind which, after much debate, was removed from the Federal Plaza in New York City in 1989.
7. www.lozano-hemmer.com/under_scan.php [Accessed: 26 September 2014].
8. http://www2.tate.org.uk/intermediaart/underscan.htm [Accessed:26 September 2014].
9. The 100-word description of, invitation to, the project read:

> Under Scan is a large-scale public video art installation featuring 1000 interactive portraits that are activated by the shadows of passers-by. The next Under Scan installation will take place in Trafalgar Square. The world's brightest projector will be used to flood the square with white light. As people walk past, the shadows they cast will activate video portraits that will interact with them. You have the opportunity to be digitally immortalized in this installation, by having your video portrait filmed at a preliminary event taking place at Tate Modern on 19–21 September ('Under Scan' Facebook group – [currently deactivated]).

10. As mentioned before, the participants were instructed to look towards and away from the camera, and had 3 minutes at their disposal to express themselves in any way they wished.
11. Nelson's Column is the 52-metre-tall, central monument in Trafalgar Square. The fourth plinth constitutes one of the plinths that are located in the corners of the square. It remained bare until 1999, when the Royal Society of Arts commissioned the 'Fourth Plinth Project' and then the 'Fourth Plinth Commission', in order to give the opportunity to a succession of works by contemporary artists to occupy the plinth.
12. Such as trying to interact with their video-projected counterpart by moving frantically, standing close to each other in order to produce a bigger projection, dancing, attempting to 'fool' their shadow by jumping away from it and returning to it shortly after.
13. An interesting example is the case of Re: Positioning Fear [Graz, 1994], where the artist initially wanted to communicate feelings of fear and anxiety but the crowd adopted a playful approach instead (McQuire 2009, p. 58).
14. In this, it differentiates itself from an artwork or projection piece, since it unsettles the traditional viewing regime of screen media, i.e. to sit (in a cinema or a gallery space) and watch the action happen in front of one's eyes.
15. For a quick overview of the developments that took place in the last four decades resulting in the media city, see McQuire, 2009, pp. 45–47.
16. http://www2.tate.org.uk/intermediaart/underscan.htm [Accessed: 26 September 2014].

Bibliography

Büchler, P. and Leighton, T. (eds.) (2002) *Saving the Image: Art after Film* Glasgow and Manchester: CCA and Manchester Metropolitan Press.
Canogar, D. (2004) Illuminating Public Space – Light Shows Contemporary Art. *Public Art Review*, Light, Fifteenth Anniversary Issue, 15 (2), issue 30, 9–13.

Fagone, C. (2009) Rafael Lozano-Hemmer: Designing the Unexpected. *D–, Lux,* 5 (April), 124–131.

Gabbatt, A. (2010) Rafael Lozano-Hemmer: Visitor Virtuoso. *The Guardian,* 17 September.

Galilee, B. (2009) In Trafalgar Square. *Icon,* pp. 36–37.

Graham, B. (2003) Digital Media. In: Graham, B. (ed.) *Directions in Art,* Oxford: Heinemann, pp. 28–31.

Graham, B. (2007) Interaction/Participation: Disembodied Performance in New Media Art. In: Harris, J. (ed.) *Dead History, Live Art?.* Liverpool: Liverpool University Press, pp. 254–258.

Graham, B. and Cook, S. (2002) Net and Not Net – Curating New Media. *Art Monthly,* 261 (November), 44.

Graham, B. and Cook, S. (2010) *Rethinking Curating – Art after New Media,* Cambridge and London: The MIT Press.

Lozano-Hemmer, R. and Hill, D. (eds.) (2007) *Under Scan.* Nottingham: emda.

Iles, C. (2002) Issues in the New Cinematic Aesthetic in Video. In: Bchler, P. and Leighton, T. (eds.) *Saving the Image: Art after Film,* Glasgow and Manchester: CCA and Manchester Metropolitan Press.

Menotti, G. (2013) Façadelifts – New Media Installations, Public Space and the Negotiation of Civic Identity. In: Scullion, R. et al. (eds.) *The Media, Political Participation and Empowerment,* London: Routledge.

McQuire, S. (2009) Mobility, Cosmopolitanism and Public Space in the Media City. In: McQuire, S., Martin, M. and Niederer, S. (eds.) *Urban Screens Reader,* Inc Reader #5, Amsterdam: Institute of Network Cultures.

Stoel, E. (2008) Rafael Lozano-Hemmer: Urban Projections. *Praxis,* (10), 114–119

Vanagan, D. (2009) Rafael Lozano-Hemmer – Trafalgar Square, London. *Canadian Art,* 26 (Spring), 86–87.

Index

Printed and bound by CPI Group (UK) Ltd, Croydon, CR0 4YY